Life in Eastern Kentucky

A Pictorial History: The Early Years

PRESENTED BY THE LEXINGTON HERALD-LEADER

Acknowledgments

Many thanks to the citizens of Eastern and Central Kentucky, whose sharing of their family photographs made this book possible.

The text was written by *Herald-Leader* staff writer Andy Mead.

Other photographs in this book were graciously provided by these organizations:

Bobby Davis Museum and Park in Hazard

The Appalachian Collection of the McGaw Library and Learning Center at Alice Lloyd College

Bryan W. Whitfield Jr. Public Library in Harlan

Pikeville Public Library

Rowan County Public Library

Godbey Appalachian Archives at Southeast Kentucky Community and Technical College

Transylvania University Library Archives

Special Collections at the Hutchins Library in Berea

Camden-Carroll Library Special Collections at Morehead State University

Table of Contents

FOREWORD

The first people of Eastern Kentucky were Native Americans, who arrived thousands of years ago. They were later joined by adventurous frontiersmen of European descent who risked and sometimes lost their lives to explore a rich new world.

Many more have followed, including immigrants new to the country and share-croppers from the South.

The land and the work melded them all into something unique: A stubbornly independent group of people with a strong sense of family and place.

Many photos of these people are presented on the following pages and in all, those attributes show through.

There are the innocent faces of children in front of their one-room school houses, the solemn older couples looking straight into the camera, the candid images of people going about an everyday life that has long since faded into memory.

The population of the mountains has ebbed and flowed, but anyone who has spent any time there always carries a part of it with them.

Look carefully through the photos. You might find a great-grandfather, a great-grandmother, or someone who is so much like your ancestor that they might as well be family.

VIEWS & SCENES

For all its open spaces, people who live on the Cumberland Plateau of Eastern Kentucky are often as close to their neighbors as city dwellers. Houses are cheek to jowl along the ribbons of flat land that line the banks of the region's many winding creeks and rivers. Groups of those houses often were built at the same time in a coal camp, giving them an architectural uniformity that also seems urban.

The cities and towns, too, were crowded into narrow valleys that required them to be long but not wide.

The scarcity of flat land had its drawbacks. But it guaranteed that if you were an Eastern Kentuckian, you knew your neighbors. And it drew people together. If you lived on Frozen Creek in Breathitt County, for example, you felt a kinship — sometimes figurative and often literal — with your neighbors.

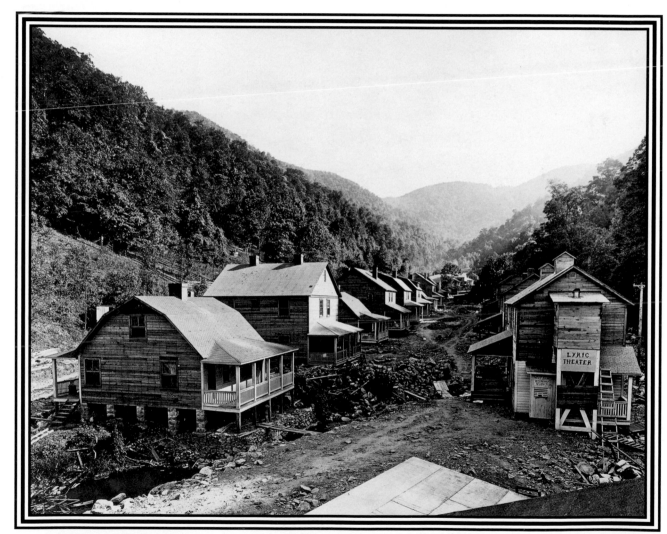

View looking up Gap Branch, Lynch, July 1, 1918. *Courtesy of Southeast Kentucky Community and Technical College, Godbey Appalachian Archives*

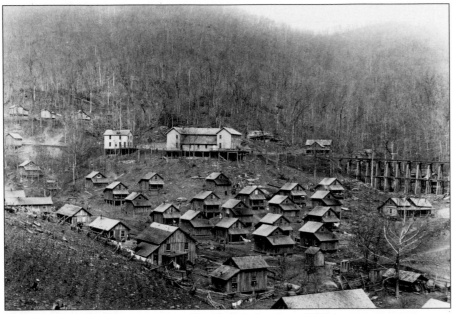

Proctor Coal Company community, Red Ash, circa 1880. *Courtesy of Photographic Archives, Appalachian Learning Laboratory, Alice Lloyd College*

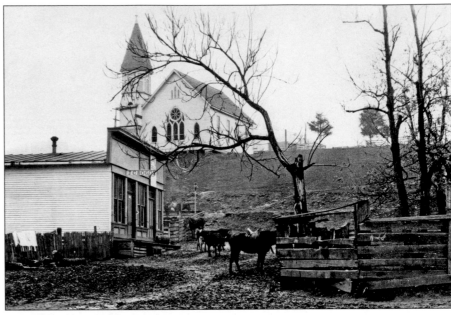

Hazard, circa 1900. *Courtesy of Photographic Archives, Appalachian Learning Laboratory, Alice Lloyd College*

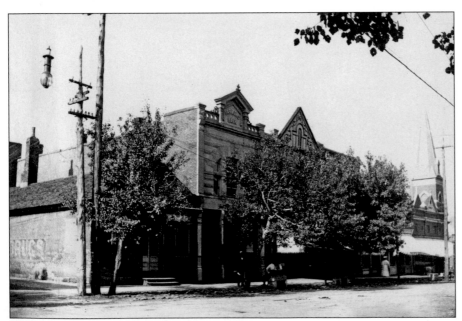

Main Street in Owingsville, circa 1905. *Courtesy of Special Collections & Archives, Camden-Carroll Library, Morehead State University*

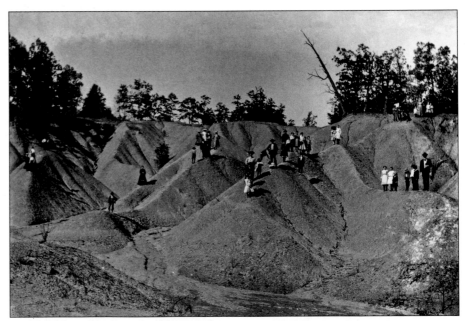

The Knobs at Salt Lick, circa 1905. *Courtesy of Special Collections & Archives, Camden-Carroll Library, Morehead State University*

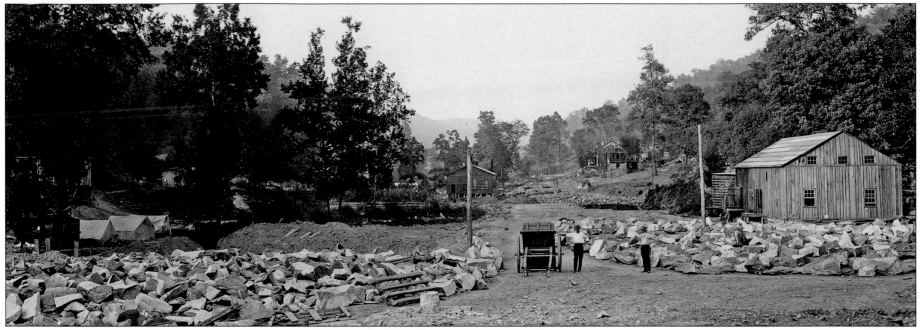

Main street of Jenkins, Sept. 20, 1911. *Courtesy of Photographic Archives, Appalachian Learning Laboratory, Alice Lloyd College*

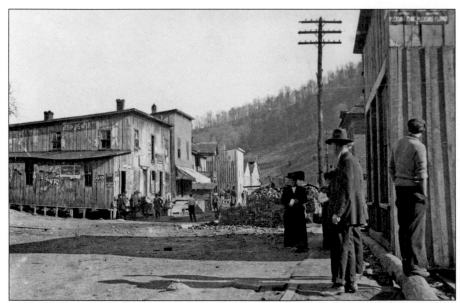

Main Street of Hazard looking toward D. Y. Combs' store, circa 1910. The man in the suit is Matt Cornett; the woman is Clara Cornett. *Courtesy of Bobby Davis Museum and Park*

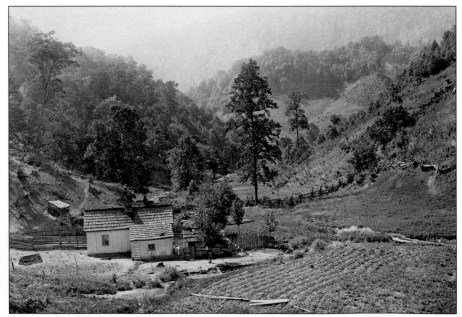

View up Little Elkhorn Creek, June 4, 1912. *Courtesy of Photographic Archives, Appalachian Learning Laboratory, Alice Lloyd College*

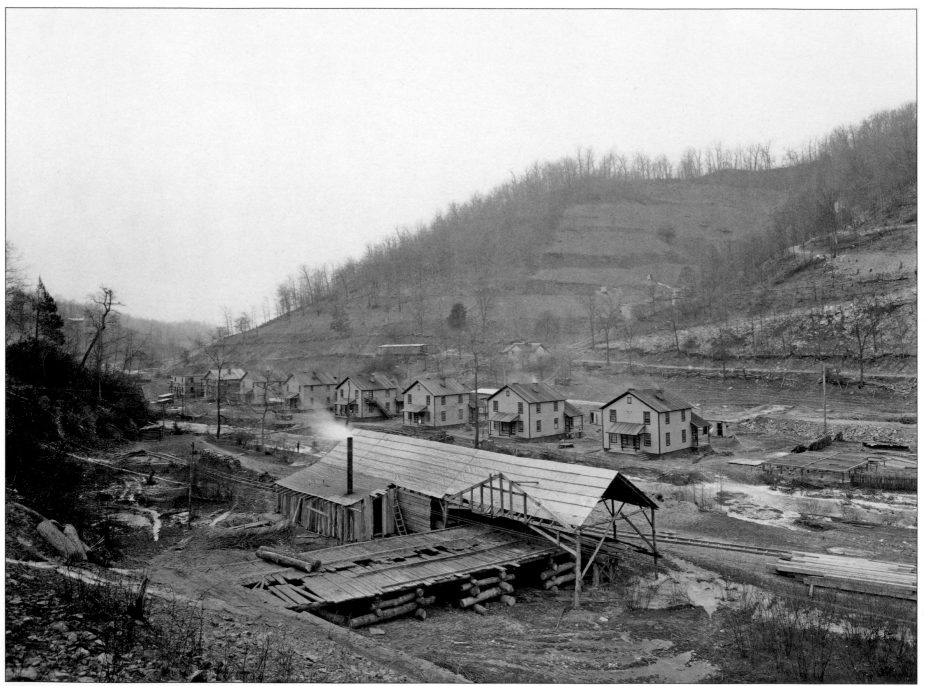

Main street of Jenkins looking east, Jan. 1, 1912. *Courtesy of Photographic Archives, Appalachian Learning Laboratory, Alice Lloyd College*

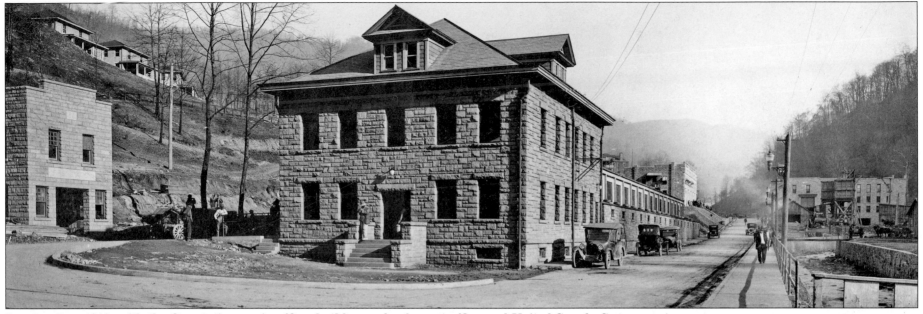

Lynch, circa 1918, with the fire station, main office, bathhouse, bank, post office and United Supply Company store. *Courtesy of Southeast Kentucky Community and Technical College, Godbey Appalachian Archives*

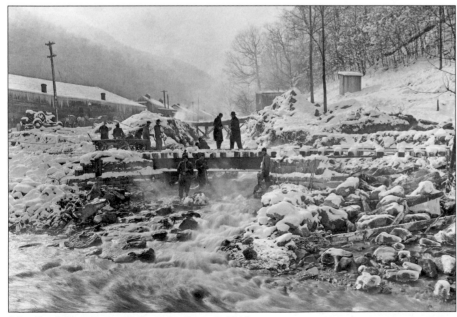

Mouth of Gap Branch, Lynch, Jan. 4, 1919. *Courtesy of Southeast Kentucky Community and Technical College, Godbey Appalachian Archives*

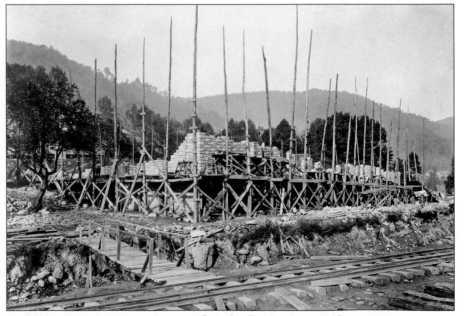

Building the company store at Lynch, September 1918. *Courtesy of Southeast Kentucky Community and Technical College, Godbey Appalachian Archives*

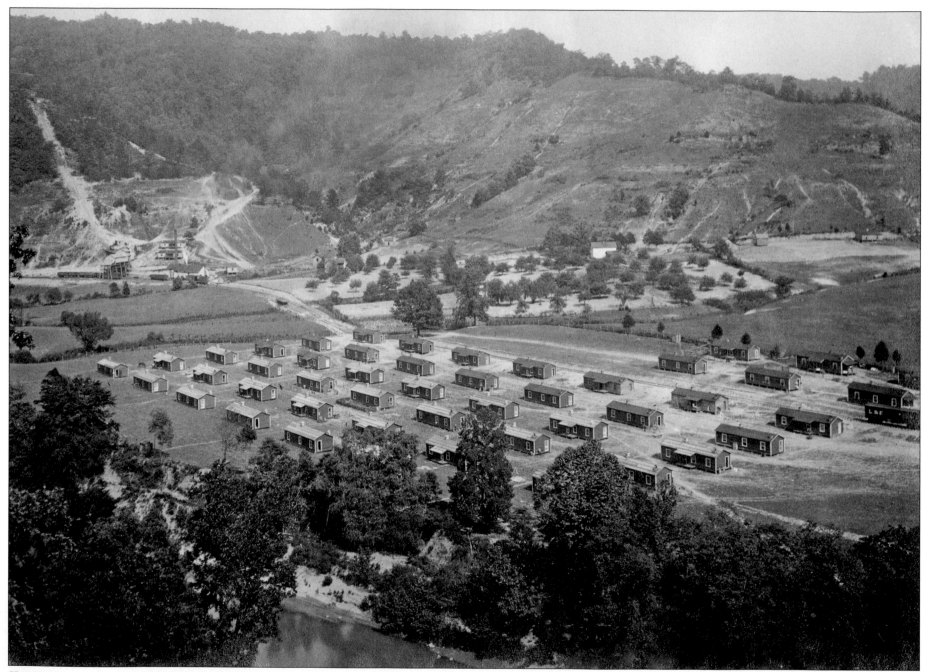

Kentucky Jewell Coal Company camp was built in 1917. The layout of neat rows of the camp shaped the future streets of Lothair. *Courtesy of Bobby Davis Museum and Park*

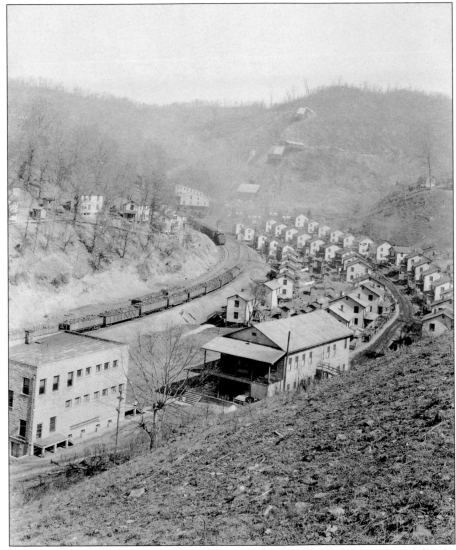

Coal camp of Hardburley, 1918. The company provided free electricity to camp houses. They had their own store, hospital, doctor's office, dentist, dry cleaning, water, baseball field and tennis court. The houses got fresh paint every two or three years. The work force was around 487. *Courtesy of Bobby Davis Museum and Park*

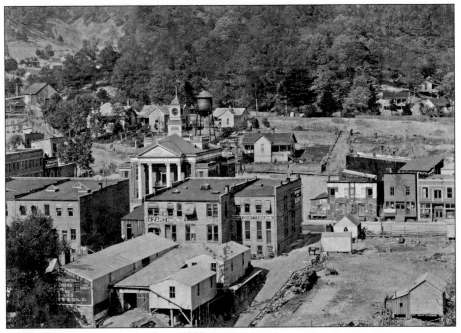

Hazard in the summer, circa 1916. *Courtesy of Bobby Davis Museum and Park*

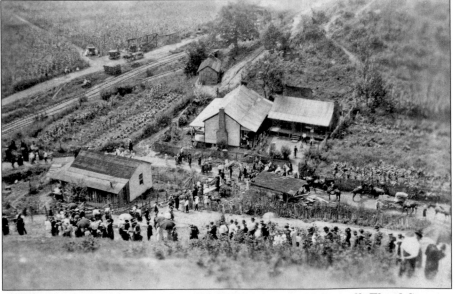

People descending from the Lucy Hall Cemetery in McDowell, Floyd County, Aug. 17, 1924. The large home in the center belonged to Ben and Lucy Hopkins Hall. *Courtesy of Barry Dean Martin*

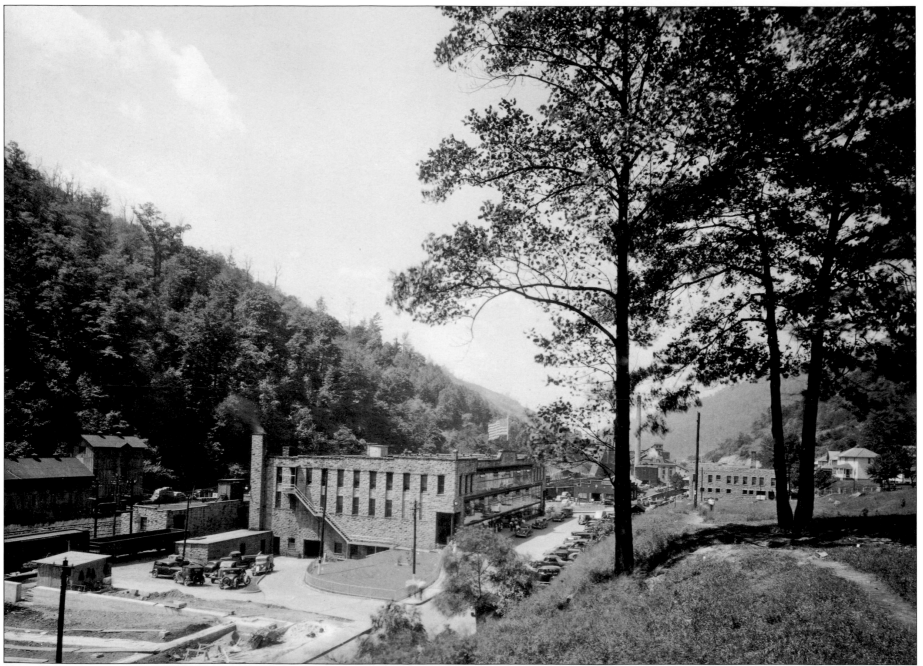

View of United Supply Company's main store, Lynch, circa 1920. The post office, tipple and shop are included in the background. *Courtesy of Southeast Kentucky Community and Technical College, Godbey Appalachian Archives*

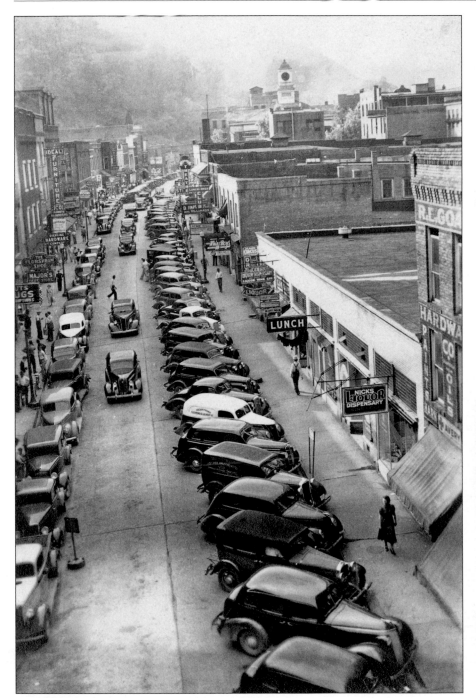

Natural Bridge State Park at Slade, circa 1930. Train excursions ran from Louisville to the park. William Swope was the curator of the park with his wife, Sallie, who cooked for the railroad staff. *Courtesy of Sue Ann Bell and Peggi Ballard with Barbara Wilson*

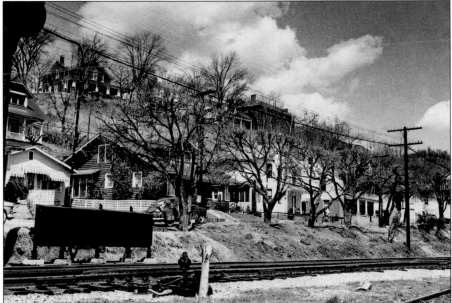

South Hellier Street, Pikeville, circa 1936. *Courtesy of Paul B. Mays Collection, Pikeville Public Library*

Main Street, Hazard, circa 1938. *Courtesy of David Ravencraft*

MINING & LOGGING

Coal and lumber have poured out of Eastern Kentucky since the last half of the nineteenth century. The two industries have provided honest hard work for generations of mountain men.

During the period covered by the photographs in this book, both were extremely labor intensive. They also were subject to periods of boom and bust. And, whether it was trees or coal, most of the profits went to corporations in faraway states.

The lush hardwood forests of Eastern Kentucky are among the most diverse collection of species found anywhere in the world. The scientists call it "mixed mesophytic." The region's early residents knew just that there was what appeared to be an endless supply of gigantic oaks, chestnuts, hickories and poplars. And, although the trees stood on remote hillsides, there was a network of rivers that could float them to sawmills, where they were turned into lumber to meet the needs of a growing nation.

The coal industry got a later start, but it soon was pulling in laborers from far away, and by 1920 well over half a million miners were wrestling coal from deep in the ground.

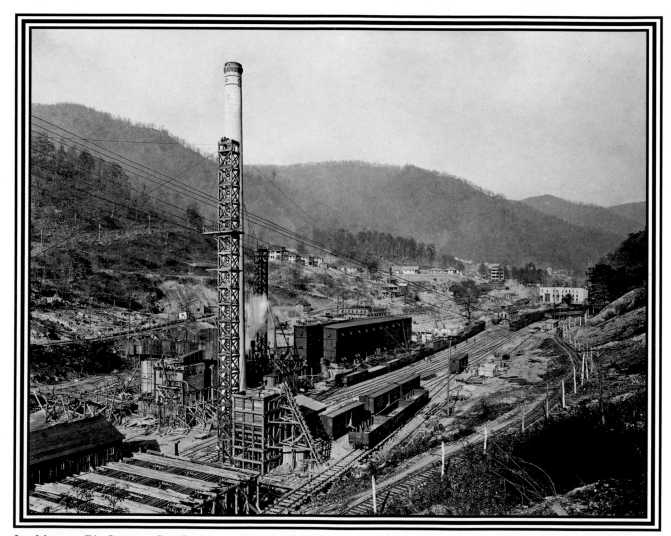

Looking up Big Looney Creek, Lynch, May 1, 1919. *Courtesy of Southeast Kentucky Community and Technical College, Godbey Appalachian Archives*

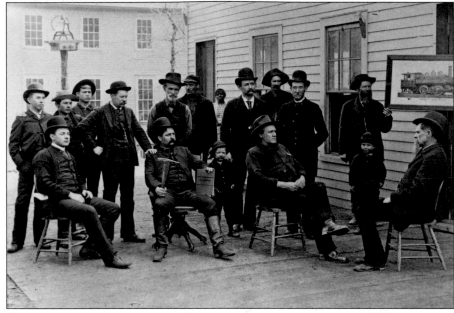

Group gathered at Proctor Coal Company store, circa 1885. *Courtesy of Photographic Archives, Appalachian Learning Laboratory, Alice Lloyd College*

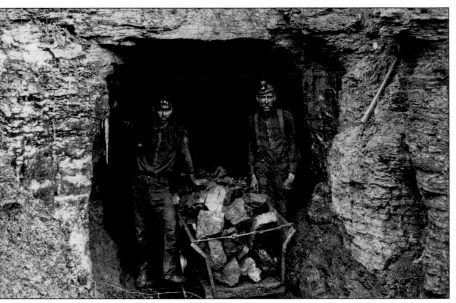

Early mine opening of the Miller's Creek Black Seam, circa 1885. *Courtesy of Bryan W. Whitfield Jr. Public Library and Photographic Archives, Appalachian Learning Laboratory, Alice Lloyd College*

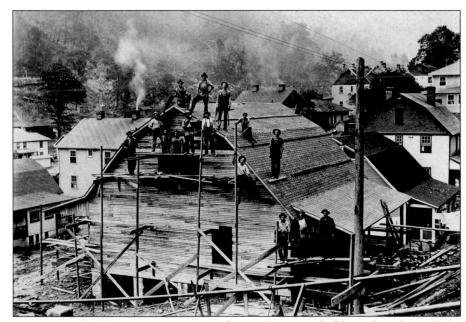

Carpenters building a structure at Camp No. 2, probably at Lynch, early in the century. *Courtesy of Bryan W. Whitfield Jr. Public Library*

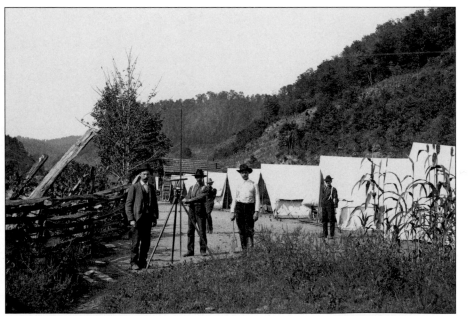

Surveying for the Northern Coal & Coke Company, Letcher County, circa 1910. *Courtesy of Appalachian Photoarchives, Southern Appalachian Archives, Berea College*

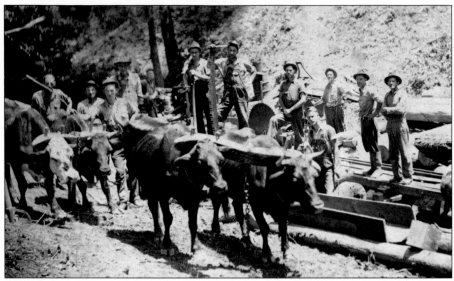

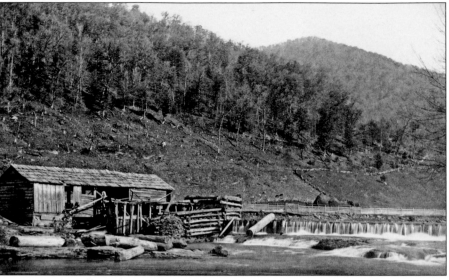

Sawmill and logging operation at Whitepost, or Hatfield, Pike County, circa 1909. Included are Lacy Lowe, Donnie Lowe and boss and father Thomas Sherman Lowe. Thomas was killed the next year by falling logs. *Courtesy of David Ravencraft*

A board and batten building serves as the sawmill of E. Winn, Esq., on Clover Fork, Harlan County. The Cumberland River flows by the mill with a small waterfall above it. *Courtesy of Photographic Archives, Appalachian Learning Laboratory, Alice Lloyd College*

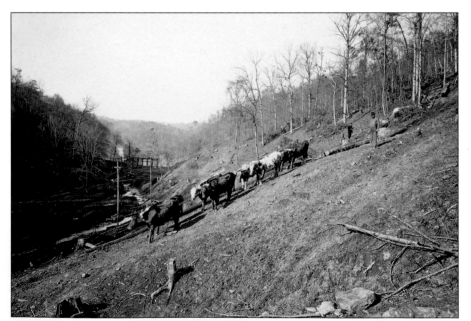

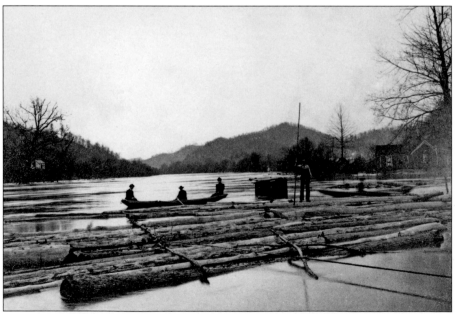

Oxen "snaking" logs down a partially cleared hill, circa 1910. *Courtesy of Photographic Archives, Appalachian Learning Laboratory, Alice Lloyd College*

Guiding a load of logs down the Big Sandy River, circa 1910. *Courtesy of Photographic Archives, Appalachian Learning Laboratory, Alice Lloyd College*

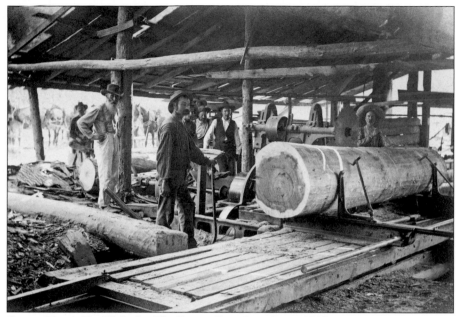

Sawmill at Redlick in Madison County, circa 1910. *Courtesy of Appalachian Photoarchives, Southern Appalachian Archives, Berea College*

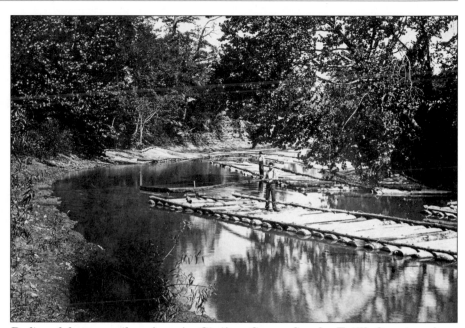

Rafts of logs on the river in Station Camp Creek, Estill County, circa 1910. *Courtesy of Appalachian Photoarchives, Southern Appalachian Archives, Berea College*

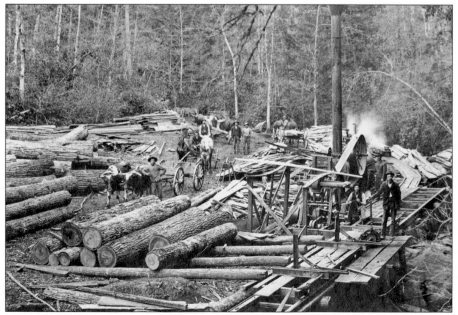

Turning the felled trees into lumber in a sawmill operation, circa 1910. *Courtesy of Appalachian Photoarchives, Southern Appalachian Archives, Berea College*

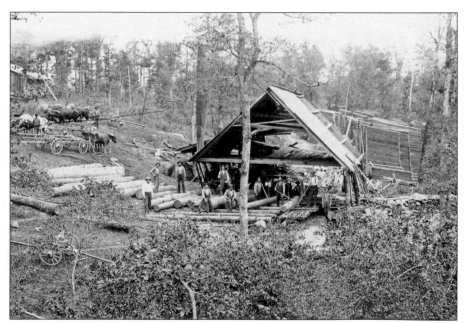

Sawmill at Redlick in Madison County, circa 1910. *Courtesy of Appalachian Photoarchives, Southern Appalachian Archives, Berea College*

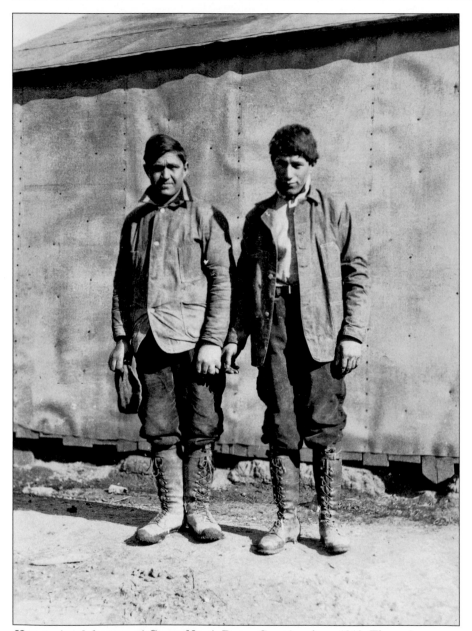

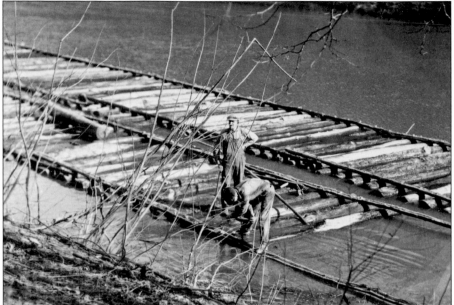

Rafts of logs ready for a "tide" in Station Camp Creek, Estill County, circa 1910. *Courtesy of Appalachian Photoarchives, Southern Appalachian Archives, Berea College*

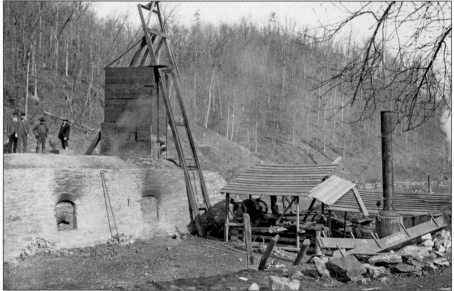

Hungarian laborers at Camp No. 4, Perry County, circa 1910. These two men were trapped in the fall of a tunnel. The man with the cap in his hand was fastened by a falling rock that crushed his foot. He was wedged in the tunnel for 48 hours. The men were summoned back to their country in 1914 to serve in the Hungarian Army in World War I. *Courtesy of Bobby Davis Museum and Park*

Experimental ovens built by Northern Coal & Coke Company at Elkhorn Creek, Letcher County, circa 1910. *Courtesy of Appalachian Photoarchives, Southern Appalachian Archives, Berea College*

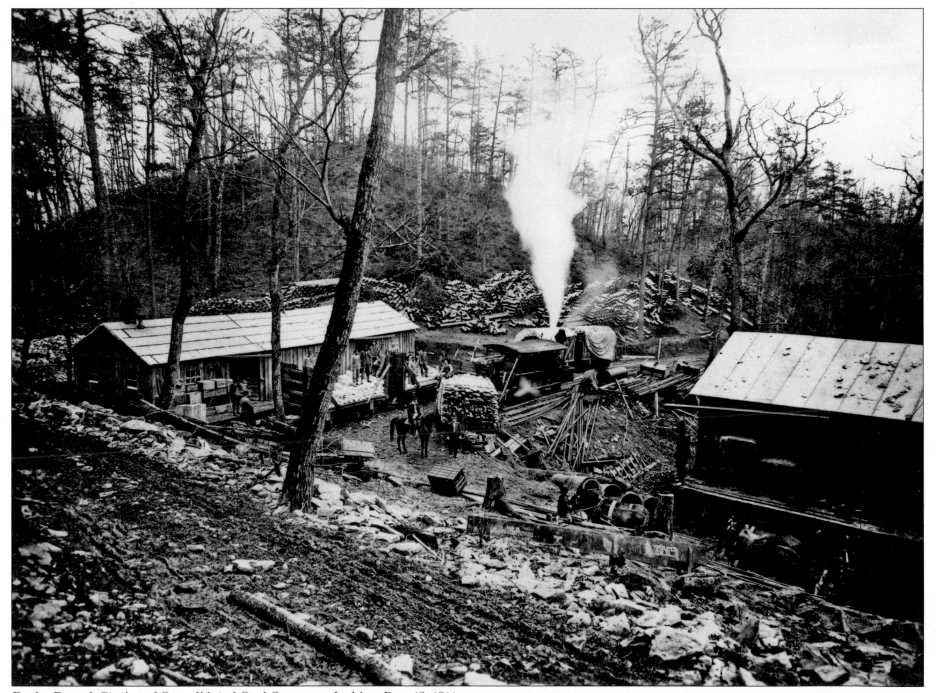

Rocky Branch Station of Consolidated Coal Company, Jenkins, Dec. 16, 1911. *Courtesy of Photographic Archives, Appalachian Learning Laboratory, Alice Lloyd College*

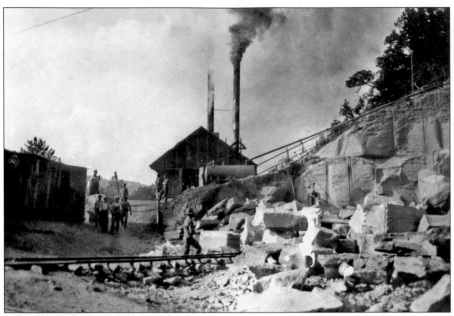

Quarrying stone at Camp No. 4 for the bridge at Combs, 1911. *Courtesy of Bobby Davis Museum and Park*

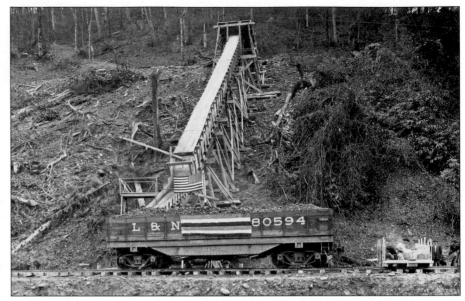

Chute and the first car of coal loaded on the Louisville & Nashville railroad, Oct. 31, 1917. *Courtesy of Southeast Kentucky Community and Technical College, Godbey Appalachian Archives*

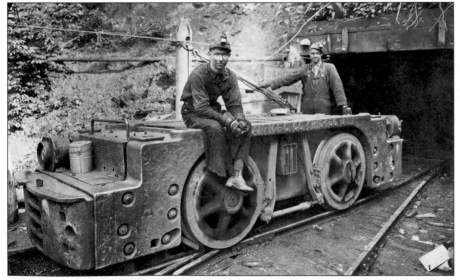

Locomotive powered by a trolley arm that extended to an overhead high-voltage wire. This engine pulled loaded coal cars out of the mine and hauled empty coal cars, equipment and supplies into the mine in Lynch, 1918. *Courtesy of Southeast Kentucky Community and Technical College, Godbey Appalachian Archives*

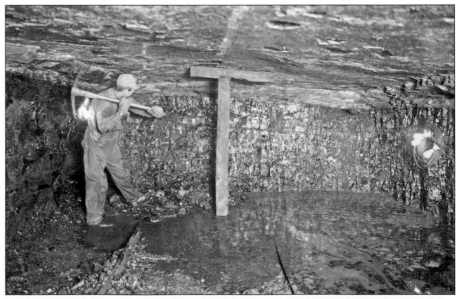

Third left heading off #30 main covering 750 feet, drove 5,655 feet, to be driven to outcrop 900 feet, Lynch, circa 1918. *Courtesy of Southeast Kentucky Community and Technical College, Godbey Appalachian Archives*

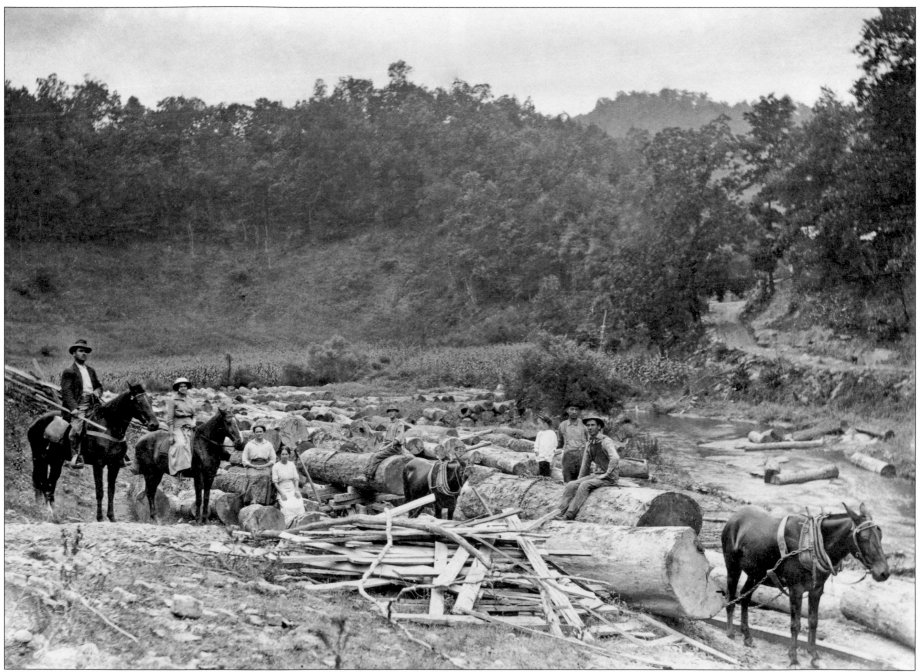

Logging at Terry Fork, 1915. Mules are harnessed to pull loaded tramcars and other logs are being floated down the creek. Included are Miles Wilson, Laura Stewart, Lender Gayheart and Dan Stamper seated on the log closest to the mule. *Courtesy of Photographic Archives, Appalachian Learning Laboratory, Alice Lloyd College*

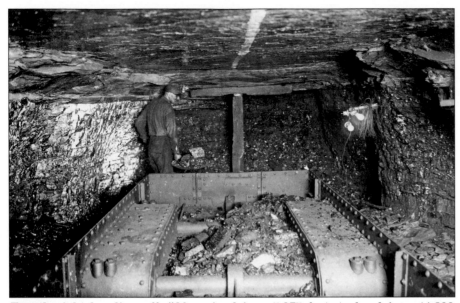

Fourth right heading off #30 main driven 5,975 feet, to be driven 14,600 feet to the line. *Courtesy of Southeast Kentucky Community and Technical College, Godbey Appalachian Archives*

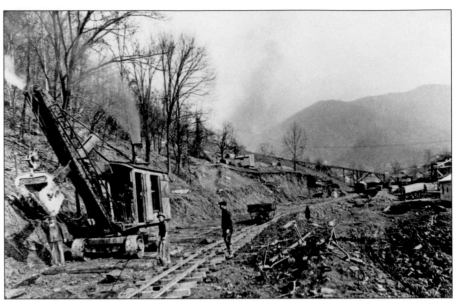

Borrow pit with the railroad tracks, No. 2 Mine, Benham, March 1, 1919. *Courtesy of Southeast Kentucky Community and Technical College, Godbey Appalachian Archives*

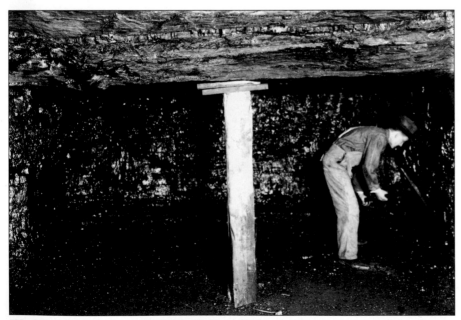

Working the mines at Benham, circa 1919. *Courtesy of Southeast Kentucky Community and Technical College, Godbey Appalachian Archives*

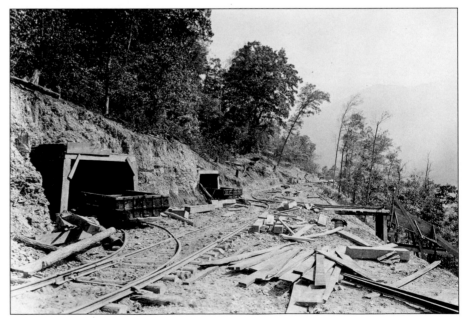

Opening No. 2 Mine main entrance, Benham, Oct. 10, 1918. *Courtesy of Southeast Kentucky Community and Technical College, Godbey Appalachian Archives*

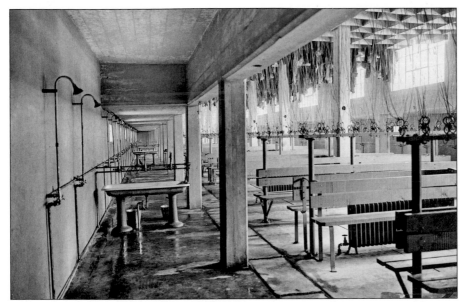

North side, the white section, of the washhouse looking east, Lynch, May 1, 1920. *Courtesy of Southeast Kentucky Community and Technical College, Godbey Appalachian Archives*

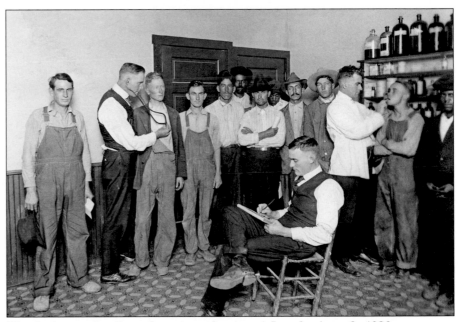

Physical examination of new employees at Lynch, Aug. 6, 1920. *Courtesy of Southeast Kentucky Community and Technical College, Godbey Appalachian Archives*

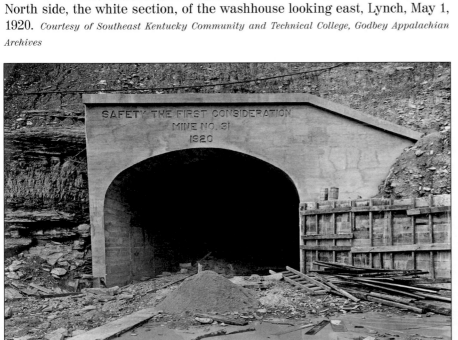

Main drift mouth Mine No. 31, Lynch, July 1, 1920. *Courtesy of Southeast Kentucky Community and Technical College, Godbey Appalachian Archives*

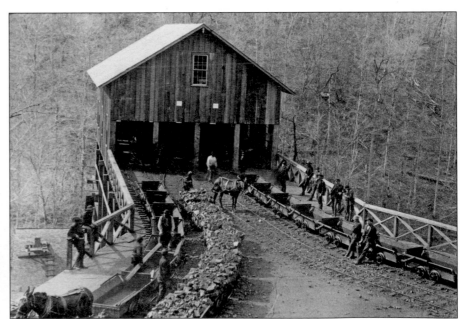

Proctor Coal Company tipple at Redash in Whitley County, circa 1920. *Courtesy of Photographic Archives, Appalachian Learning Laboratory, Alice Lloyd College*

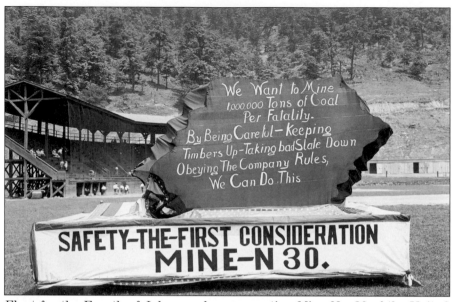

Float for the Fourth of July parade representing Mine No. 30 of the United States Coal & Coke Company, Lynch, 1925. *Courtesy of Southeast Kentucky Community and Technical College, Godbey Appalachian Archives*

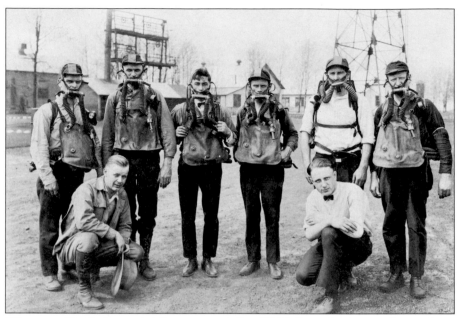

Miners with their protective gear at the Wolfpit coal camp mines, circa 1925. *Courtesy of James Grover Holland Sr. Collection, Pikeville Public Library*

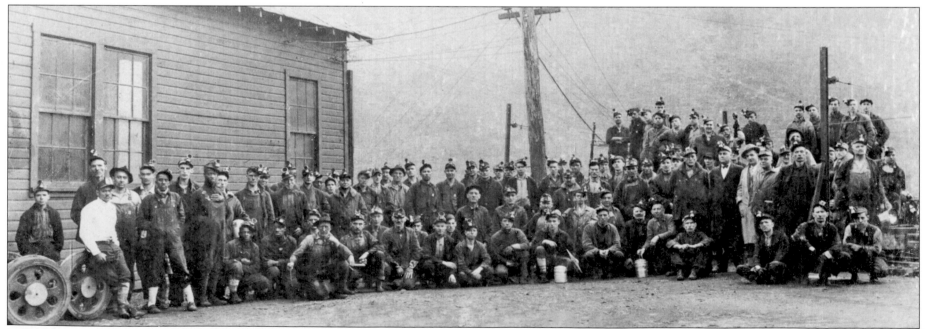

Employees of Mine No. 4, Fordson Coal Company, Pinsonfork, circa 1923. *Courtesy of Stone Heritage, Inc.*

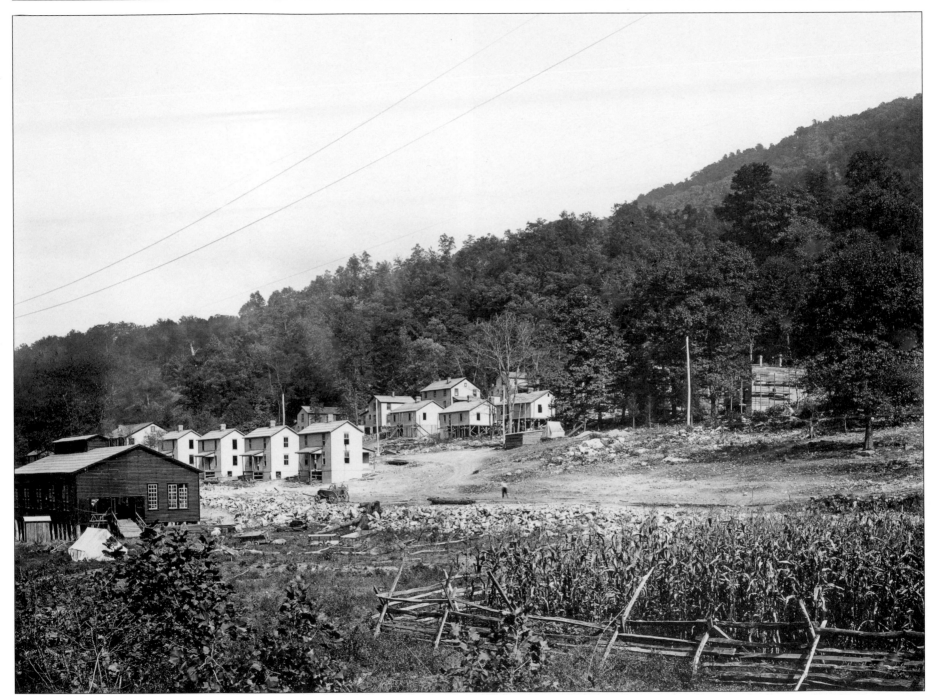

Camp town frame houses of Jenkins. *Courtesy of Photographic Archives, Appalachian Learning Laboratory, Alice Lloyd College*

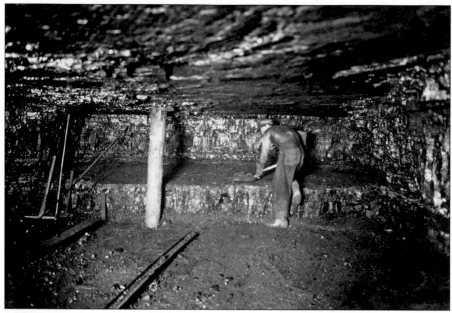

Miner working the Wolfpit coal camp mines, circa 1925. *Courtesy of James Grover Holland Sr. Collection, Pikeville Public Library*

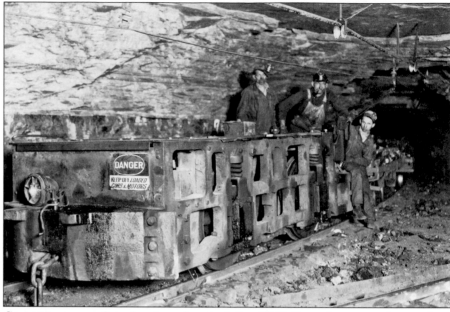

Conveyance used to haul coal out of the Wolfpit coal camp mines, circa 1925. *Courtesy of James Grover Holland Sr. Collection, Pikeville Public Library*

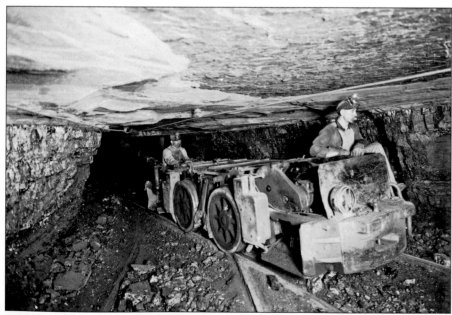

Working the Wolfpit coal camp mines, circa 1925. *Courtesy of James Grover Holland Sr. Collection, Pikeville Public Library*

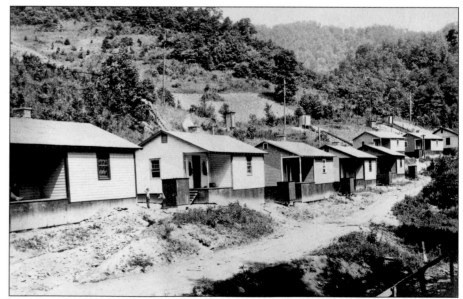

Line of new frame homes at a coal camp in McRoberts near Consolidated Coal Company's Mine No. 215, 1926. *Courtesy of Photographic Archives, Appalachian Learning Laboratory, Alice Lloyd College*

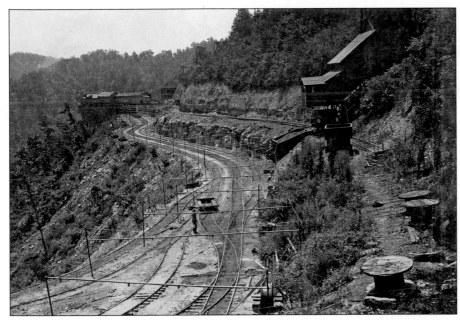

Wolfpit coal camp mining operation, circa 1925. *Courtesy of James Grover Holland Sr. Collection, Pikeville Public Library*

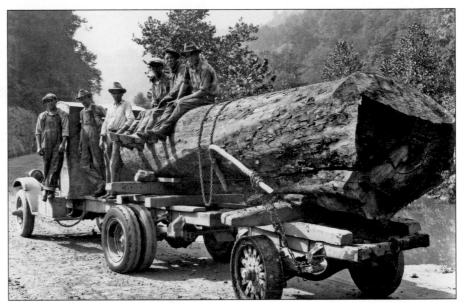

Loggers hauling an oak to Hazard. They are near the mouth of Pigeon Roost on Troublesome Creek in Perry County, circa 1930. *Courtesy of Photographic Archives, Appalachian Learning Laboratory, Alice Lloyd College*

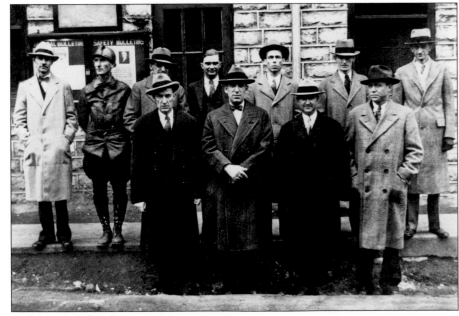

Department heads at the Wheelwright mine, 1932. *Courtesy of Special Collections & Archives, Camden-Carroll Library, Morehead State University*

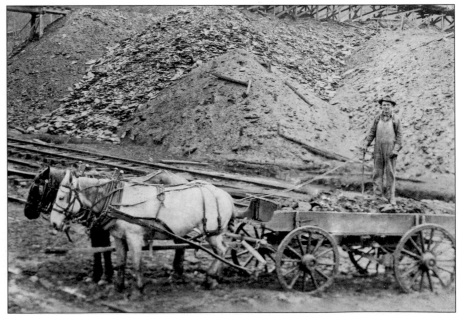

Jim Thompson at a coal mine tipple in Floyd County, 1936, when he delivered coal to families in Red Town. *Courtesy of Barbara Colema*

COMMERCE & INDUSTRY

In much of Eastern Kentucky, commerce and industry either meant logging and coal mining, or supplying those industries and its workers.

A coal company that employed thousands of workers, for example, had to make sure those workers were fed and clothed. Thus the company store was born. It could provide whatever a miner needed. Often, the store was the only source of those goods, and accepted only company script.

The people pictured on the following pages knew the good and bad of company stores. For the rest of the country, it was summed up decades later in a popular song called "Sixteen Tons."

The chorus:

"You load sixteen tons, and what do you get?

Another day older and deeper in debt.

Saint Peter, don't you call me, 'cause I can't go;

I owe my soul to the company store."

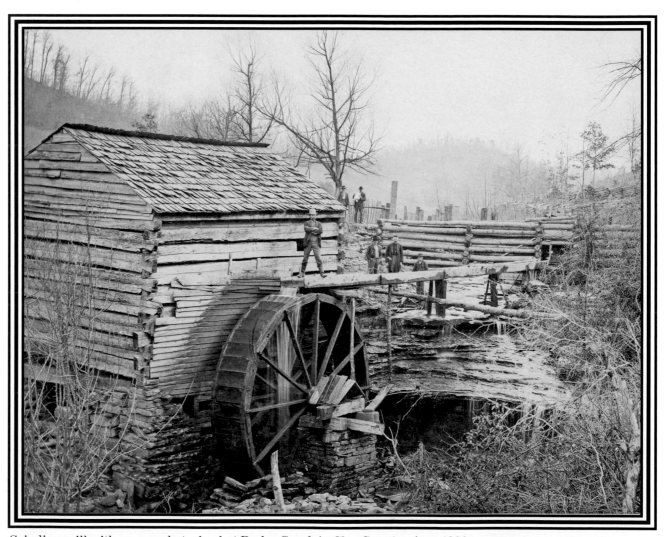

Grinding mill with an overshot wheel at Rader Creek in Clay County, circa 1900. *Courtesy of Appalachian Photoarchives, Southern Appalachian Archives, Berea College*

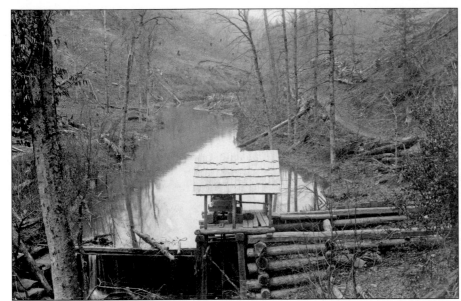

Corn mill on the road from Hyden to Manchester. The mill allowed people to grind their corn 50 miles from the railroad. *Courtesy of Appalachian Photoarchives, Southern Appalachian Archives, Berea College*

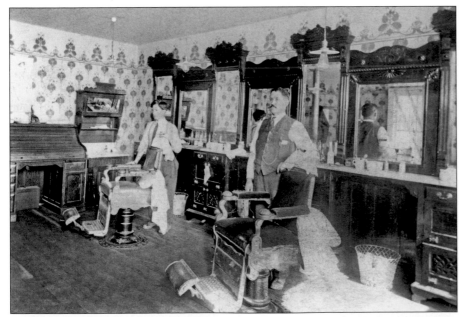

William Haddix in his barbershop in Jackson, Breathitt County, circa 1910. *Courtesy of Tom Eblen*

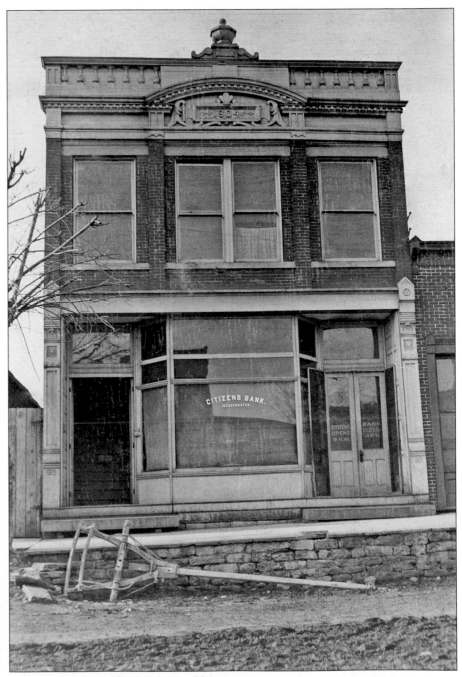

Citizens Bank at Mt. Sterling, 1904. *Courtesy of Special Collections & Archives, Camden-Carroll Library, Morehead State University*

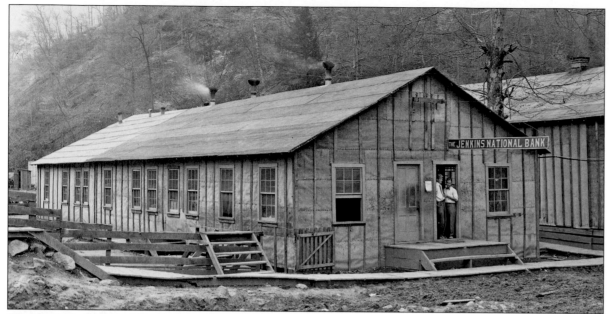

The Jenkins National Bank, May 15, 1912. *Courtesy of Photographic Archives, Appalachian Learning Laboratory, Alice Lloyd College*

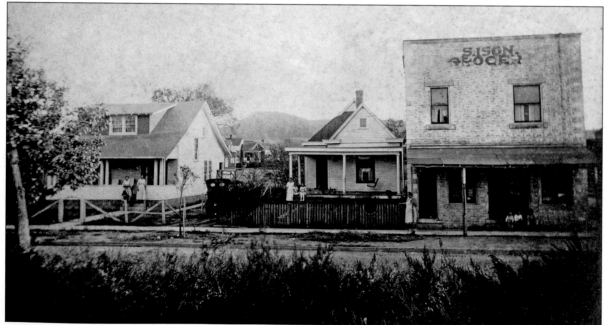

S. Ison at Ison Groceries in Lawrence County, 1912. *Courtesy of April Voit*

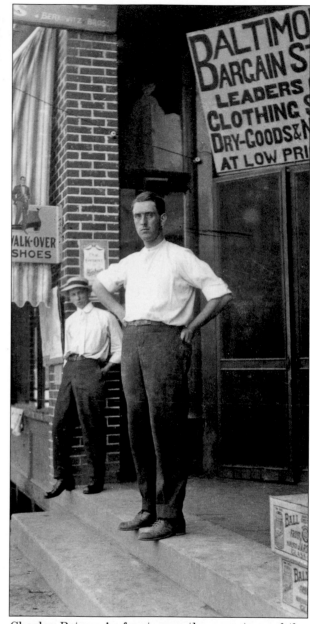

Charles Petrey, in front, was the secretary of the board that owned the Hazard Hardware Company, 1913. He later was the owner of the Charles E. Petrey Company. *Courtesy of Bobby Davis Museum and Park*

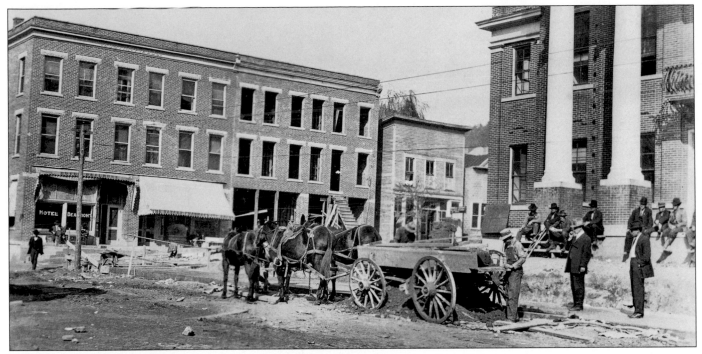

The Austin Fields building, Hazard, housed the Beaumont Hotel starting in early September 1912. The need for a larger hotel three months after the railroad arrived was proof of Hazard's increasing prosperity. The Beaumont Annex on the right, which opened in February 1914, increased the number of rooms from 24 to 48. The entrance to the hotel is on the left at ground level, and the awning on the right shelters the front door for the Hazard Pharmacy. *Courtesy of Bobby Davis Museum and Park*

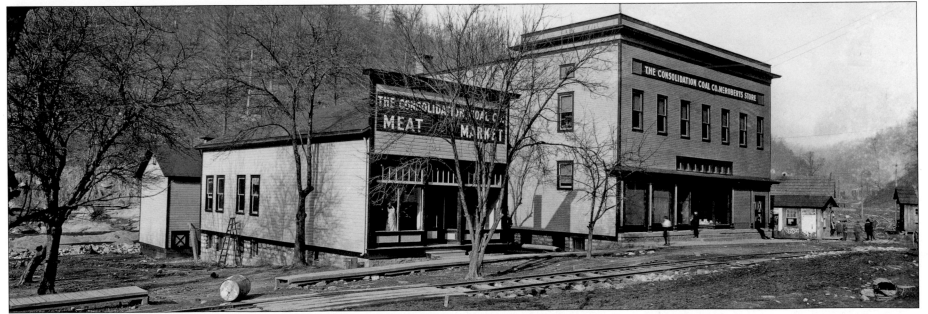

Consolidated Coal Company's Meat Market and McRoberts Store stand next to the railroad tracks, Dec. 15, 1913. *Courtesy of Photographic Archives, Appalachian Learning Laboratory, Alice Lloyd College*

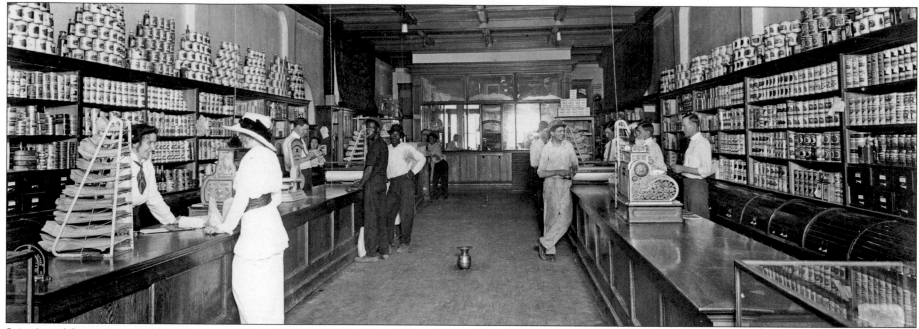

Interior of Consolidated Coal Company store, Jenkins, 1914. *Courtesy of Photographic Archives, Appalachian Learning Laboratory, Alice Lloyd College*

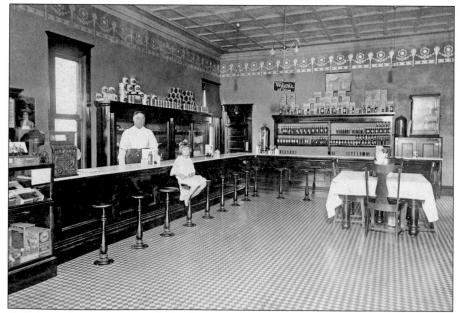

Brig Harris standing behind the counter at Harris Hotel in the Blaine area, 1916. *Courtesy of April Voit*

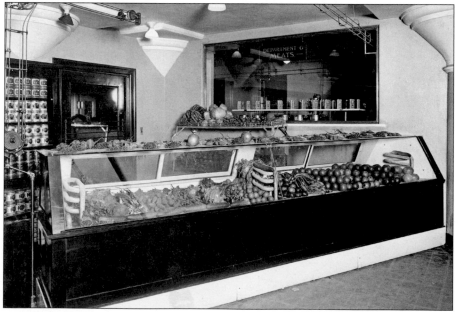

Produce counter at a store in Lynch, circa 1918. *Courtesy of Southeast Kentucky Community and Technical College, Godbey Appalachian Archives*

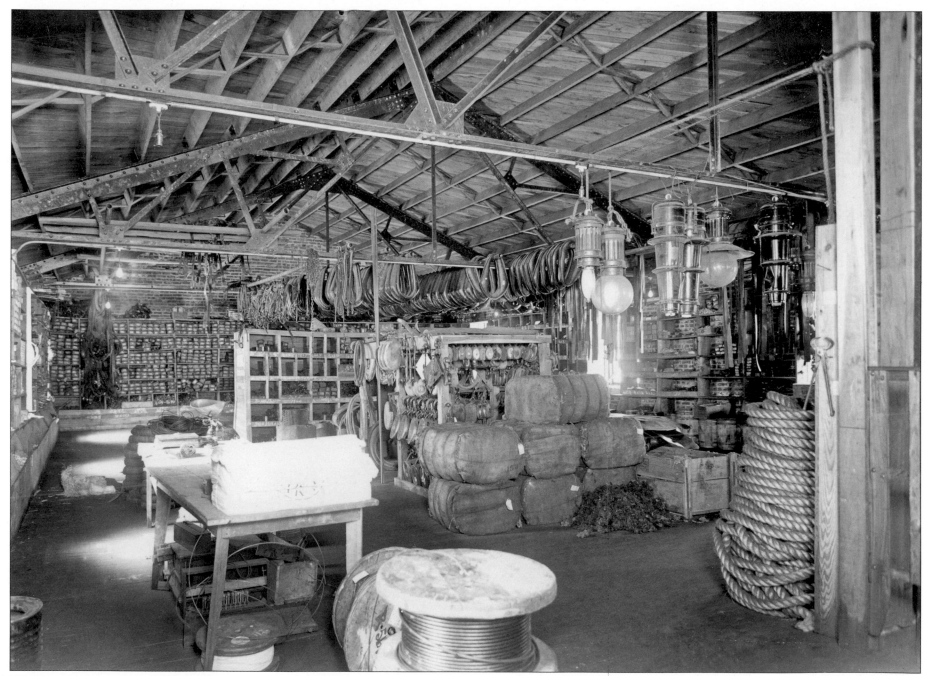

Wire, rope, harnesses and other boxes and packages of supplies inside the Central Supply House, Jenkins, March 23, 1915. *Courtesy of Photographic Archives, Appalachian Learning Laboratory, Alice Lloyd College*

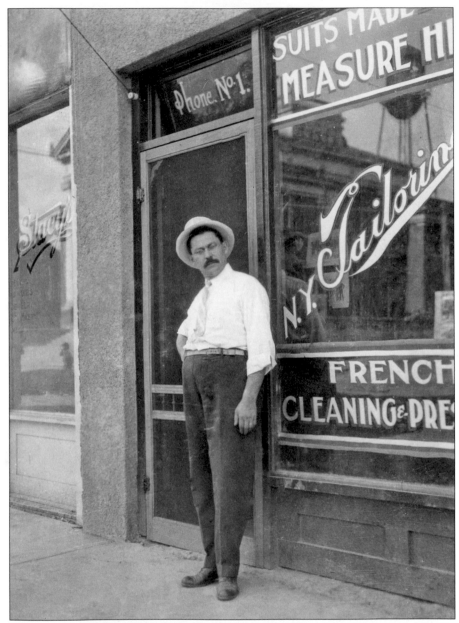

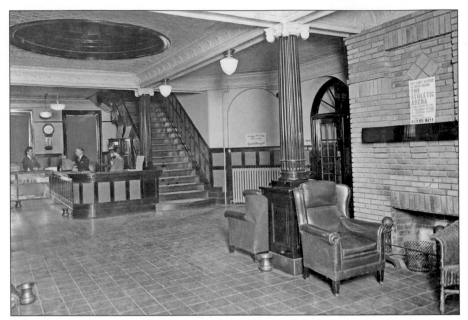

Coal Miner's Hotel lobby, Lynch, May 12, 1919. *Courtesy of Southeast Kentucky Community and Technical College, Godbey Appalachian Archives*

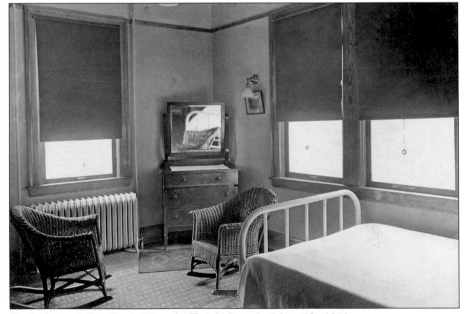

Tailoring establishment at Hazard, circa 1913. In 1896 Leon and Morris Berkowitz arrived in New York from Romania. In 1910 they moved to Pineville, then moved to Hazard and opened the Baltimore Store in the Johnson Building opposite the Perry County Courthouse. They advertised quality merchandise at low prices. *Courtesy of Bobby Davis Museum and Park*

Bedroom at the Coal Miner's Hotel, Lynch, May 12, 1919. *Courtesy of Southeast Kentucky Community and Technical College, Godbey Appalachian Archives*

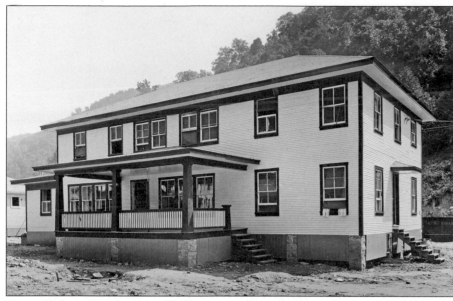

Type 42 boarding house with 22 rooms, three baths and a basement, Lynch, Aug. 1, 1919. *Courtesy of Southeast Kentucky Community and Technical College, Godbey Appalachian Archives*

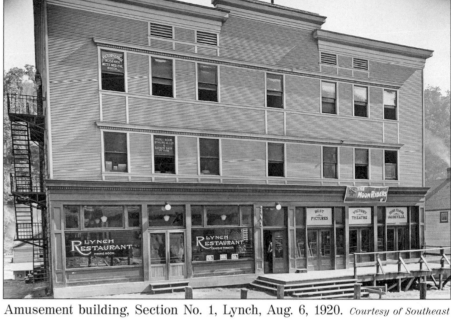

Amusement building, Section No. 1, Lynch, Aug. 6, 1920. *Courtesy of Southeast Kentucky Community and Technical College, Godbey Appalachian Archives*

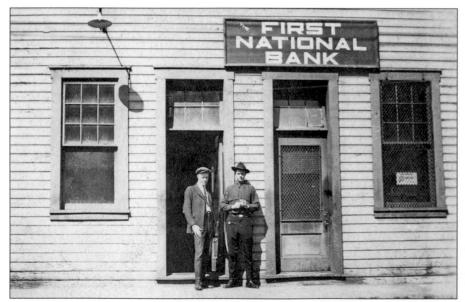

In front of the First National Bank in Fleming are Dewey Elliott and John Mundy, 1921. Elliott worked for Elkhorn Coal, and Mundy worked for Louisville & Nashville Railroad. *Courtesy of Ann Ross*

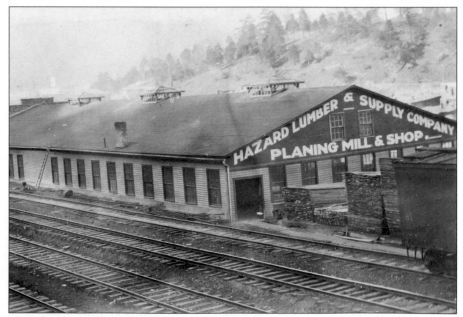

Hazard Lumber & Supply Company was built in 1923. *Courtesy of Bobby Davis Museum and Park*

J. W. Armstrong in front of a mill shed at Licking Union, 1920. *Courtesy of Special Collections & Archives, Camden-Carroll Library, Morehead State University*

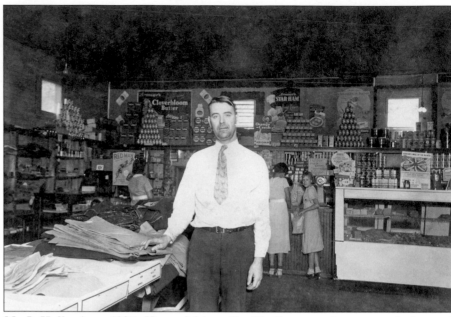

M. J. Hall, circa 1935. He and his wife, Birdie, owned a general store at Weeksbury, a coal mining camp near Wheelwright. *Courtesy of Opal Hall Waddell*

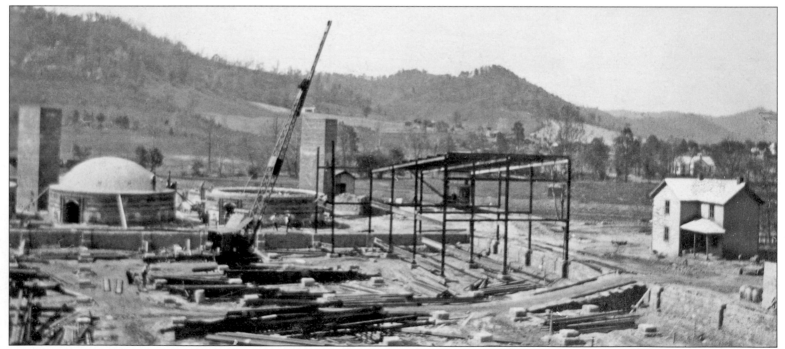

Early work at Lee Clay Company in Morehead, May 13, 1925. *Courtesy of Rowan County Public Library*

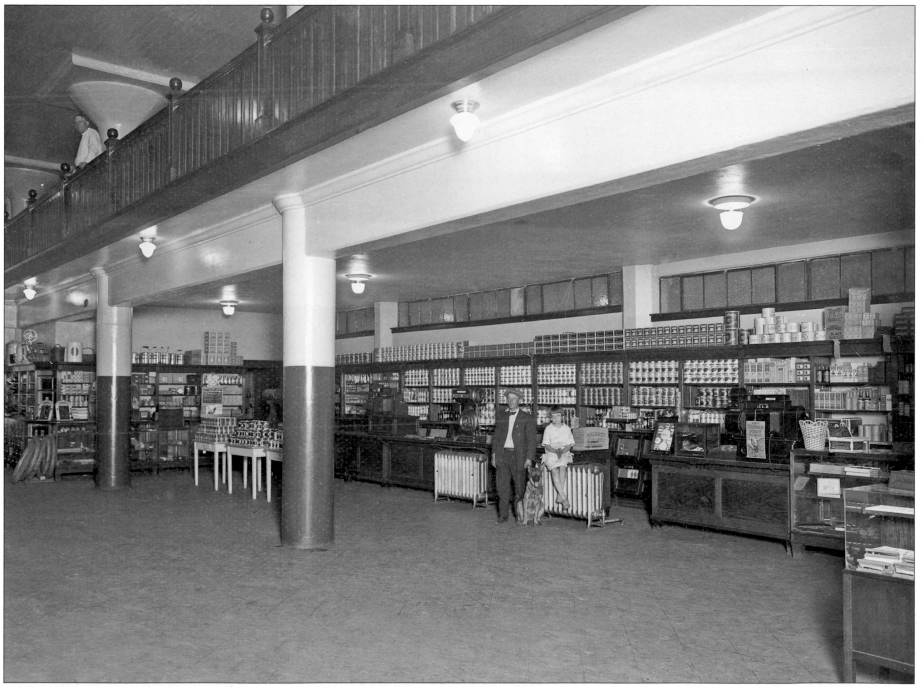

Grocery department at the new commissary in Benham, June 27, 1923. *Courtesy of Southeast Kentucky Community and Technical College, Godbey Appalachian Archives*

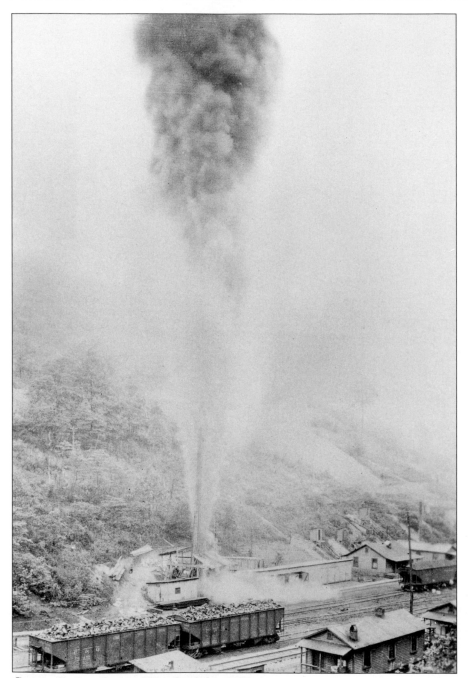

Gas well shooting at Wheelwright, 1931. *Courtesy of Special Collections & Archives, Camden-Carroll Library, Morehead State University*

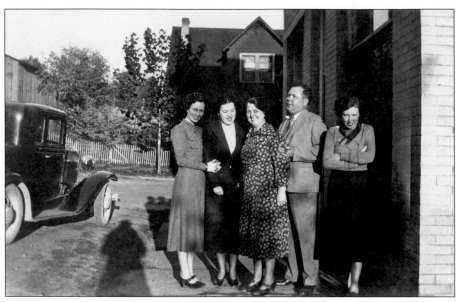

Farmers and Traders Bank in Campton, 1936. Those included: president of the bank Rush Evans, Lizzie Evans and Margaret Swope. *Courtesy of Sue Ann Bell and Peggi Ballard with Barbara Wilson*

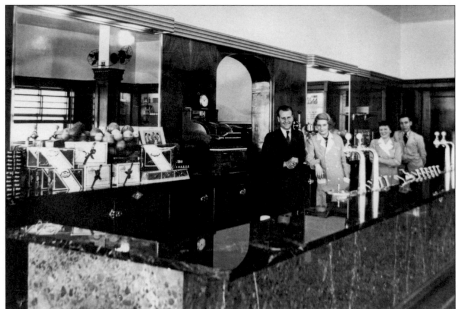

Staff in the Wheelwright soda fountain, 1937. *Courtesy of Special Collections & Archives, Camden-Carroll Library, Morehead State University*

TRANSPORTATION

Until recently, when explosives and huge earth-moving equipment make it possible to go through a mountain instead of around it, and put a road almost anywhere, the transportation patterns in Eastern Kentucky were stable and predictable.

Bison and other animals took the path of least resistance through the trackless wilderness, and that usually meant a winding route through a valley. Native American paths followed the wildlife trails. The early roads were laid on top of those paths, and later the railroads ran beside them.

Transportation, or the lack thereof, isolated Eastern Kentucky. When it was no longer necessary to walk from one place to another, a trip often meant taking a buggy or automobile over a rough road. Boats navigated the larger rivers. And, as shown in one of the photos in the following section, people could always mount a horse and saunter down a creek.

The automobile brought a new mobility, and having the first one in your area was a point of pride.

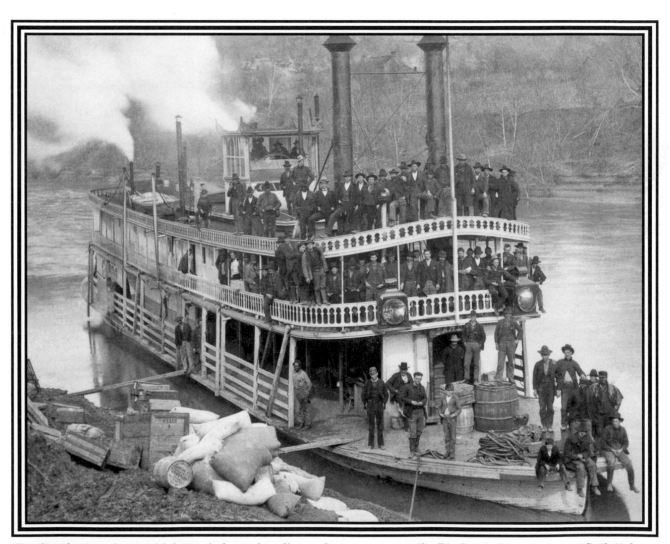

The *Cando* steamboat, which carried merchandise and passengers on the Big Sandy River between Catlettsburg and Pikeville, circa 1890. It was owned by the Chesapeake & Ohio Railway and christened the *Cando* by a sign painter who interpreted his instruction to paint a "C and O" on the stern too literally. *Courtesy of Photographic Archives, Appalachian Learning Laboratory, Alice Lloyd College*

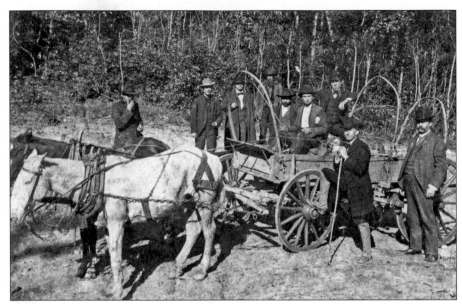

Exploration and inspection party headed by John C. C. Mayo, third from the left, in Pike County. *Courtesy of Photographic Archives, Appalachian Learning Laboratory, Alice Lloyd College*

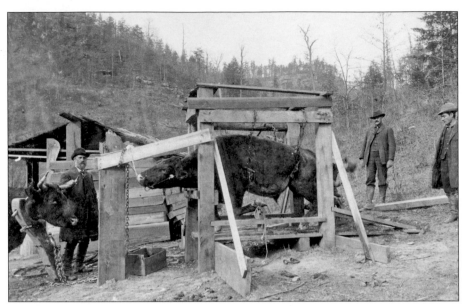

Shoeing an ox on Mill Creek, Middle Fork of the Red River near the Wolfe and Powell county line, April 1892. *Courtesy of Photographic Archives, Appalachian Learning Laboratory, Alice Lloyd College*

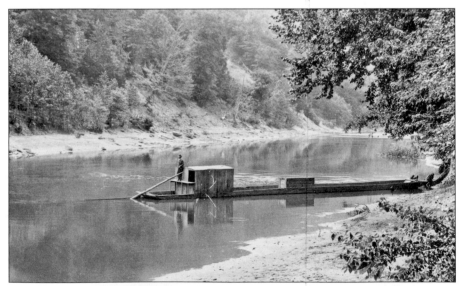

The Cheek family of Beaver Creek, Floyd County, used this push boat to transport merchandise, barrels of salt and flour and slabs of bacon, up the Big Sandy to Whitehouse from Allen, circa 1900. *Courtesy of Photographic Archives, Appalachian Learning Laboratory, Alice Lloyd College*

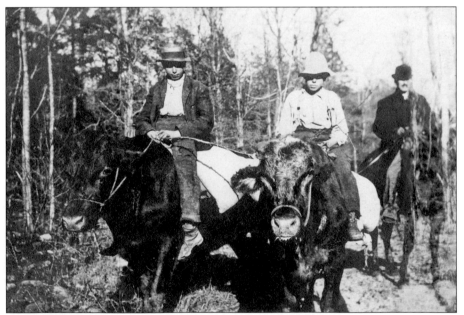

Traveling to the mill on oxen in Harlan County. *Courtesy of Appalachian Photoarchives, Southern Appalachian Archives, Berea College*

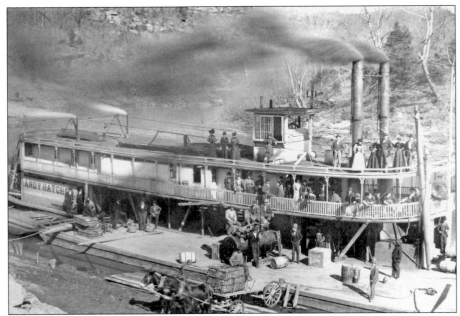

The *Andy Hatcher* steamboat unloading freight, circa 1902. *Courtesy of Photographic Archives, Appalachian Learning Laboratory, Alice Lloyd College*

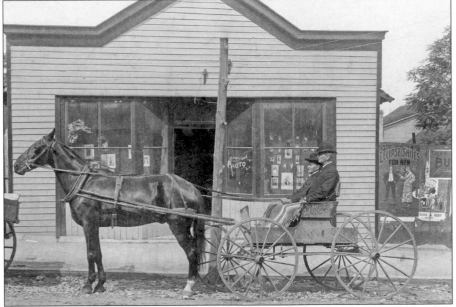

Dr. Francis A. Taylor driving a horse and buggy with Dr. Joshua Taylor Wesley in Somerset, May 23, 1906. *Courtesy of Frank Godbey*

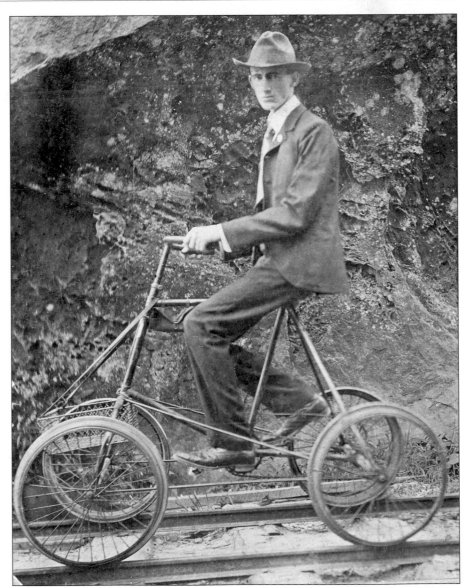

Carl Thomas Ashley was working in timber near Torrent, Powell County, 1902, when he was eighteen years old. This railroad quadricycle was his favorite way to get around. *Courtesy of Carl Thomas Ashley*

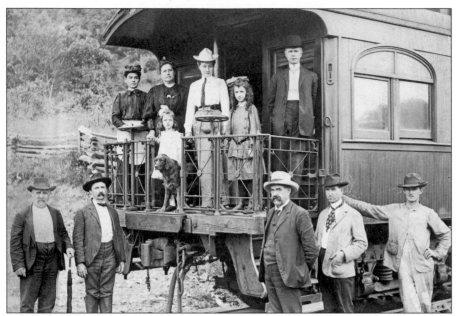

Kentucky and Tennessee Railway near Stearns, circa 1909. On the ground, second from the right, is Dr. Lemuel Jones Godbey. *Courtesy of Frank Godbey*

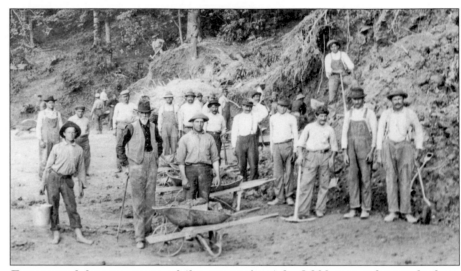

European laborers, some of the approximately 6,000 men who worked on building the line from Jackson to McRoberts. Roof falls and bad weather caused delays. A conservative estimate of the earth and rock removed in grading the railroad from Jackson to McRoberts was around 7.5 million cubic yards. *Courtesy of Bobby Davis Museum and Park*

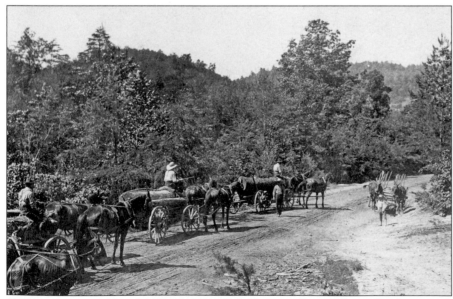

College boys coming to Berea over the Narrow Gap Hill on the improved mountain roads, circa 1910. *Courtesy of Appalachian Photoarchives, Southern Appalachian Archives, Berea College*

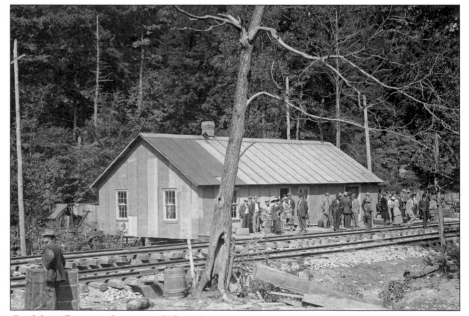

Jenkins Depot, Oct. 1, 1912. *Courtesy of Photographic Archives, Appalachian Learning Laboratory, Alice Lloyd College*

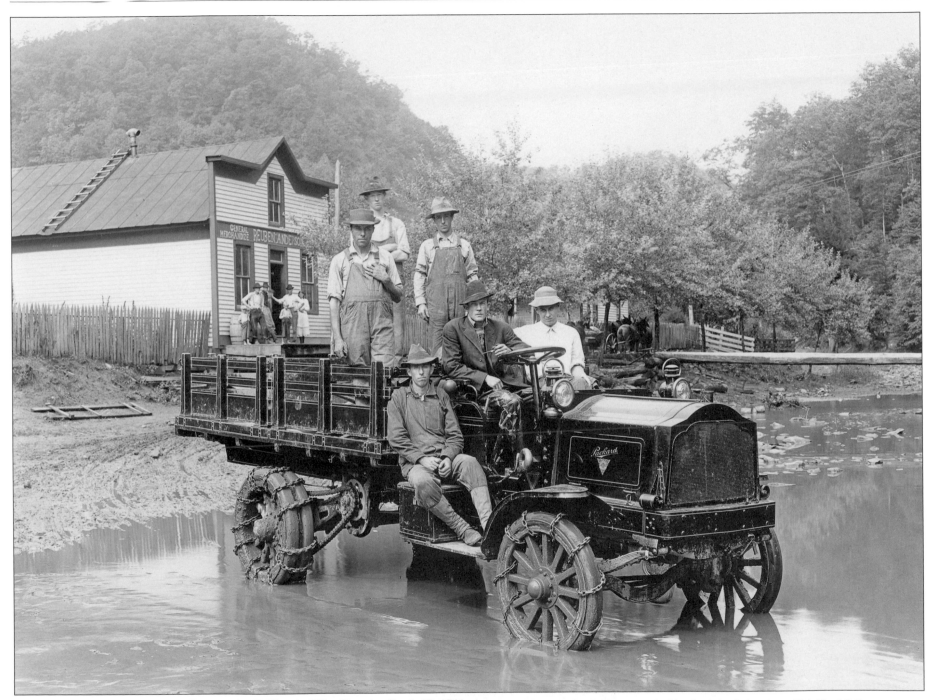

Chain-driven motor truck on the way to Hellier in Pike County, Sept. 16, 1911. *Courtesy of Photographic Archives, Appalachian Learning Laboratory, Alice Lloyd College*

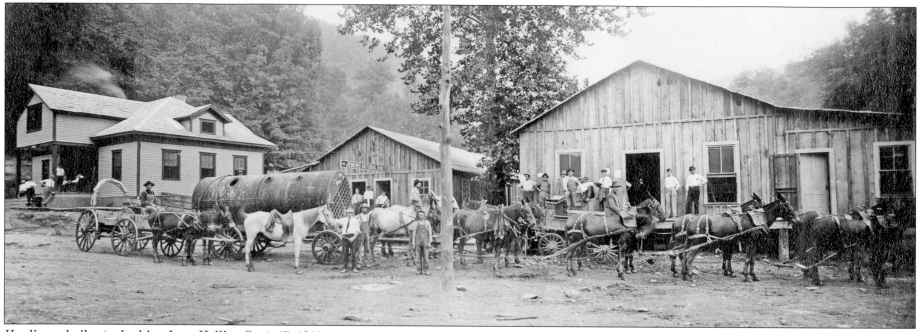

Hauling a boiler to Jenkins from Hellier, Sept. 15, 1911. *Courtesy of Photographic Archives, Appalachian Learning Laboratory, Alice Lloyd College*

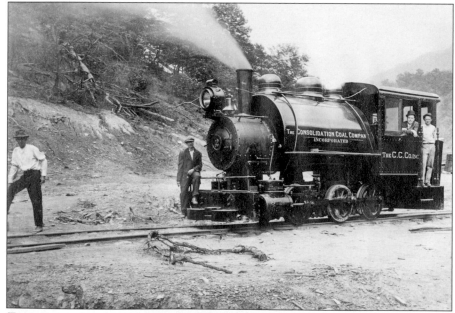

Twenty-ton locomotive on a trial trip, Jenkins, May 25, 1912. *Courtesy of Photographic Archives, Appalachian Learning Laboratory, Alice Lloyd College*

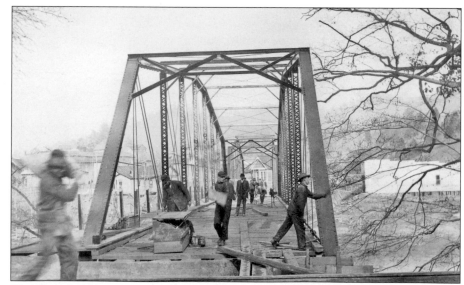

The first bridge at Hazard, 1912. The bridge, named the Penny Bridge for the amount of toll, from Main Street to the depot was completed Jan. 9, 1913, about seven months after the railroad arrived in town. *Courtesy of Bobby Davis Museum and Park*

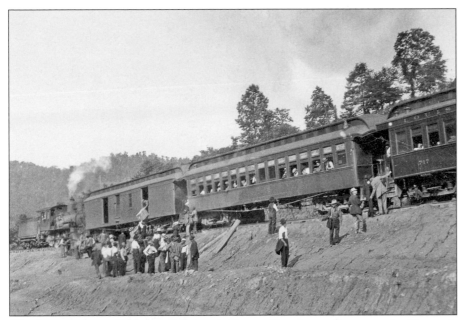

First passenger train arriving at Camp No. 4 on the way to Hazard, 1912. *Courtesy of Bobby Davis Museum and Park*

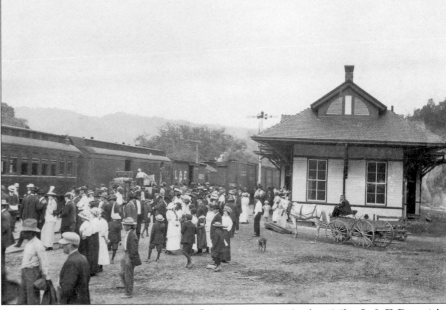

Hundreds turned out to meet the first passenger train at the L & E Depot in Hazard, 1912. *Courtesy of Bobby Davis Museum and Park*

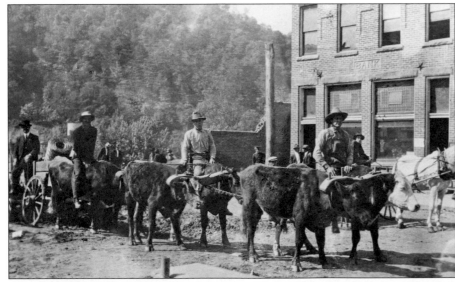

Ox team driven through Hazard by John Flat Williams, the man on the last ox on the left, passing the shell of a burned-out section of town resulting from the fire on Dec. 30, 1913. The building on the right is the Perry County State Bank. *Courtesy of Bobby Davis Museum and Park*

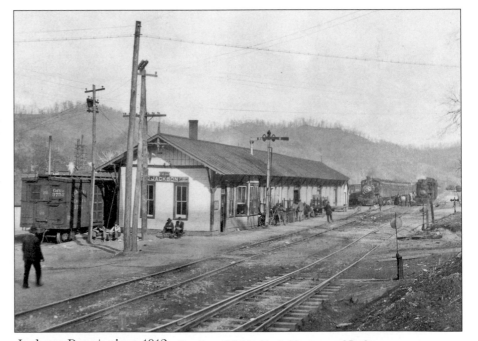

Jackson Depot, circa 1912. *Courtesy of Bobby Davis Museum and Park*

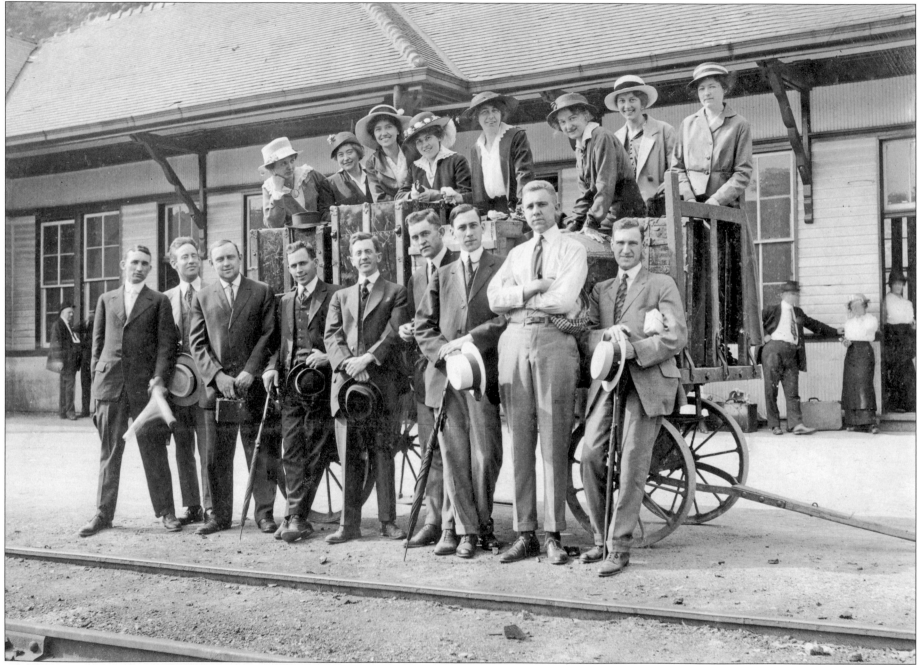

Local men meeting new school teachers arriving at the depot in Hazard, 1914. Mary Belle Pence, nicknamed "Pencie," is on the top right and George Wolfe is on the right in front. *Courtesy of Bobby Davis Museum and Park*

East end of the grade with the railroad tracks at Mine No. 2, Benham, April 21, 1919. *Courtesy of Southeast Kentucky Community and Technical College, Godbey Appalachian Archives*

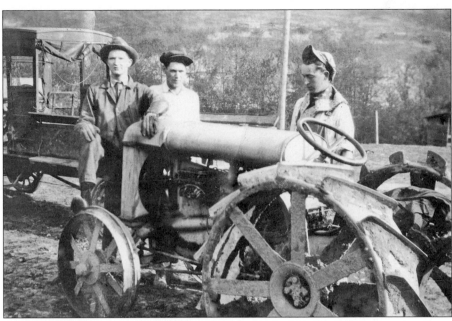

A flathead tractor on the Stumbo family farm in Martin, Floyd County, circa 1920. *Courtesy of Sharon Stumbo*

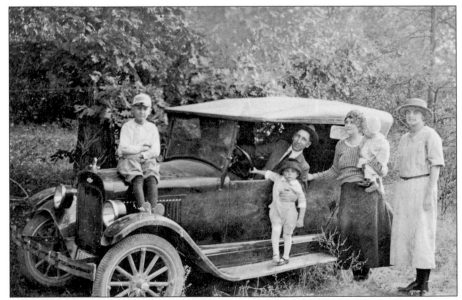

At McDowell in Floyd County, 1922. Left to right: John Lovell Hall, Dr. John F. Hall with Glennon, Mina Frazier Hall holding Franklin and an unidentified woman. *Courtesy of Johnny and Patti Hall and Barry Dean Martin*

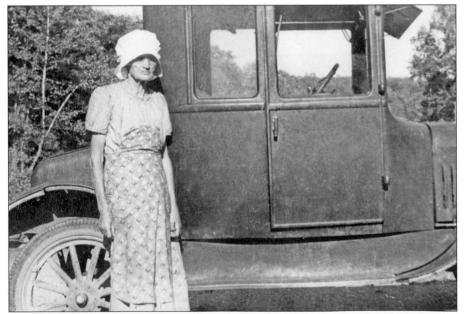

Mary Daroset with her 1924 Model T Ford in Frenchburg. She was one of the first people in Menifee County to own a car. *Courtesy of Julie Buchanan*

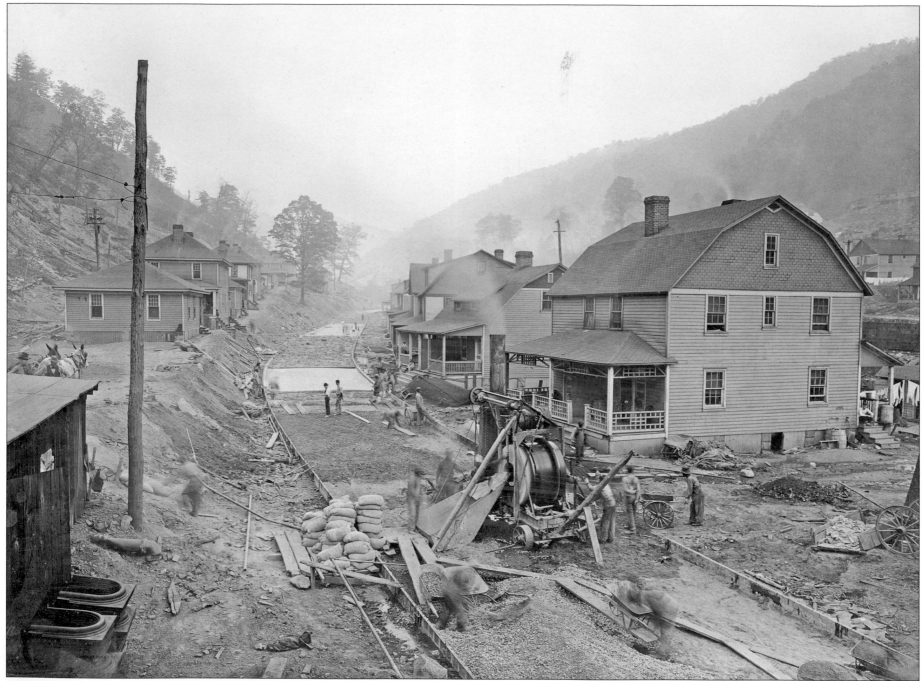

Lynch road under construction, Oct. 20, 1920. *Courtesy of Southeast Kentucky Community and Technical College, Godbey Appalachian Archives*

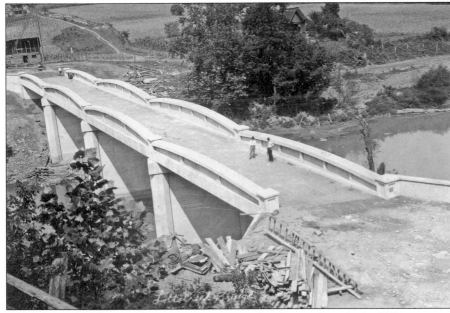

The state of Kentucky built Lotts Creek Bridge, Perry County, in 1925. *Courtesy of Bobby Davis Museum and Park*

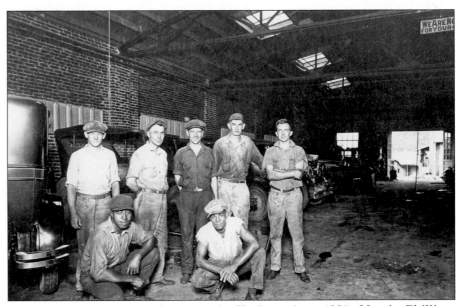

Garage of Black Motor Company in Harlan, circa 1925. Morris Phillips, standing second from the left, worked as a mechanic in the garage. *Courtesy of Virginia Nunn*

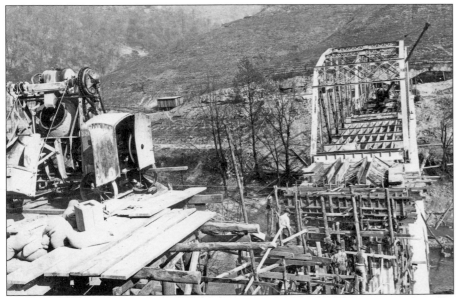

In 1925 a company was hired to build two bridges on either side of Hazard, Walkertown and Glomar. The construction of this Glomar Bridge was completed in 1926. *Courtesy of Bobby Davis Museum and Park*

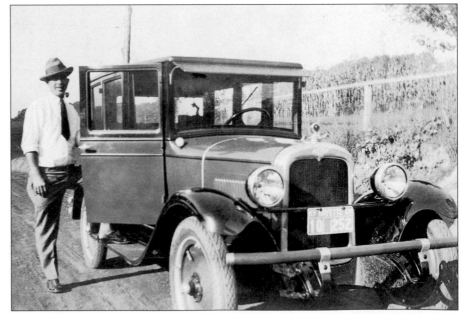

James Swope, first owner of a car in Wolfe County, on Route 15 in front of his home in Campton, 1927. *Courtesy of Sue Ann Bell and Peggi Ballard with Barbara Wilson*

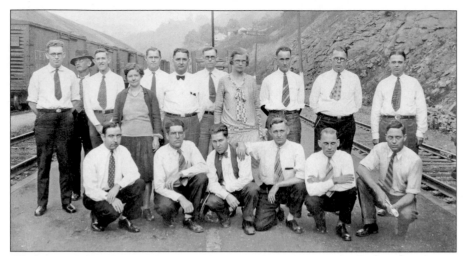

Workers at the Louisville & Nashville Depot, Hazard, circa 1930. Front row, left to right: C. B. Caudill, F. D. Baker, Marcus Steele, Tom Kelly, D. E. Waltman and W. A. Baird. Back row: L. W. Pope, W. A. Peterman, Mrs. Cora Holt, E. L. Benton, J. M. Johnston, J. B. Nichols, Jessie Combs, G. D. Brashear, J. V. Waltman and Calvin Turner. In back with the hat is F. L. Collins, Police Sergeant. *Courtesy of Bobby Davis Museum and Park*

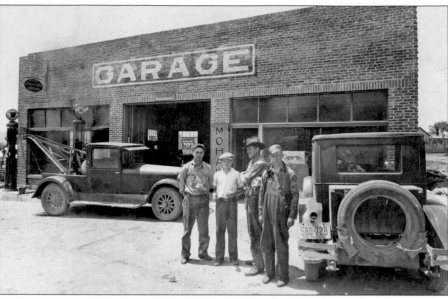

Garage in Berea owned by Morris Phillips and Rube Abney, circa 1930. The men in front are Morris Phillips, Leonard Abney, Rube Abney and Jim Petrey. It was located in the west end of Berea on Route 25. *Courtesy of Virginia Nunn*

Bridge leading to the railroad depot in Hazard, circa 1935. *Courtesy of Jo Anne Brand*

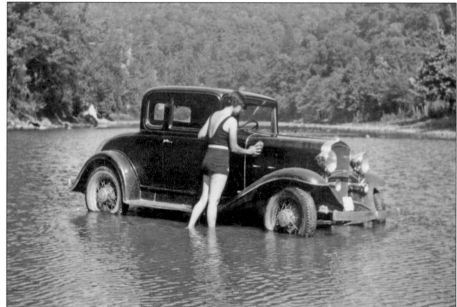

A Chevy getting a cleaning in the creek in Leslie County, circa 1935. *Courtesy of Camp Nathanael*

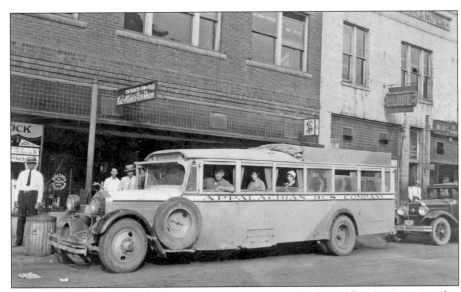

Appalachian Bus Company carried passengers from Lexington to the Eastern Kentucky coalfields in the 1930s. Northbound buses leaving Hazard turned left on Fleet Street and left on High Street. *Courtesy of Bobby Davis Museum and Park*

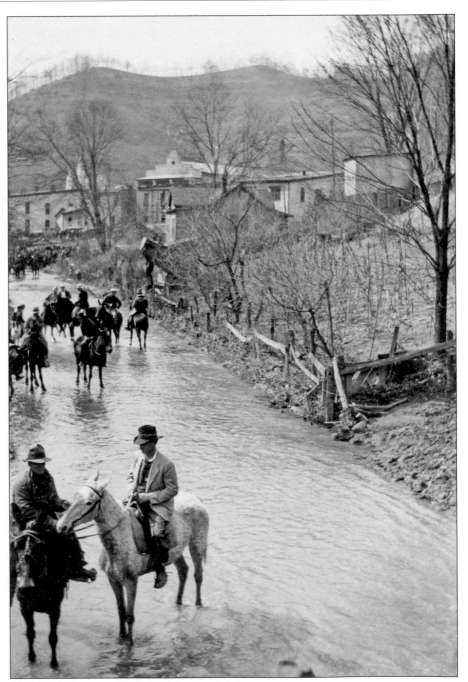

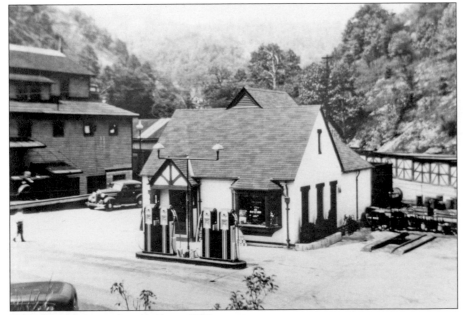

Wheelwright service station, 1936. *Courtesy of Special Collections & Archives, Camden-Carroll Library, Morehead State University*

Going down the creek at Hindman, circa 1935. *Courtesy of Special Collections & Archives, Camden-Carroll Library, Morehead State University*

PUBLIC SERVICE

Kentuckians must like governments; we've created so many of them. The state's 120 counties often are cited as a root of inefficiency, but, especially in the early days, it really was important to have a county judge or magistrate or sheriff within a day's ride.

In this section, we see several county courthouses, which were always the public service heart of their area.

We also see doctors, dentists, firefighters and others who worked tirelessly for the public good.

The photographs of medical personnel in this section are especially important. They show people who worked long hours against almost insurmountable odds to ease suffering and save lives in an area that has had a chronic dearth of health care.

Note, too, some of the mail carriers, and try to imagine a time when taking a vow that the mail must go through meant being willing to carry fat bags of letters and packages on horseback, or taking along a bicycle for those areas where a car simply wasn't able to get to that house at the head of some hollow.

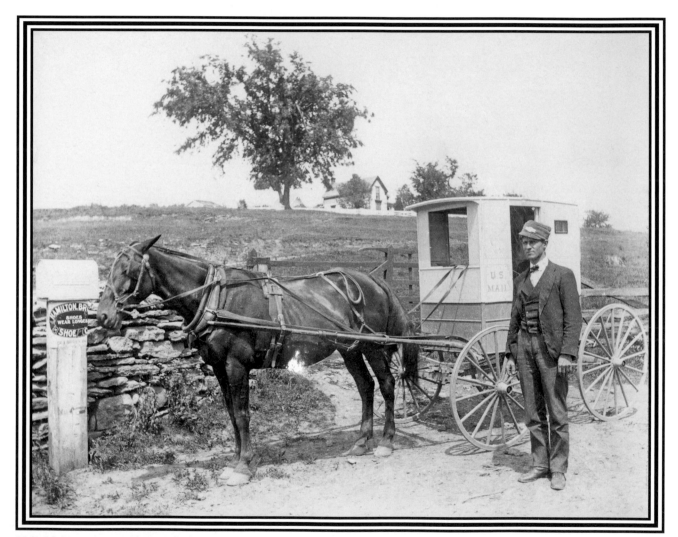

U.S. Mail delivery, Bath County, circa 1905. *Courtesy of Special Collections & Archives, Camden-Carroll Library, Morehead State University*

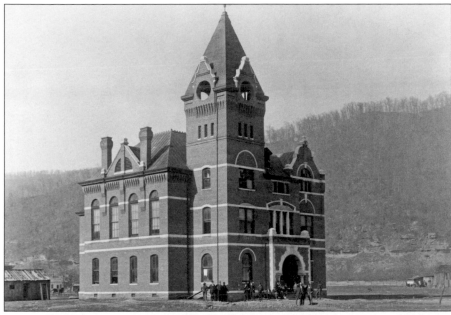

Bell County Courthouse, Pineville, 1890. *Courtesy of Photographic Archives, Appalachian Learning Laboratory, Alice Lloyd College*

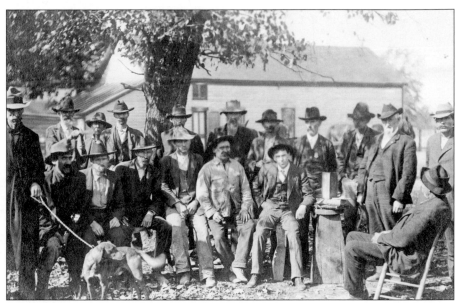

Magistrate Court trying a case regarding the possession of hound dogs, circa 1910. *Courtesy of Appalachian Photoarchives, Southern Appalachian Archives, Berea College*

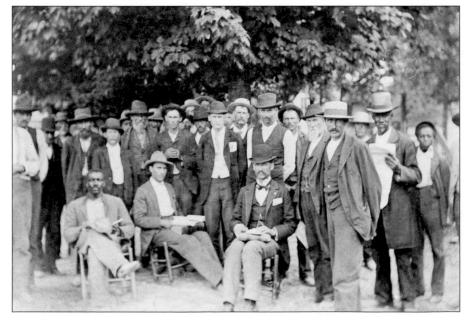

Court held under the trees in the open air, circa 1910. *Courtesy of Appalachian Photoarchives, Southern Appalachian Archives, Berea College*

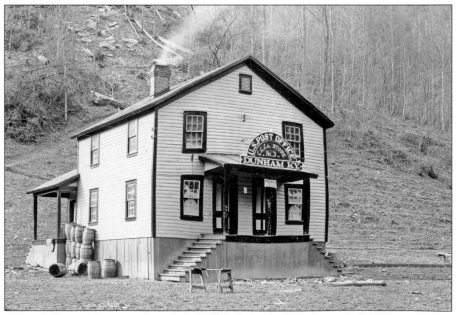

Post Office and store for Consolidated Coal Company at Dunham, 1912. *Courtesy of Photographic Archives, Appalachian Learning Laboratory, Alice Lloyd College*

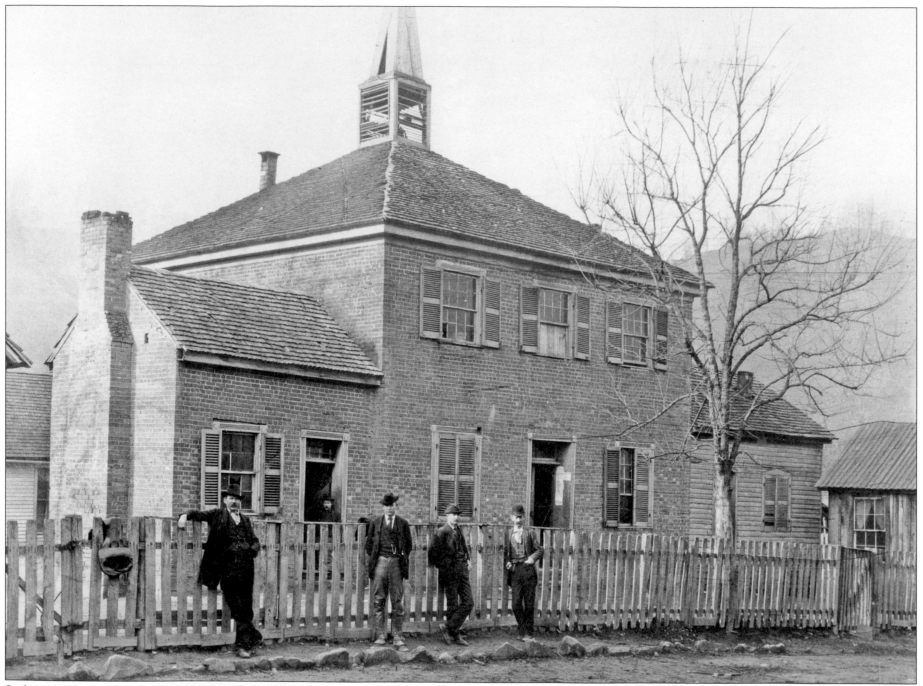

In front of the Letcher County Courthouse in Whitesburg. *Courtesy of Photographic Archives, Appalachian Learning Laboratory, Alice Lloyd College*

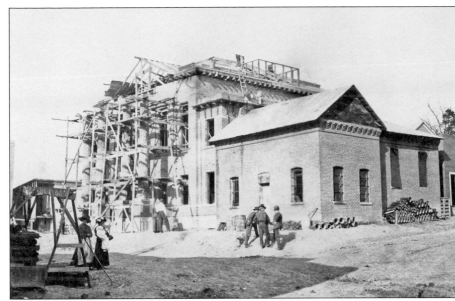

Perry County Courthouse under construction, 1912. The county's fourth courthouse, it would replace the one destroyed by fire the previous year. *Courtesy of Bobby Davis Museum and Park*

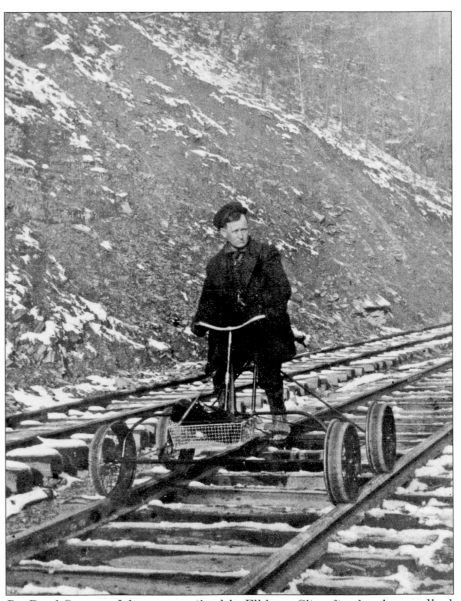

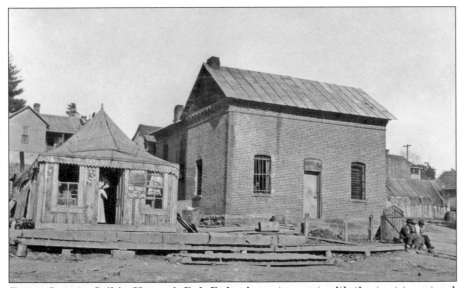

Perry County Jail in Hazard. Bob Baker's restaurant with the tent top stood briefly beside the jail after fire destroyed Perry County Courthouse in 1911 and before construction on the new courthouse began. *Courtesy of Bobby Davis Museum and Park*

Dr. Reed Spencer Johnson practiced in Elkhorn City after leaving medical school in Louisville in 1912. He used this "velocipede," a light but wide and tall bicycle-like contraption whose wheels fit the railroad tracks, to make house calls, circa 1914. He moved to Pikeville around 1920 and spent the remainder of his career there. He was one of the six members of the Pikeville clinic and was involved in the building of Pikeville's first hospital. *Courtesy of Ann E. Carty*

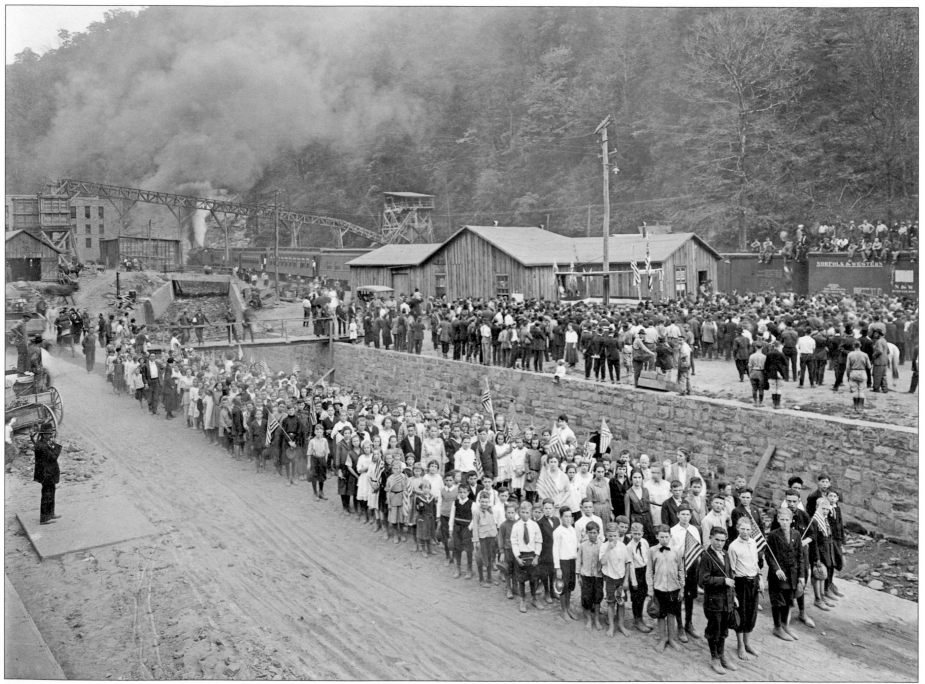

People of Lynch assembled to hear Gov. Frank Lowden of Illinois, Oct. 20, 1920. *Courtesy of Southeast Kentucky Community and Technical College, Godbey Appalachian Archives*

Rodney Little, Hazel Green, serving in the Navy in World War I. *Courtesy of Harold L. Mann*

Second Lt. J. K. Charles from Pikeville, 1917, served in France during World War I. *Courtesy of John C. Charles*

Webster Berckman in his World War I Army uniform, 1917. He was from Williamsburg and graduated from Cumberland College in 1916. He started pre-med studies at the University of Kentucky, and then enlisted in the Army while he was in Lexington. *Courtesy of Winifred "Wini" Berckman Humphrey*

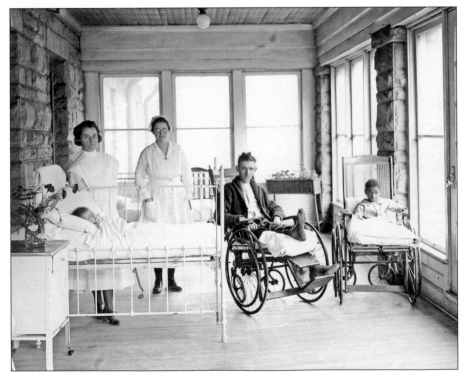

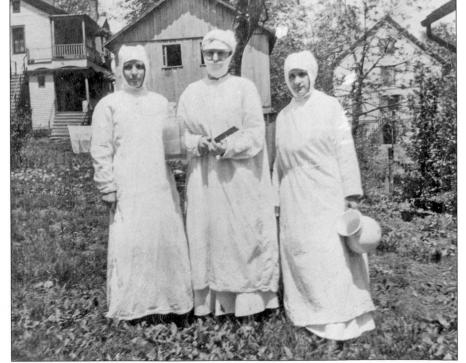

On the sun porch at Lynch Hospital, circa 1920. *Courtesy of Southeast Kentucky Community and Technical College, Godbey Appalachian Archives*

At Robinson Hospital in Berea, circa 1912, left to right: Evelyn England, Annie Ingram and unidentified. *Courtesy of Virginia Browning*

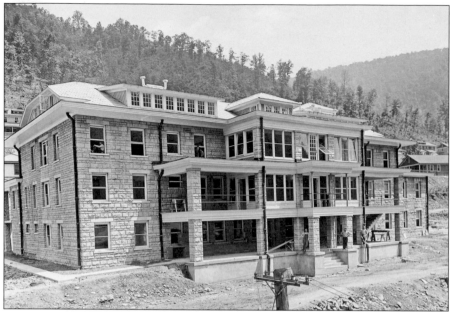

Lynch Hospital, Aug. 6, 1920. *Courtesy of Southeast Kentucky Community and Technical College, Godbey Appalachian Archives*

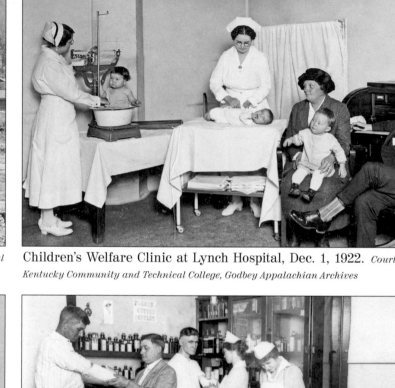

Children's Welfare Clinic at Lynch Hospital, Dec. 1, 1922. *Courtesy of Southeast Kentucky Community and Technical College, Godbey Appalachian Archives*

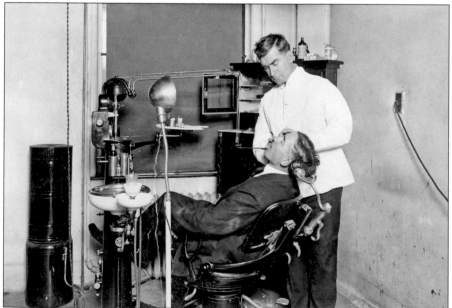

Dental office at Lynch Hospital, Dec. 1, 1922. *Courtesy of Southeast Kentucky Community and Technical College, Godbey Appalachian Archives*

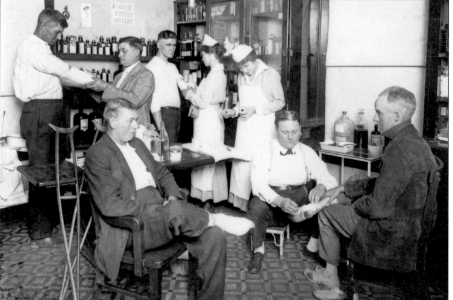

Receiving medical care at Benham, circa 1922. *Courtesy of Southeast Kentucky Community and Technical College, Godbey Appalachian Archives*

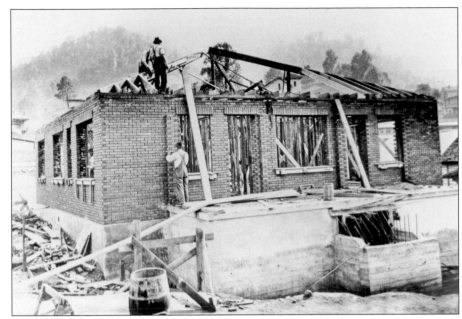

Building the new doctor's office at Benham, Oct. 3, 1922. *Courtesy of Southeast Kentucky Community and Technical College, Godbey Appalachian Archives*

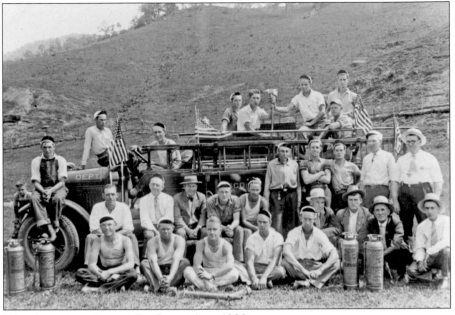

Fire department crew, Benham, circa 1922. *Courtesy of Southeast Kentucky Community and Technical College, Godbey Appalachian Archives*

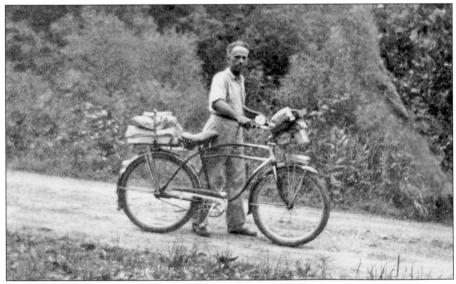

C. O. Leach delivering the mail on bicycle to residents of the Paragon area of Rowan County, circa 1925. The roads were under construction, and he carried the bicycle on top of his mail car when the roads became impassable. *Courtesy of Cindy Leach*

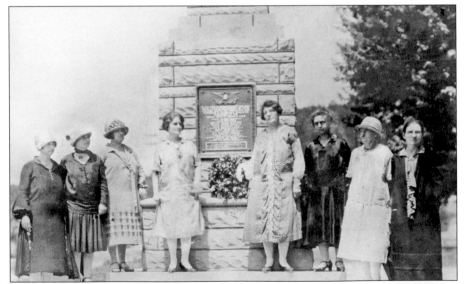

Ladies who headed the effort to build the World War I memorial in Morehead, circa 1925. Those included: Rene Wells, Arie Lewis, Mary Bell Cassity, Leora B. Hurt, Hallie Bradley, Jimmie Bishop, Maggie Hogge and Lucy T. Evans. *Courtesy of Rowan County Public Library*

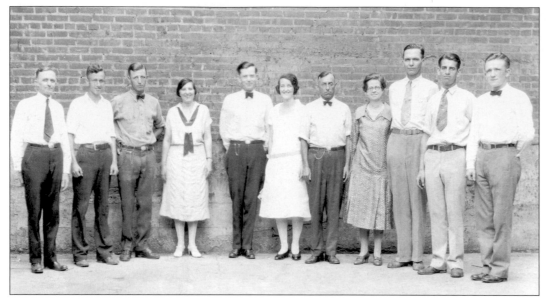

Perry County post office employees, Hazard, 1926. William Cash Goodloe Combs is seventh from the left. He was a defense attorney who worked for the post office. *Courtesy of David Ravencraft*

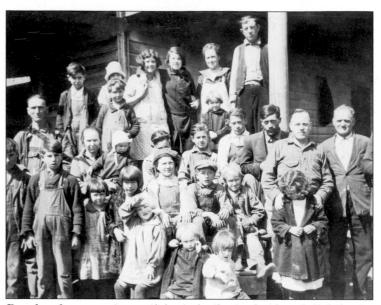

People who came to participate in the typhoid and diphtheria immunization clinic at Cutshin Creek, circa 1928. *Courtesy of J. A. Stucky Papers, Southern Appalachian Archives, Berea College*

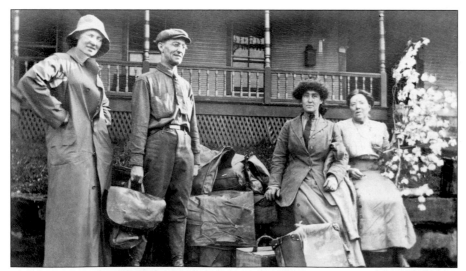

Dr. J. A. Stucky and his team traveled throughout Eastern Kentucky setting up clinics and hospitals to treat trachoma, an eye disease that affected many children in the region, circa 1928. He operated on the patients he could in the remote facilities and brought more complicated cases to a Lousiville hospital. *Courtesy of J. A. Stucky Papers, Southern Appalachian Archives, Berea College*

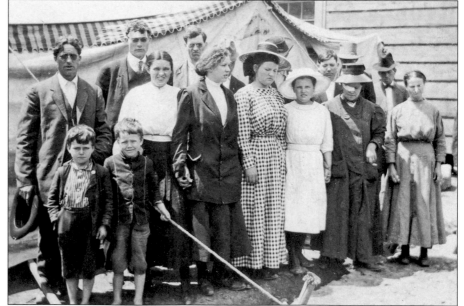

Patients beside a hospital tent used by Dr. J. A. Stucky to do eye surgery, circa 1928. *Courtesy of J. A. Stucky Papers, Southern Appalachian Archives, Berea College*

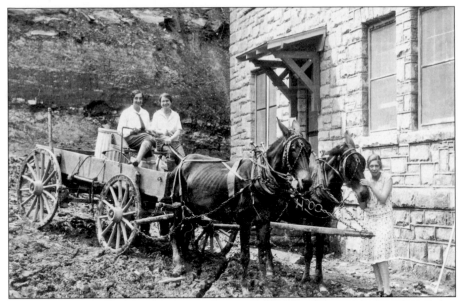

The hospital in Hyden where Dr. J. A. Stucky provided his treatment for trachoma, June 26, 1928. *Courtesy of J. A. Stucky Papers, Southern Appalachian Archives, Berea College*

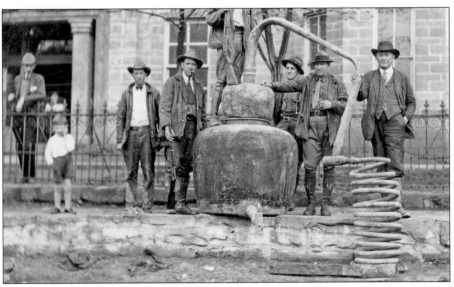

Still found in Morgan County, circa 1929. It was believed to have been in operation for many years and well known to many people until federal agents came into the county and discovered its operation. *Courtesy of Appalachian Photoarchives, Southern Appalachian Archives, Berea College*

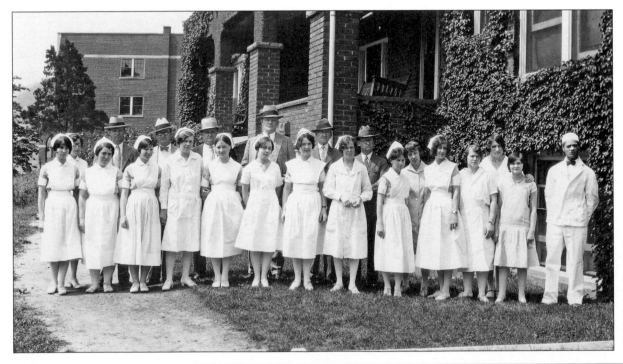

The Methodist Hospital of Kentucky in Pikeville, 1930. In the back row: Rev. S. K. Hunt, Dr. Adam Osborne, Dr. R. W. Raynor, Dr. Paul Gronnerud, Dr. Thompson and Dr. R. S. Johnson. In front are the nurses and orderlies. The hospital building later served as facilities for Pikeville College. *Courtesy of Pikeville Medical Center*

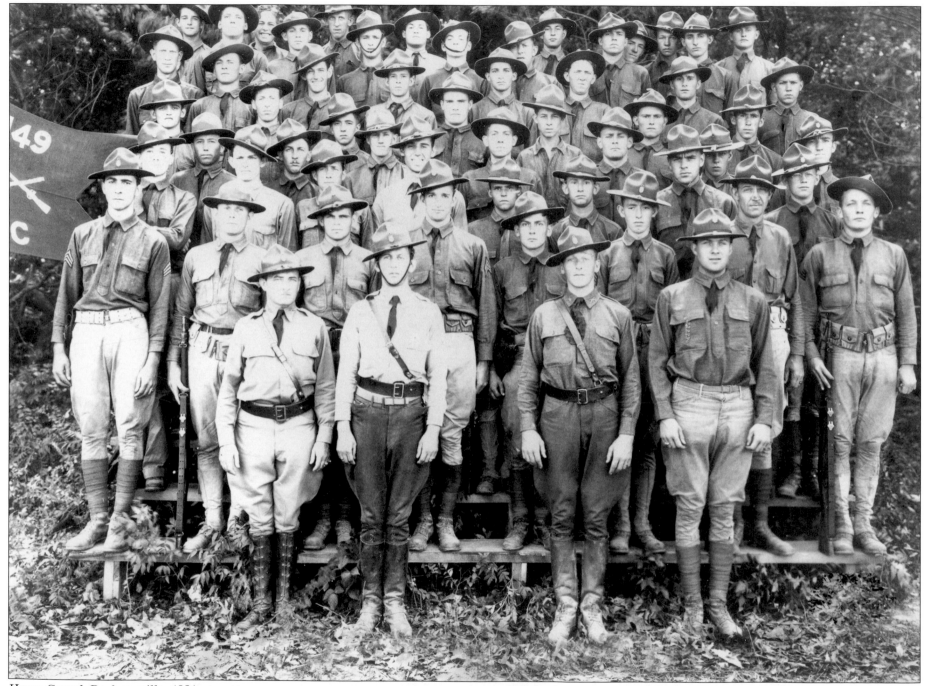

Home Guard, Barbourville, 1931. *Courtesy of Photographic Archives, Appalachian Learning Laboratory, Alice Lloyd College*

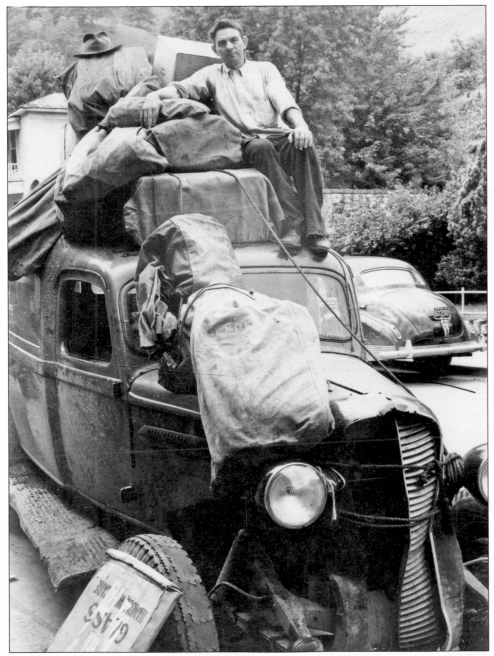

Crockett Watson, circa 1935, carried the mail from Lackey to Hazard. He carried passengers inside the car and the mailbags on the top. *Courtesy of Photographic Archives, Appalachian Learning Laboratory, Alice Lloyd College*

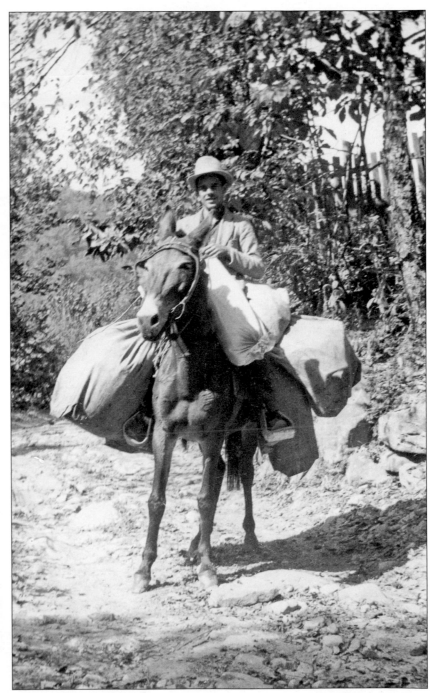

Mail carrier in Leslie County, circa 1935. *Courtesy of Camp Nathanael*

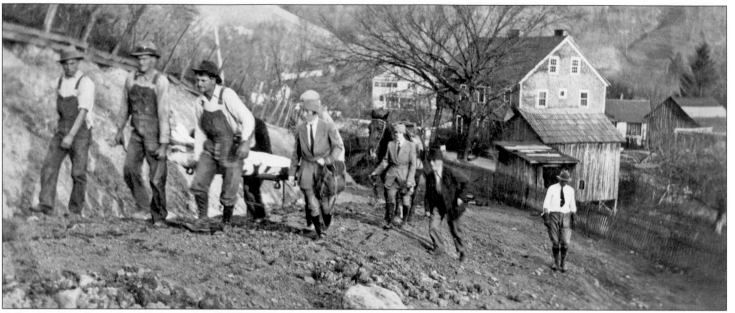

A Leslie County patient being taken to the hospital on a stretcher, circa 1935. There were no roads for a car to access the area. *Courtesy of Camp Nathanael*

Edgille "Ed" Hall, son of Mr. and Mrs. M. J. Hall of McDowell, during his attendance at the Annapolis Naval Academy, circa 1938. *Courtesy of Opal Hall Waddell*

Emmalena Post Office, 1937. *Courtesy of Camp Nathanael*

Office for the Kentucky District of Forestry near Putney, Harlan County, 1938. Three offices are on the left with the home of the district forester, Webster Berckman, on the right. *Courtesy of Winifred "Wini" Berckman Humphrey*

EDUCATION

The following section has more photos, and more people per photo, than any other in this book.

From one-room schoolhouses to Pikeville College, there was something about having a bunch of students together that made people want to line them up and set up a camera.

Many of these photos were from an era when education was considered rare and precious, and when readin', ritin' and 'rithmetic often were accompanied by an honest-to-goodness hickory stick.

In a few of the photos, the students' faces aren't distinct, so you are left with only an impression of a group of youngsters trying to stand very still for posterity. One of those photos, however, catches James Still, later one of Kentucky's most revered authors, as a young teacher.

And take extra time to pore over those photos in which someone bothered to write down and save the name of each smooth-faced student in the group. You might have an ancestor in there.

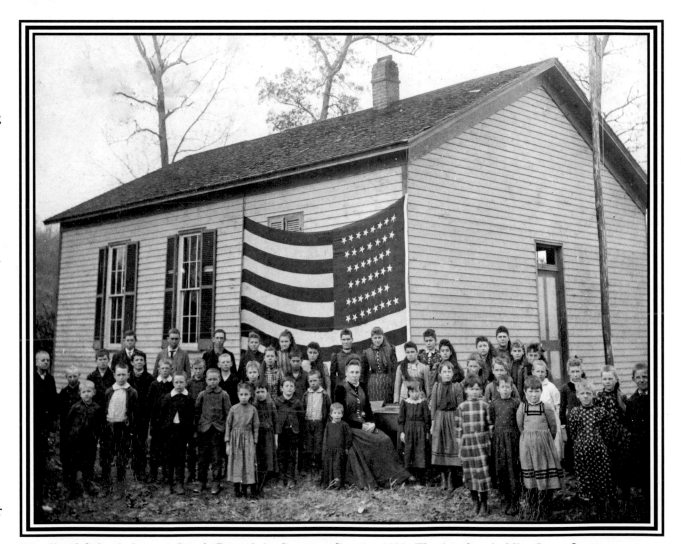

Woodland School class at Gray's Branch in Greenup County, 1892. The teacher is Miss Loue Jones. *Courtesy of Michael Wells*

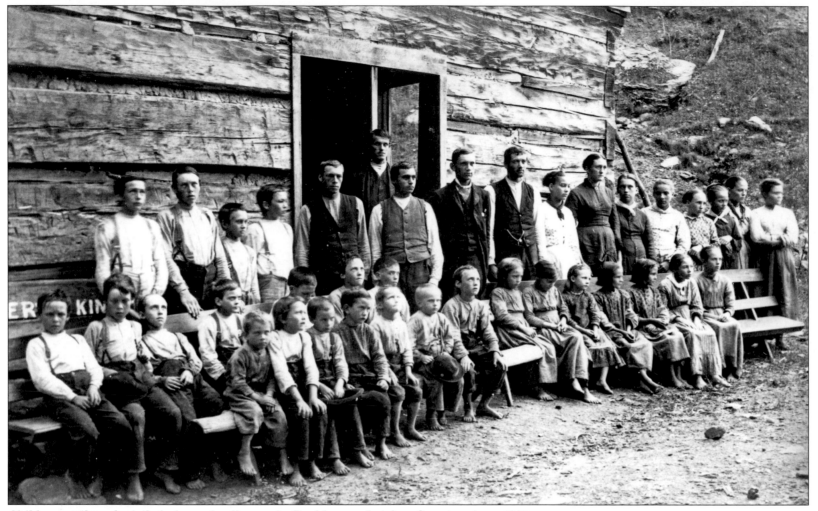

Children gathered at their log schoolhouse in Rockhouse, Letcher County, circa 1885. *Courtesy of Photographic Archives, Appalachian Learning Laboratory, Alice Lloyd College*

Hindman Public School students, 1896. Their three teachers, including Prof. George Clark, are on the right.
Courtesy of Photographic Archives, Appalachian Learning Laboratory, Alice Lloyd College

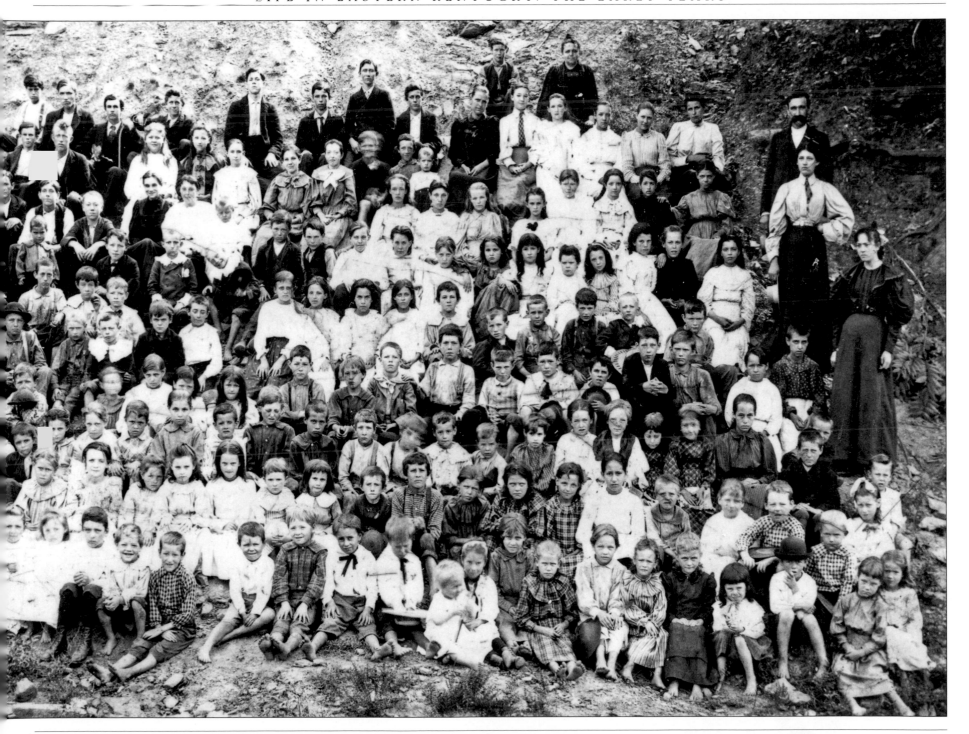

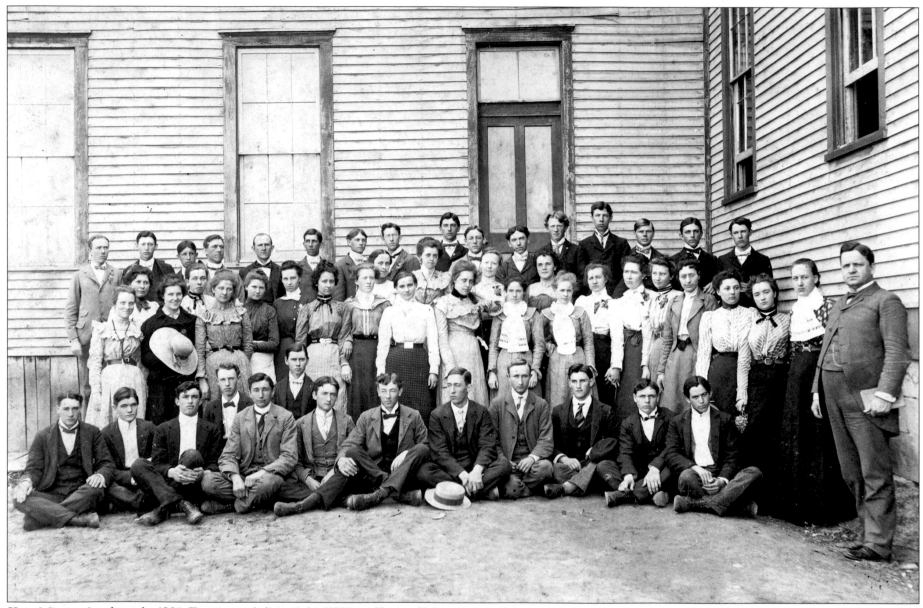

Hazel Green Academy in 1901. Front row, left to right: William Haney, Kelse Nickell, Edward Watson, George Amyx, Robert Carpenter, Jimmy Dunn, James Helton, Lee Perkins, Harlen Oldfield, Wick Wells, Osa Byrd, Noah Mann and Bib Raney. Second row: Stella Hurst, Falay Long, Julia Nickell, Anna Wheeler, Minnie Millard, Nolda Davis, Nora Boggs, Nettie Payne, Alma Swango, Lula Evans, Minnie Wallace, Fannie Hurst, Lillie Hurst, Sarah Vest, Pearl Johnson, Bertha Samle, Lillie Rose, Ella Millard, Etta Swango, Mattie Cope, Effie Kilgore, Nora Cruey and Prof. William H. Cord. Back row: Steve Sample, Estill Clark, Wayne Long, John Cisco, Alonzo Cosco, Sam Kash, Banford Mannin, Leroy Boggs, Eli Kash, Asa Rose, Jim Rose, Galoway Sebastian, Dan Kash, James Wells, Hardin Hurst and William Mann. *Courtesy of Hazel Green Academy Collection, Southern Appalachian Archives, Berea College*

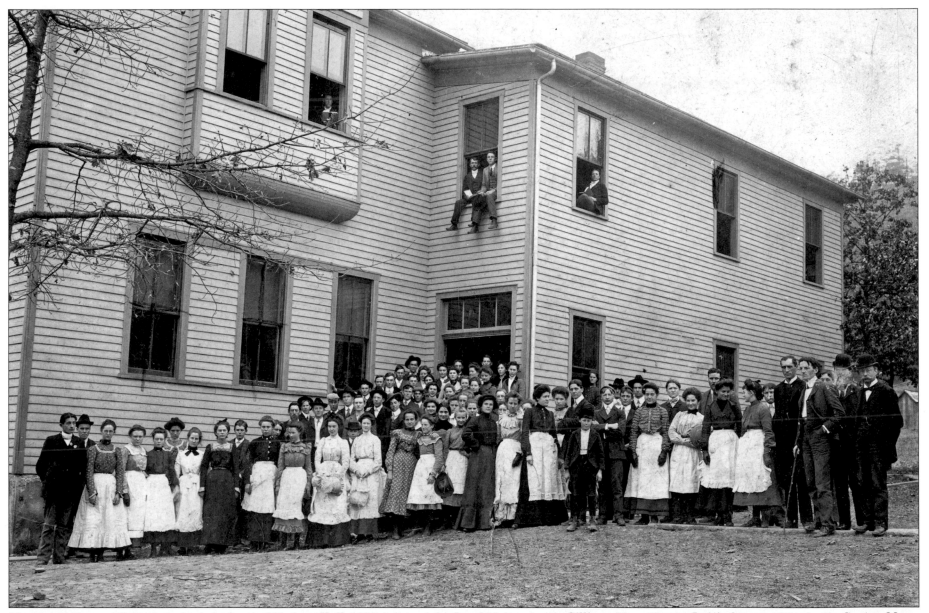

Morehead Normal School students in front of Hodson Hall, 1902, left to right: Isaal Mabry, Lottie Gilliam, Mary Young, Lottie Stewart Dix, Lydia Carter, Mary Bear, unidentified, Clyde Huffman, Flora Johnson, Flora Wilson, Maggie Warnock, Elery Bry, Cora Perry, Minta Woolman, Nona Banfield, Bess Sexton, Manie Evans, unidentified, Lena Carey, Alice Whitt, Blanche Evans, Edgar Phippe, Joe Lyttleton, Hirston Lyttleton, Tylor Paudfield, Anna Knapp, Grover Nickell, Maud Tappett, Sherman Evans, Maud Claire, Dixie Nohn, Rev. Dixon, Mr. McDiarmid and Bro Button. Dane Caudill is in the upstairs window. Also included are Elliot Brammel, George Johnson, Laura Saudridge, Hallie Bradley, Stella Wilson and Mrs. Jesse Hulette. *Courtesy of Special Collections & Archives, Camden-Carroll Library, Morehead State University*

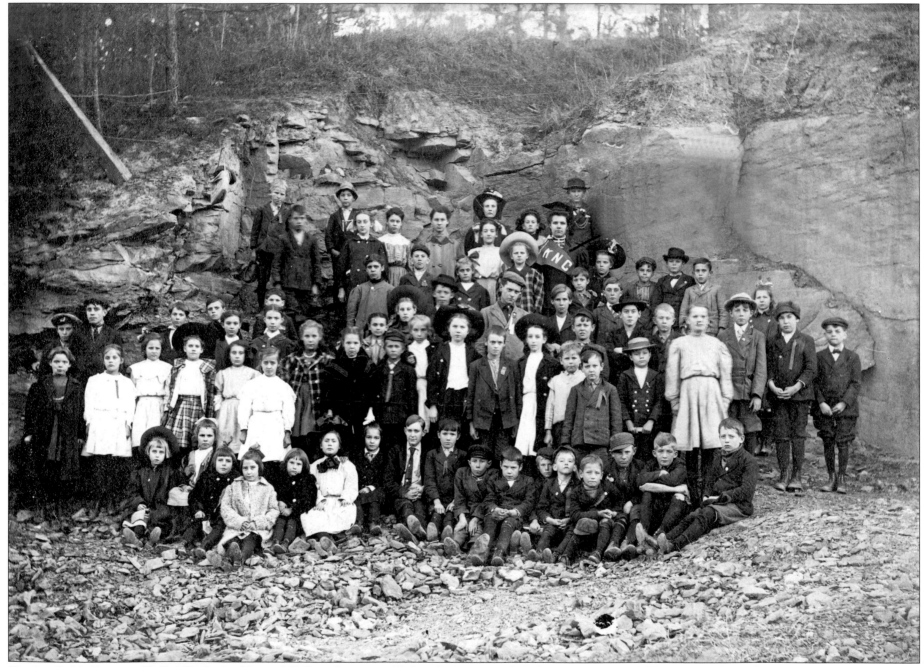

Eunice Golda Lowe, with the Kentucky Normal College banner, with her first group of students at Big Creek Elementary School, grades one through eight, at Whitepost, Pike County, circa 1908. *Courtesy of David Ravencraft*

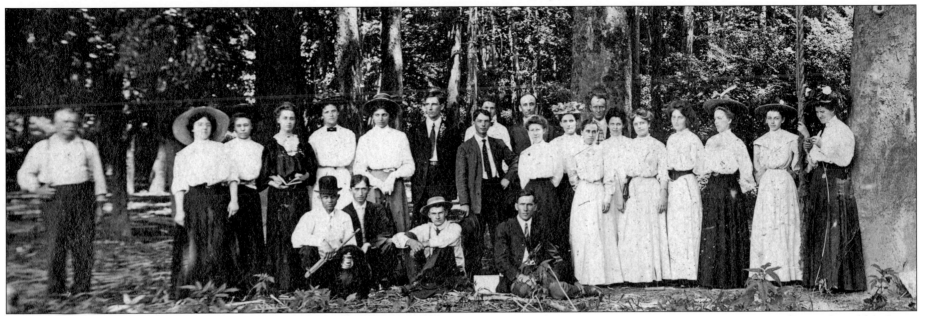

Summer term students at Eastern State Teachers College, Richmond, on a field trip in the early 1900s to visit the tree where Daniel Boone is said to have carved his initials and that he had killed a "bar." Zora Daniel Preston, Paintsville, is next to the tree. *Courtesy of Anna Daniel Hall*

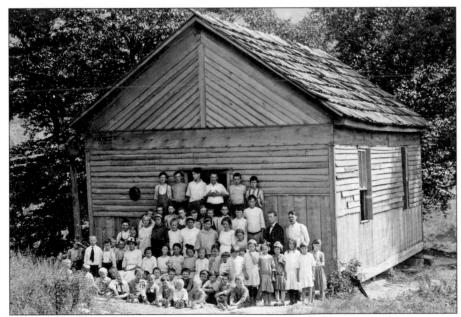

School in Perry County, circa 1910. *Courtesy of Southern Appalachian Archives, Special Collections & Archives, Berea Colleg*

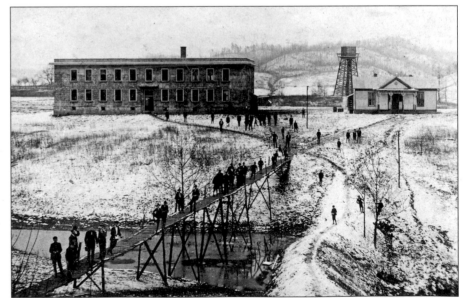

Helen E. Moses Memorial Boys' Dormitory and students' cottage at Hazel Green Academy, circa 1910. *Courtesy of Hazel Green Academy Collection, Southern Appalachian Archives, Berea College*

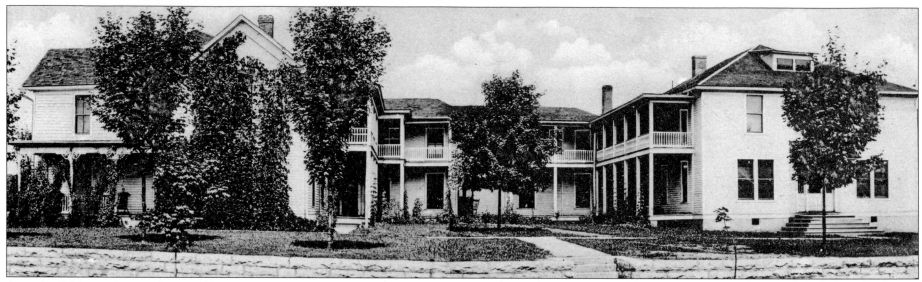

Langdon Memorial School, Mt. Vernon, circa 1910. It was established as a mission school by the Presbyterian Church in the late 1800s. It was a boarding school for girls with boys able to attend classes during the day. The school influenced both the education and culture of Rockcastle County during its existence and into the future. *Courtesy of Ann L. Henderson*

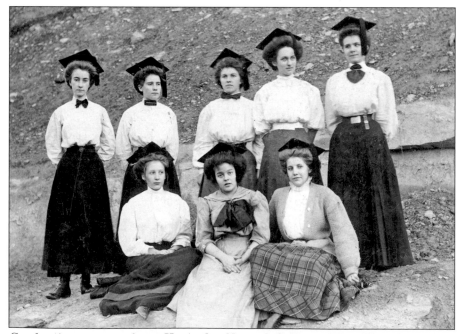

Graduating women from Kentucky Normal College, Pikeville, circa 1911. Eunice Golda Lowe is on the right in the back row. *Courtesy of David Ravencraft*

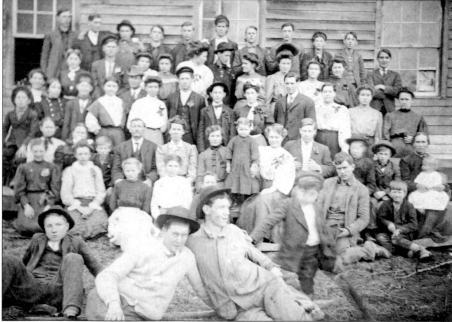

Lawrence County School, 1912. In the third row is Elva Rose. *Courtesy of April Voit*

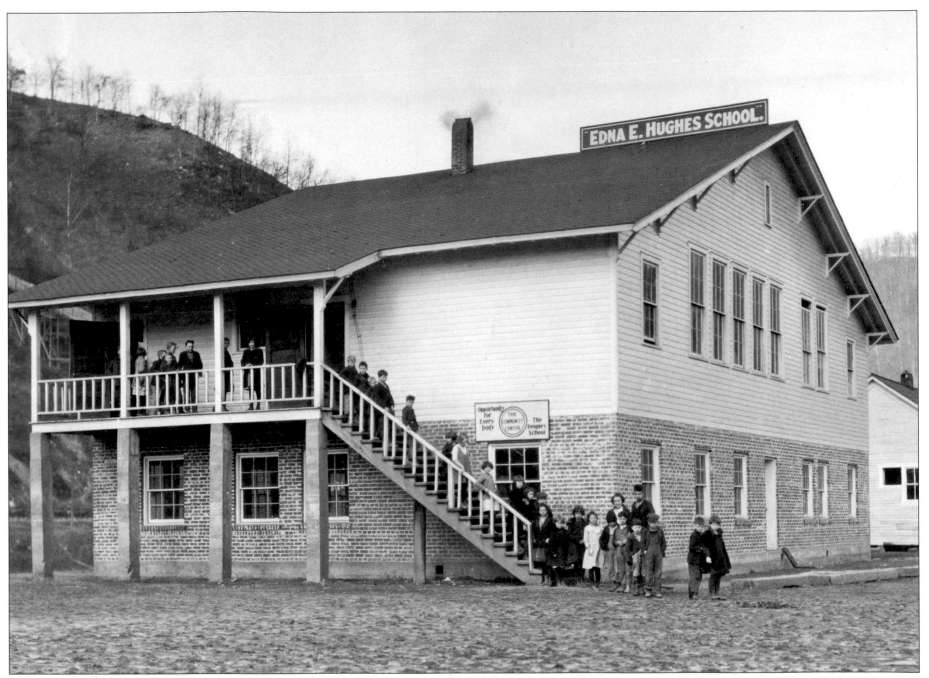

Edna E. Hughes School at Beaver Creek with a class on the stairs. Miss Hughes taught in this school for a year, contributing the salary paid by the county to furthering the work. Her father gave $500 toward the construction. *Courtesy of Photographic Archives, Appalachian Learning Laboratory, Alice Lloyd College*

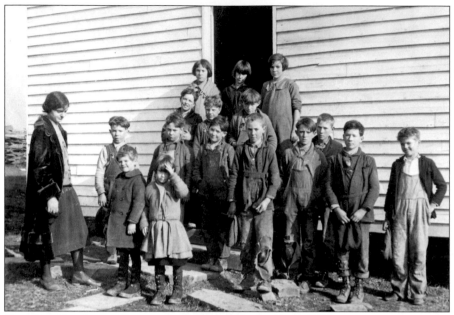

County school near Farmen in Rowan County, circa 1915. *Courtesy of Appalachian Photoarchives, Southern Appalachian Archives, Berea College*

Young students at Caney Creek Community Center, which later became Alice Lloyd College, sitting in front of their dormitory, Syracusan, in Pippa Passes, Knott County, circa 1920. *Courtesy of Photographic Archives, Appalachian Learning Laboratory, Alice Lloyd College*

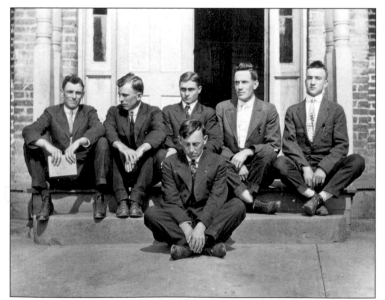

Graduating class of Hazard Baptist Institute, Hazard, 1917. William Cash Goodloe Combs, headmaster of the institute, is in the front center. *Courtesy of David Ravencraft*

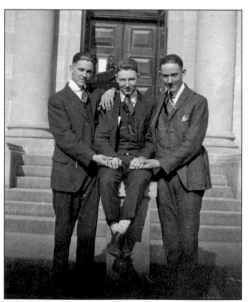

At Berea College, 1918, left to right: Andrew Hurst, Ted Durham and Carl Davis. *Courtesy of Alfred E. Durham*

Last day of school after exams at Berea College, 1918. From left to right: Verda Pursiful, Addie Skidmore and Lucille (unknown). *Courtesy of Alfred E. Durham*

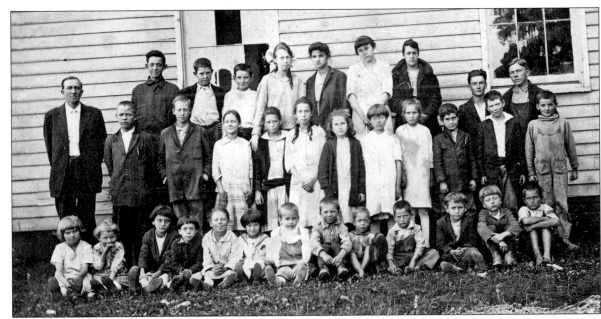

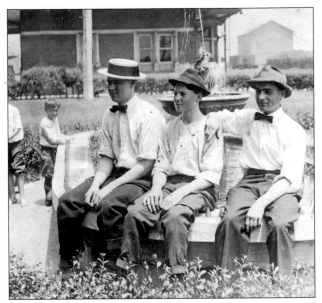

Woodland School at Gray's Branch in Greenup County, Sept. 12, 1917. The teacher is Mr. Edmond Earwood. *Courtesy of Michael Wells*

Students on a Sunday afternoon at Hazel Green Academy, 1915. Included are Arlie Mann and Peter Craft. *Courtesy of Harold L. Mann*

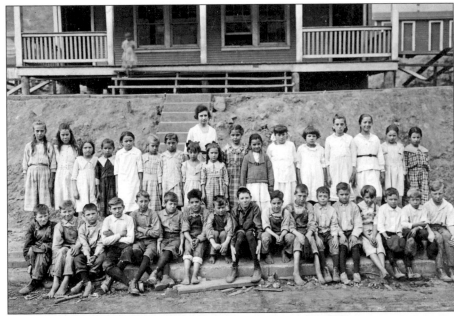

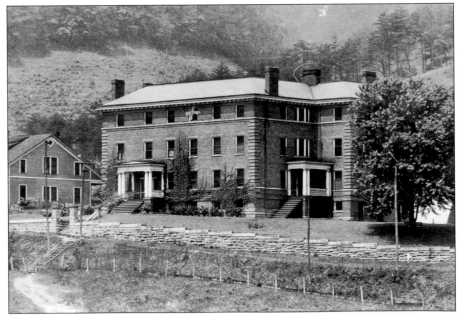

Third-grade class at Lynch Graded Schools, Oct. 20, 1920. *Courtesy of Southeast Kentucky Community and Technical College, Godbey Appalachian Archives*

Girls' dormitory, The Derriana, at Pikeville College. *Courtesy of Pikeville College Archives*

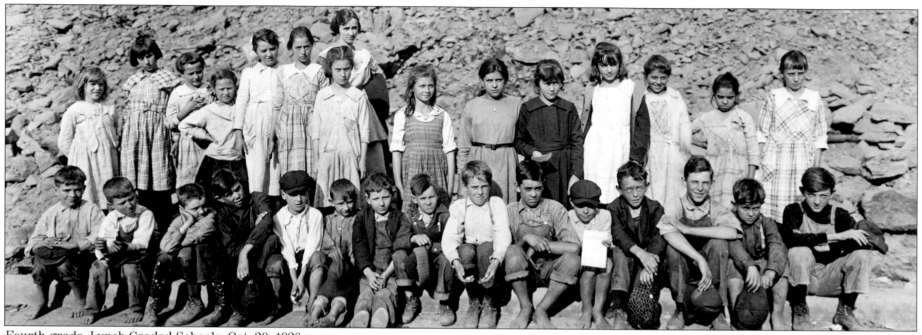

Fourth grade, Lynch Graded Schools, Oct. 20, 1920. *Courtesy of Southeast Kentucky Community and Technical College, Godbey Appalachian Archives*

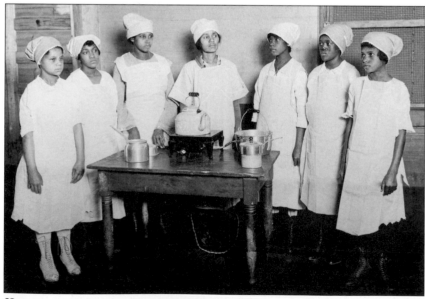

Home economics class sponsored by the Black YMCA for which students could receive credit in the public school, circa 1920. *Courtesy of Southeast Kentucky Community and Technical College, Godbey Appalachian Archives*

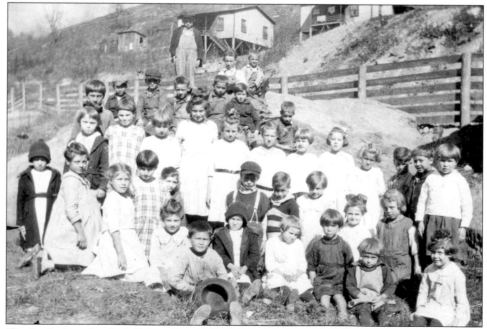

Students in school at Solar, Perry County, 1922. *Courtesy of Karen Fritts Bates*

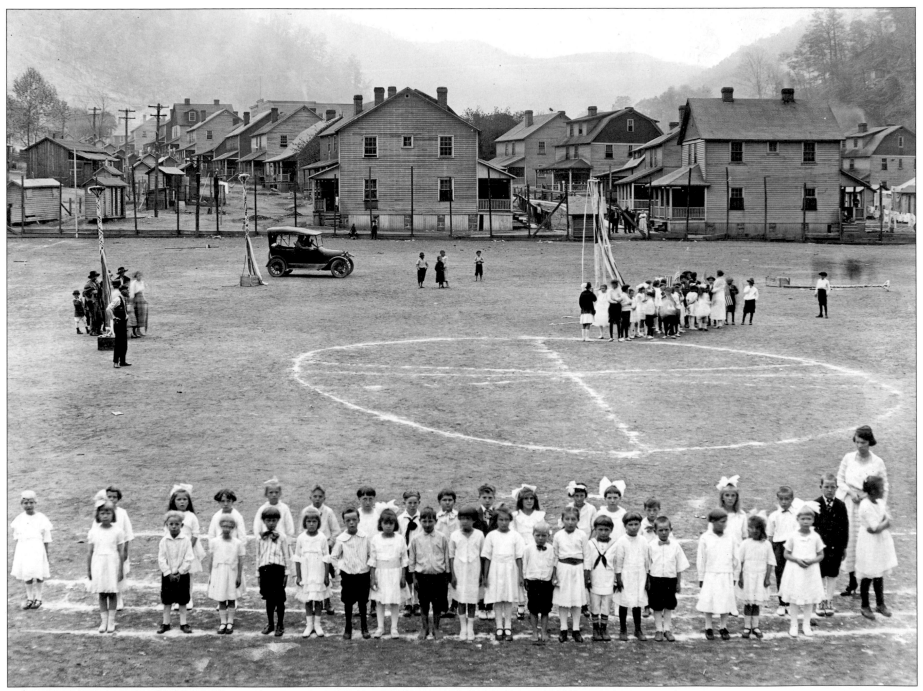

Second graders from Lynch Graded Schools, May 12, 1921. *Courtesy of Southeast Kentucky Community and Technical College, Godbey Appalachian Archives*

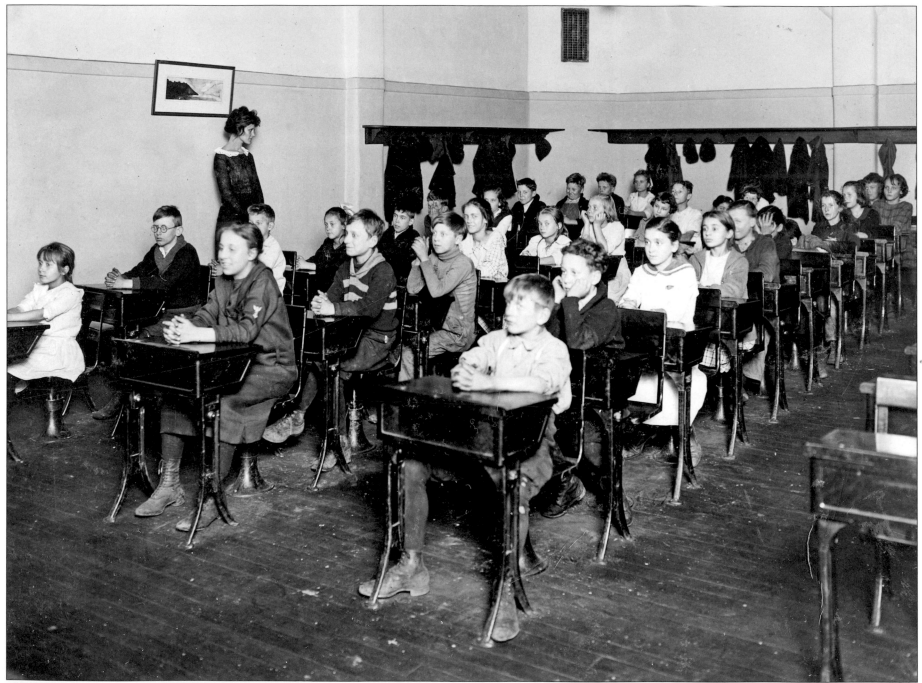

Fourth grade at Lynch Graded Schools, Dec. 1, 1922. *Courtesy of Southeast Kentucky Community and Technical College, Godbey Appalachian Archives*

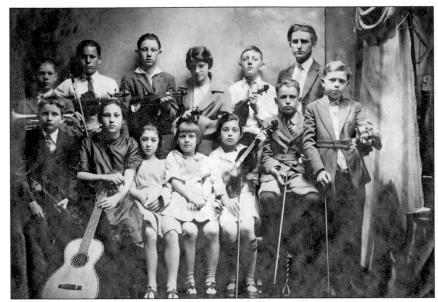

Music class at Corbin School, circa 1922. Standing on the far left is Malcolm Shotwell, and seated in the second row on the far right is Bruce Cannon. *Courtesy of John Shotwell*

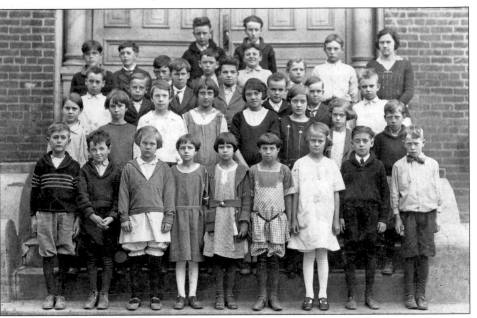

McDowell Grade School in Floyd County, 1923. In the front row, the first boy on the left is John L. Hall. *Courtesy of Johnny and Patti Hall*

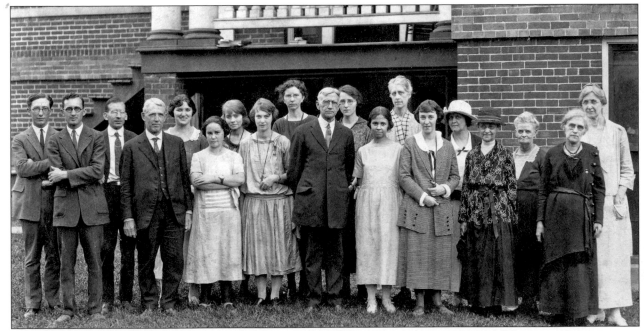

Faculty of Pikeville College in front of The Derriana, 1924. *Courtesy of Pikeville College Archives*

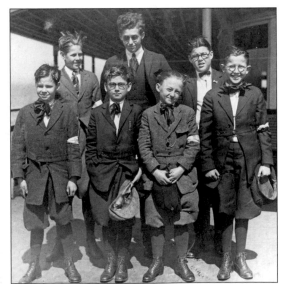

Students in the early days of Alice Lloyd College. Included are Dan Martin and Rush Slone. *Courtesy of Photographic Archives, Appalachian Learning Laboratory, Alice Lloyd College*

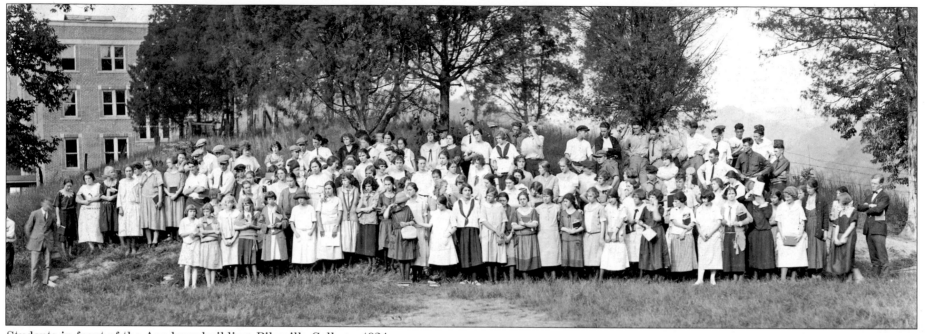

Students in front of the Academy building, Pikeville College, 1924. *Courtesy of Pikeville College Archives*

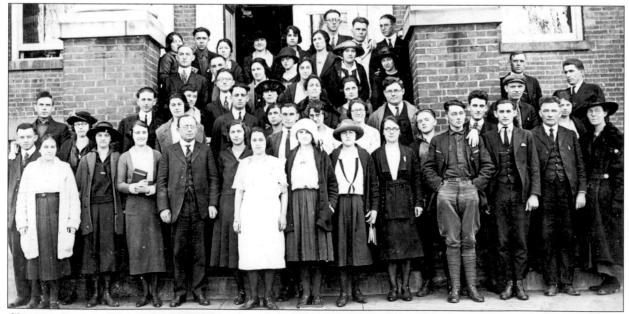

Class at Berea, circa 1924. Fifth from the right with glasses is Dora Burton of Frozen Creek, Breathitt County. *Courtesy of Carolyn Dunn Durham*

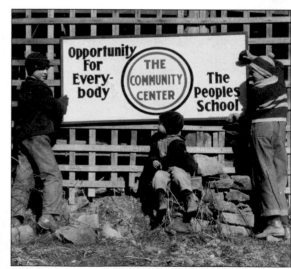

Chester Terry and Henry Slone nailing up one of the Community Center signs found throughout the mountains. James Prater is sitting on the rocks. *Courtesy of Photographic Archives, Appalachian Learning Laboratory, Alice Lloyd College*

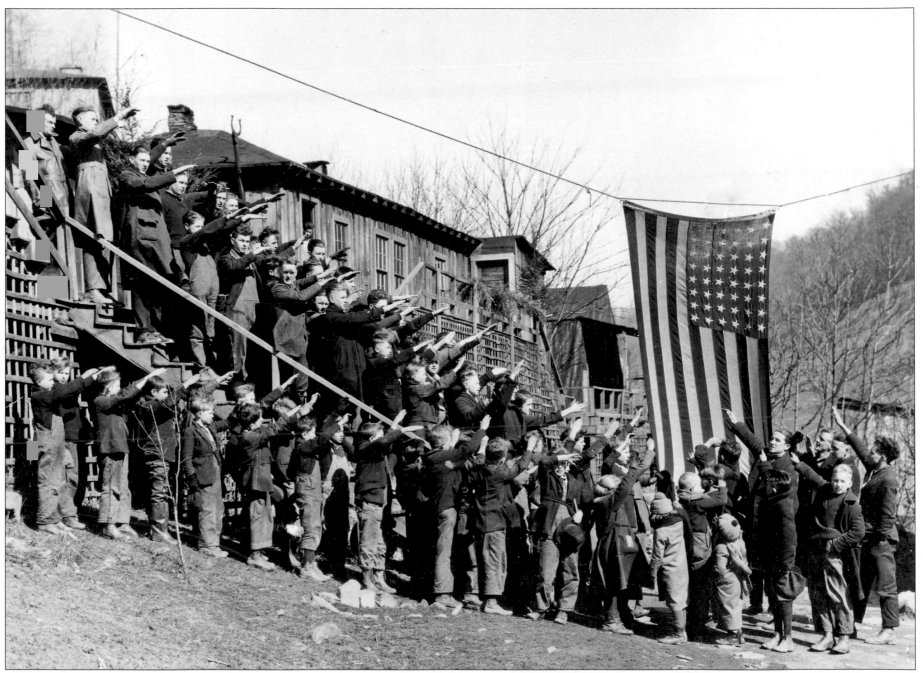

Morning salute to the flag at Caney Creek Community Center, circa 1925. The entire membership of the school stood at salute and pledged its allegiance daily as the colors were raised. *Courtesy of Photographic Archives, Appalachian Learning Laboratory, Alice Lloyd College*

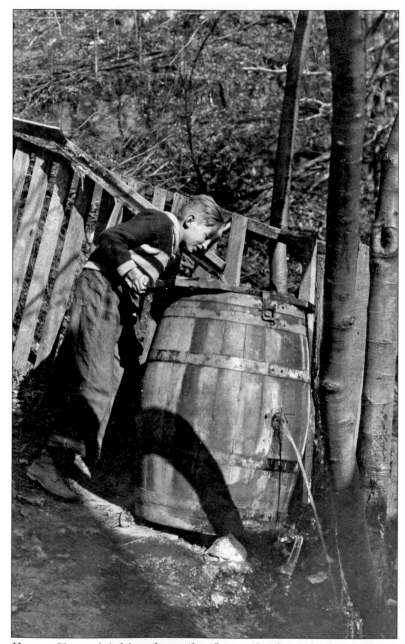

Henry Slone drinking from the flume the boys built to divert a mountain spring to the door of their shack at Caney Creek Community Center, circa 1925. *Courtesy of Photographic Archives, Appalachian Learning Laboratory, Alice Lloyd College*

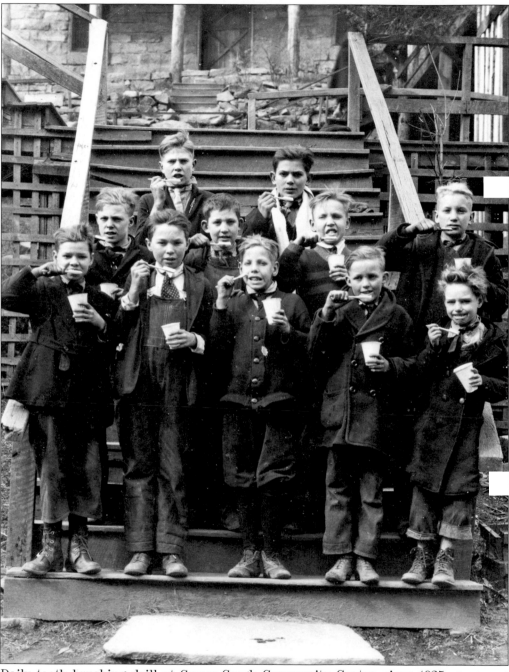

Daily tooth brushing drill at Caney Creek Community Center, circa 1925. *Courtesy of Photographic Archives, Appalachian Learning Laboratory, Alice Lloyd College*

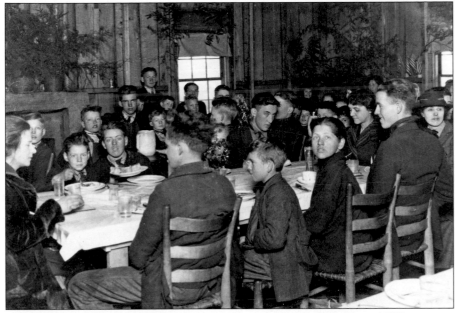

Part of the dining hall at Caney Creek Community Center, circa 1925. *Courtesy of Photographic Archives, Appalachian Learning Laboratory, Alice Lloyd College*

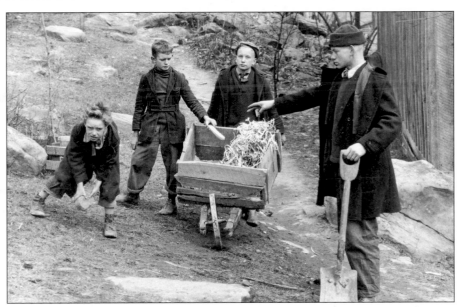

Students policing the grounds of the Caney Creek Community Center, circa 1925. The boys voluntarily kept the grounds scrupulously clean of litter. *Courtesy of Photographic Archives, Appalachian Learning Laboratory, Alice Lloyd College*

Mrs. Alice S. G. Lloyd talking with Humtty Abisha, the mountaineer who contributed the first land for Caney Creek Community Center. *Courtesy of Photographic Archives, Appalachian Learning Laboratory, Alice Lloyd College*

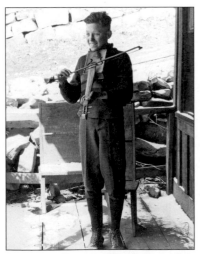

Kirby Amburgy playing a fiddle, the body made from a cigar box, at Caney Creek Community Center, circa 1925. *Courtesy of Photographic Archives, Appalachian Learning Laboratory, Alice Lloyd College*

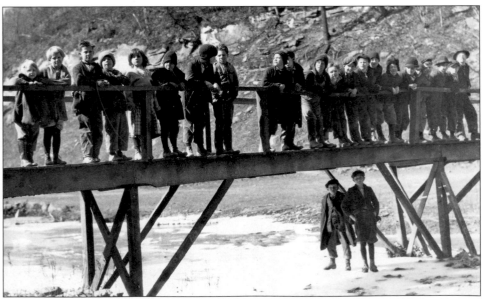

Caney Creek Community Center students on the bridge over the creek leading to the schoolhouse, circa 1925. On the ice are Otis Sparkman and Otto Martin. *Courtesy of Photographic Archives, Appalachian Learning Laboratory, Alice Lloyd College*

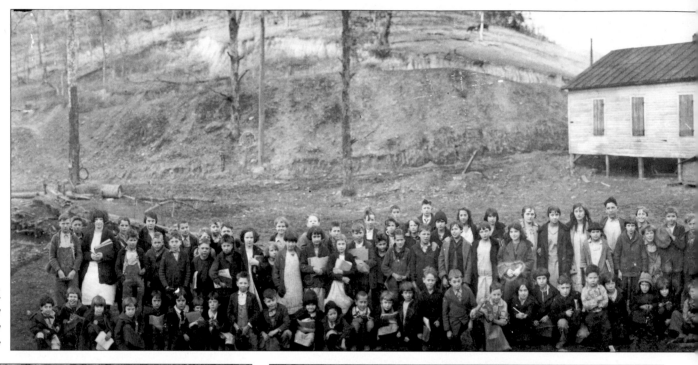

Hardburley High and Graded School in Perry County, Dec. 8, 1925. *Courtesy of Photographic Archives, Appalachian Learning Laboratory, Alice Lloyd College*

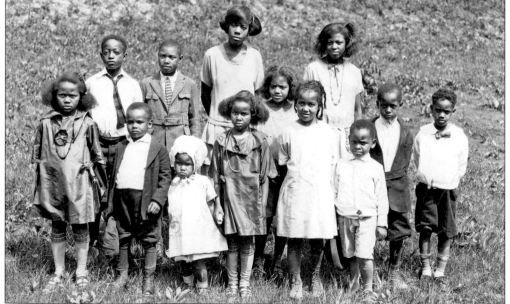

Children at Wolfpit school, circa 1925. *Courtesy of James Grover Holland Sr. Collection, Pikeville Public Library*

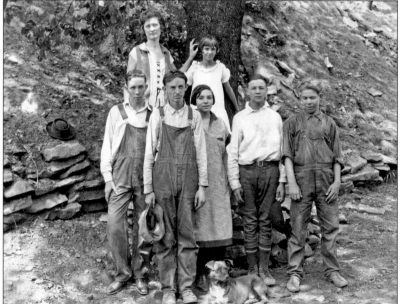

Seventh-grade class of the school at Wolfpit, circa 1925. *Courtesy of James Grover Holland Sr. Collection, Pikeville Public Library*

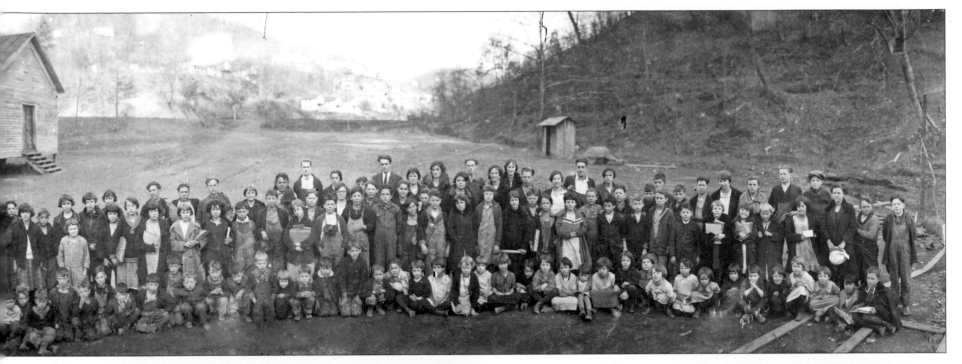

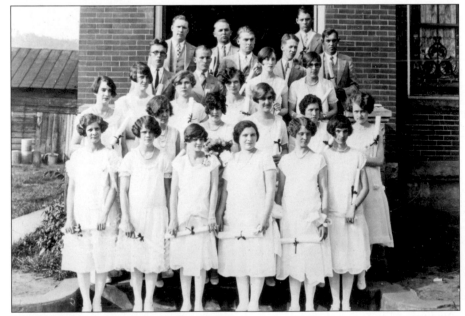

Graduating class at Pikeville College, circa 1925. *Courtesy of Pikeville College Archives*

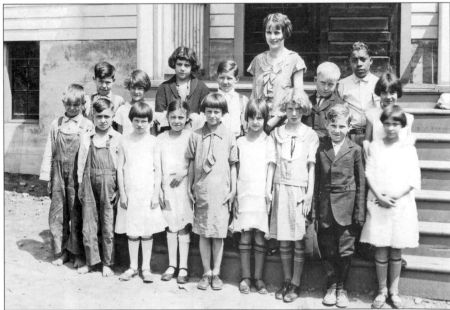

Third-grade class at Wolfpit school, circa 1925. *Courtesy of James Grover Holland Sr. Collection, Pikeville Public Library*

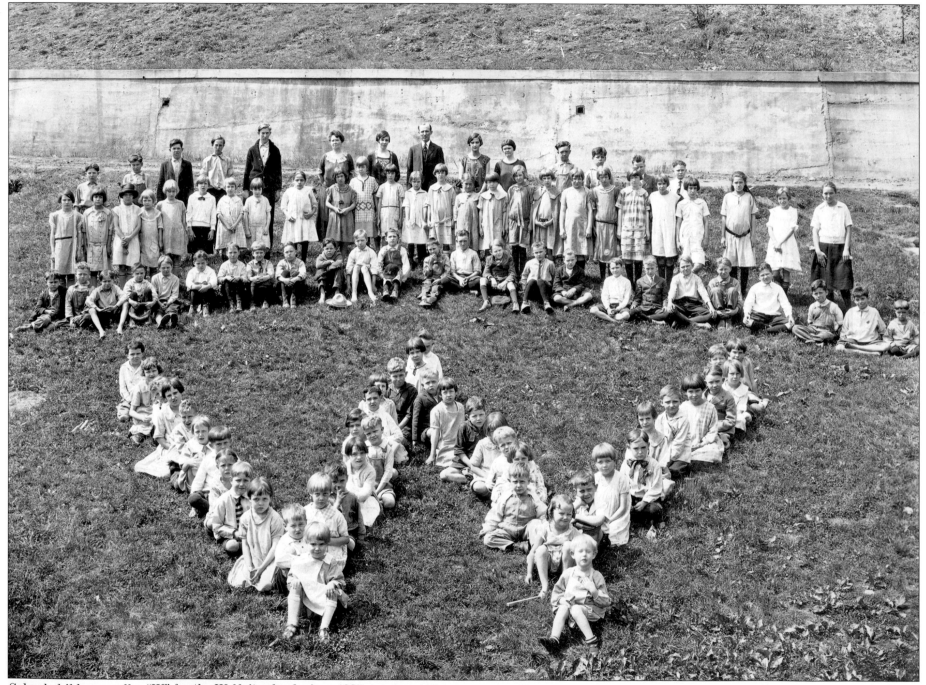

School children spell a "W" for the Wolfpit school, circa 1925. *Courtesy of James Grover Holland Sr. Collection, Pikeville Public Library*

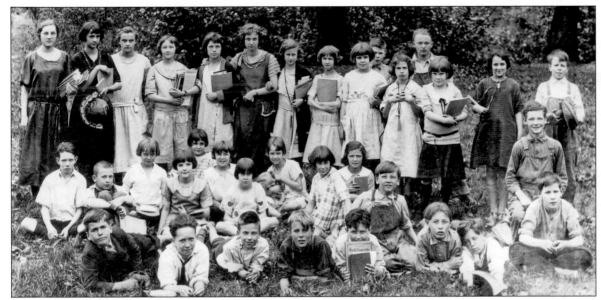

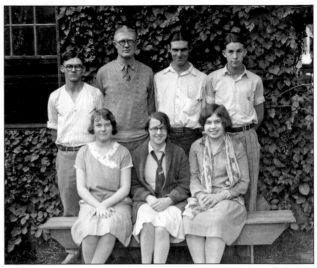

Six A class from Pikeville Academy, 1927. Included: Bill Hambley, Billy Burke, Chester Smith, Paul B. Mays, Joe Amick, Glema Hughes, Gene Thomas, Ruth Repass and Nina Mae Parker. *Courtesy of Paul B. Mays Collection, Pikeville Public Library*

Hindman Class of 1929. Front row, left to right: Gertrude Maggard, Marie Stewart and Alma Pigman. Back row: Beckham Miller, Chyle Hammond and Andrew Hammond. *Courtesy of Photographic Archives, Appalachian Learning Laboratory, Alice Lloyd College*

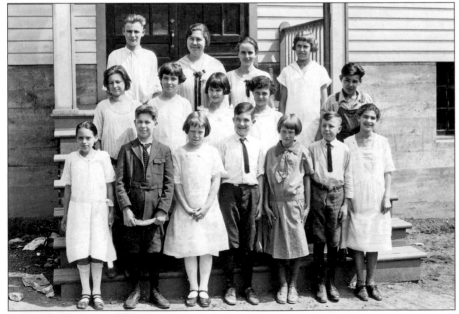

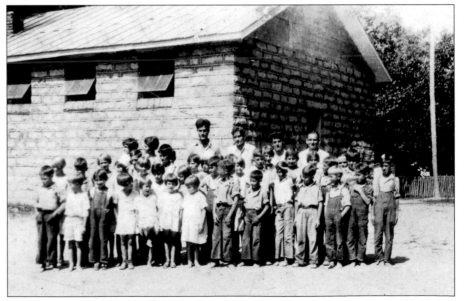

Fifth graders at Wolfpit school, circa 1925. *Courtesy of James Grover Holland Sr. Collection, Pikeville Public Library*

Students at Mill Creek School, 1932. James Still is the adult in the back on the far right. *Courtesy of Special Collections & Archives, Camden-Carroll Library, Morehead State University*

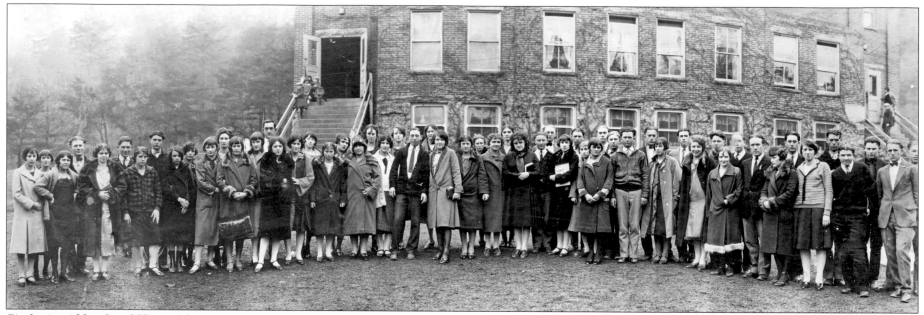

Students at Morehead Normal School, circa 1926. Sixth and eighth from the right in the front row are Ersa and Atness Burton, sisters from Frozen Creek in Breathitt County. *Courtesy of Carolyn Dunn Durham*

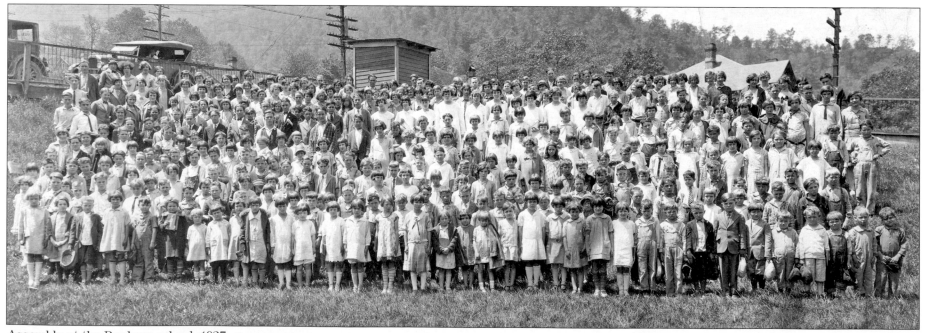

Assembly at the Benham school, 1927. *Courtesy of Southeast Kentucky Community and Technical College, Godbey Appalachian Archives*

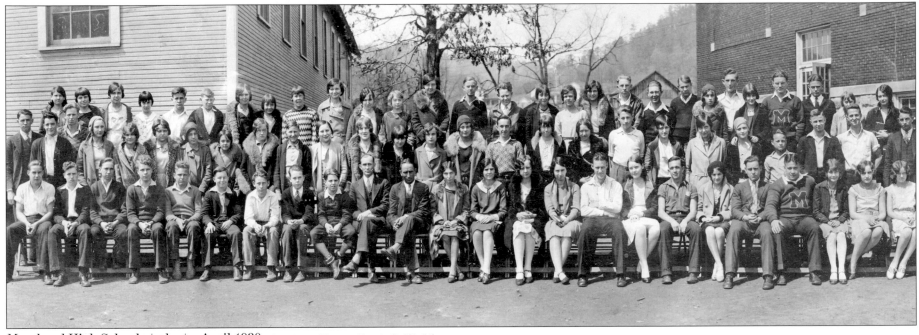

Morehead High School students, April 1930. *Courtesy of Rowan County Public Library*

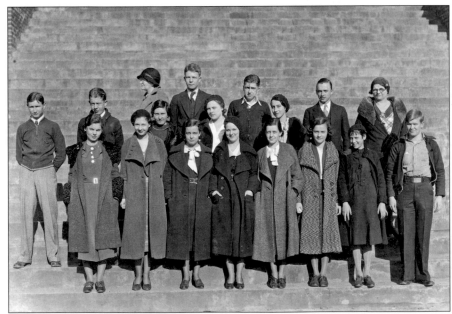

High school students at Pikeville Academy, circa 1934. John Bill Trivette is on the left in the back row. *Courtesy of Patty T. Blair*

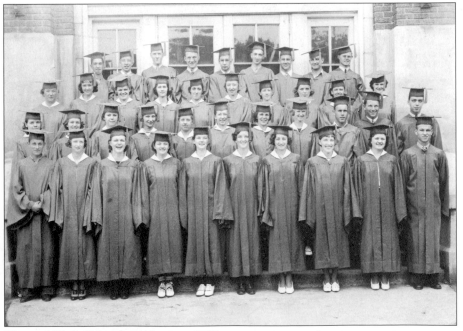

Hazard High School graduates, 1935. *Courtesy of Bobby Davis Museum and Park*

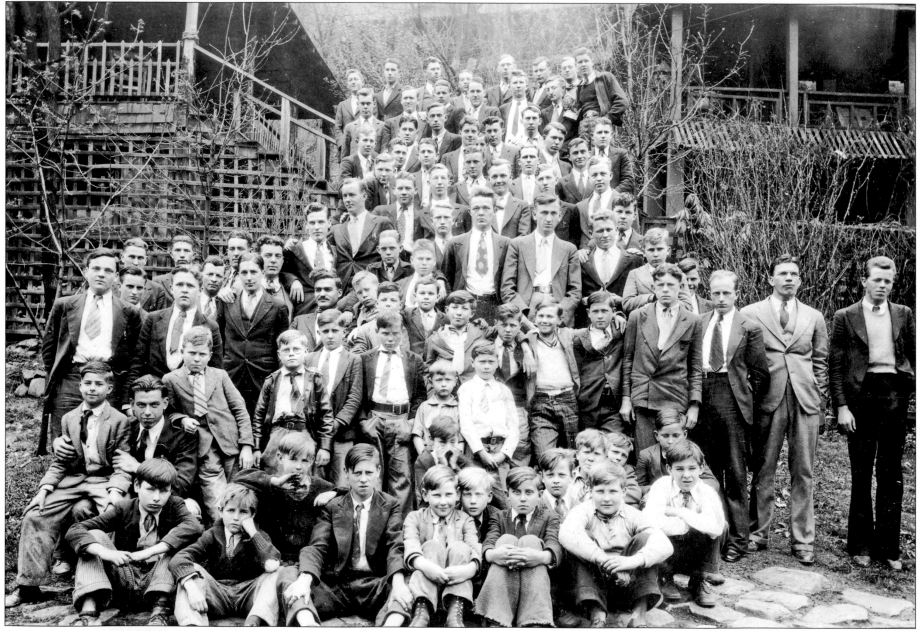

Students of Alice Lloyd College, 1934–35. *Courtesy of Photographic Archives, Appalachian Learning Laboratory, Alice Lloyd College*

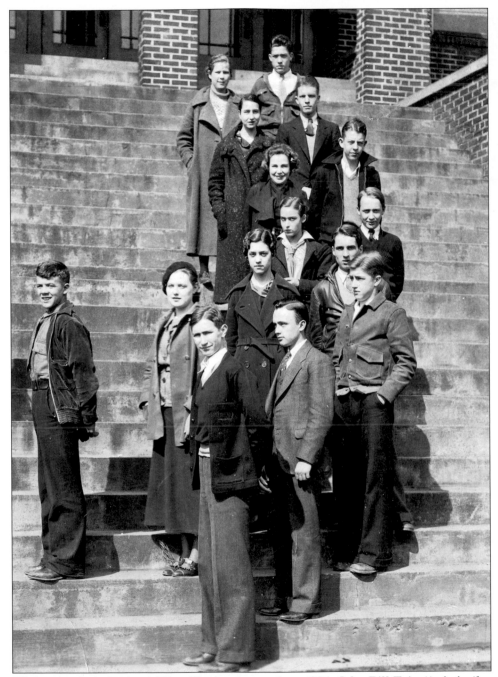

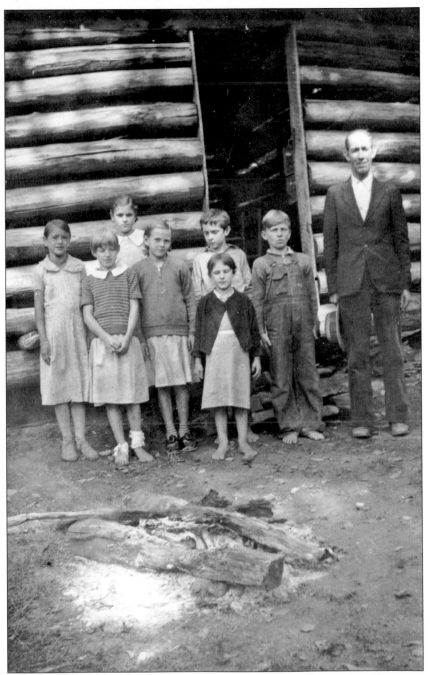

High school students at Pikeville Academy, circa 1934. John Bill Trivette is in the center front. *Courtesy of Patty T. Blair*

Leslie County school, circa 1935. They had no stove in the building so built a fire outside and sat around it in the sun. *Courtesy of Camp Nathanael*

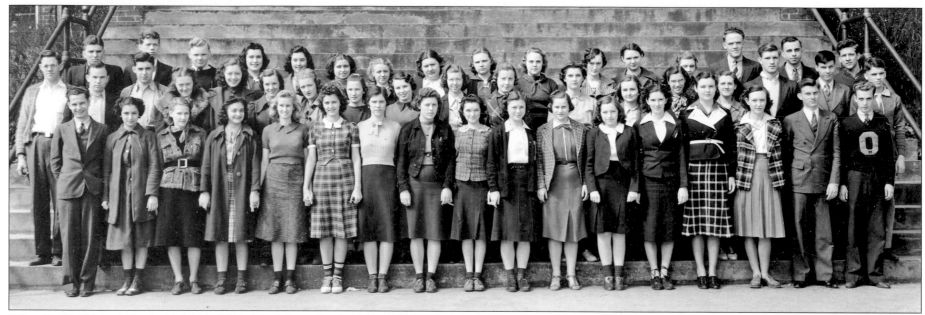

Pikeville College students in front of the Administration building, 1939. *Courtesy of Pikeville College Archives*

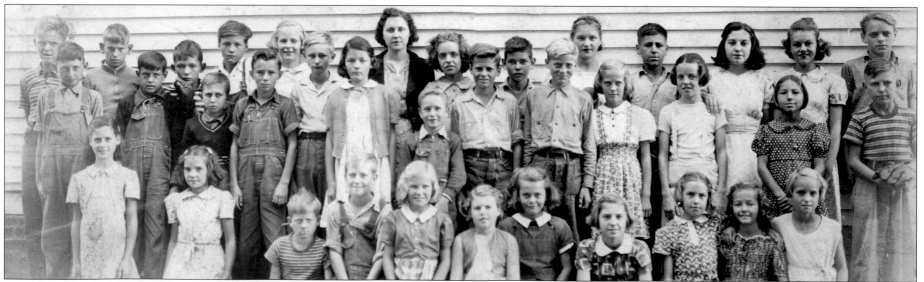

Woodland School at Gray's Branch in Greenup County, 1939. Bottom row, left to right: Evelyn Potters, Jean Brown, Don Potters, Herman Patterson, Lois Wells, June Lilghman, Kathleen Moore, Betty Pauley, Charlotte Sandy, Mary Lowe Batchelor and Marcella Newsome. Middle row: (unknown) Coffie, Clyde Coffie, Richard Earwood, Robert Long, Billy Ray Mauk, Marion Wells, Jackie Setser, Junior Potters, Cecil Potters, Peggy Wells, Mary Evelyn Hieneman, Jette Jo Mowery and Ray Russell Wells. Third row: Junior Setser, Jimmie Sandy, Bud Wells, Carl Moore, Jean Wells, teacher Mrs. Hart, Betty Brown, Otis Clay, Dana Setser, Bill Mowery, Helen Pauley, Garnet Moore and Earl McCormic. *Courtesy of Michael Wells*

SPORTS & LEISURE

I s there any better story than the one about the scrappy team from the small mountain school going up against the larger, better-equipped flatlanders?

On the following pages we have basketball, football and baseball teams, including the great Vicco roundball squad from the mid-1930s.

Also shown are Eastern Kentuckians at their leisure: Coon and squirrel hunters in Knott and Floyd counties, the former with their dogs; a Maypole being wrapped in Hindman back when May 1 was celebrated in this country; and carefree youngsters splashing in Troublesome Creek.

Modern readers will note that none of the sports is "extreme," and none of the pastimes involves an electronic device.

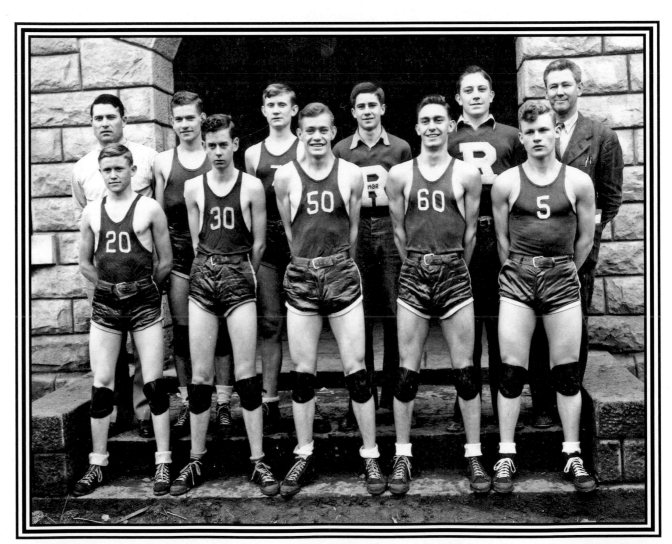

Basketball team from Robinson School, Ary. On the left in the back is Bill Reynolds; on the right is Robert Talent, principal. Front row, left to right: Fielding Richie, Homer Noble, J. M. Salyers, unidentified and Clarence Baker. *Courtesy of Photographic Archives, Appalachian Learning Laboratory, Alice Lloyd College*

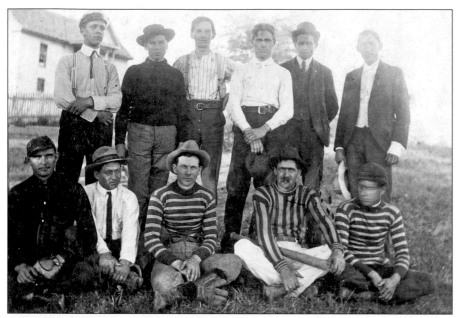

Hazel Green Academy baseball team, 1900. Charles Mann is second from the left in the back row. *Courtesy of Harold L. Mann*

Mountaineers horsing around in Elkhorn City, Pine County, circa 1910. *Courtesy of Photographic Archives, Appalachian Learning Laboratory, Alice Lloyd College*

An outing to the cliffs in the big bend above Hazard, 1913. *Courtesy of Bobby Davis Museum and Park*

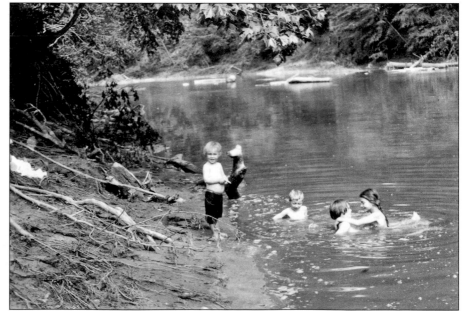

Children from Camp No. 4, Perry County, swimming in the creek, circa 1912. *Courtesy of Bobby Davis Museum and Park*

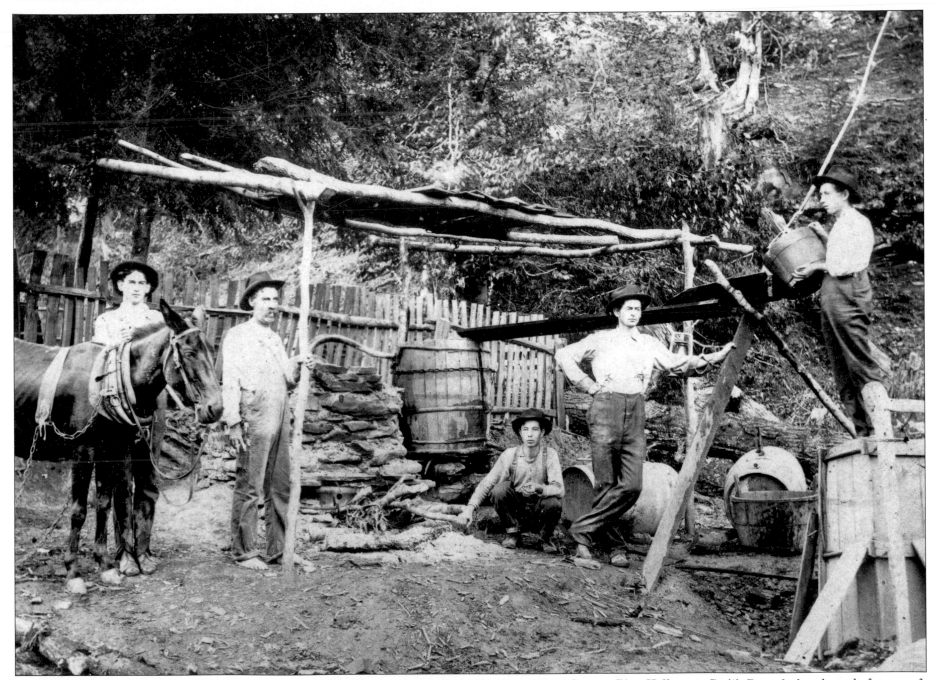

Men standing around a government still making brandy from apples, fall of 1910. The still, at Spruce Pine Hollow on Smith Branch, has boards for a roof.
Courtesy of Photographic Archives, Appalachian Learning Laboratory, Alice Lloyd College

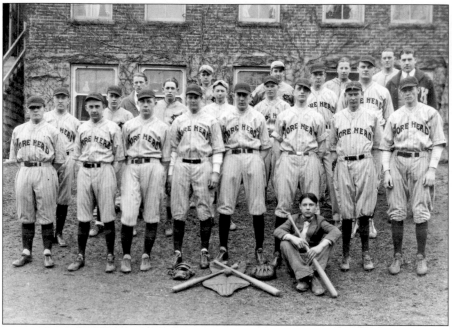

Morehead baseball team, circa 1915. *Courtesy of Rowan County Public Library*

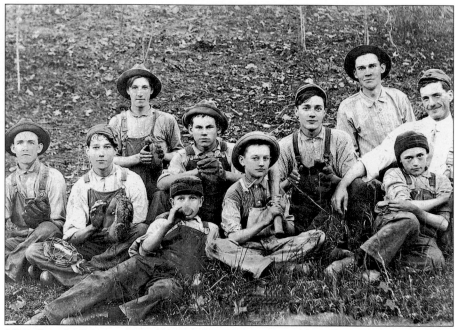

Mize baseball team, Morgan County, 1914. *Courtesy of Sylvia L. Lovely*

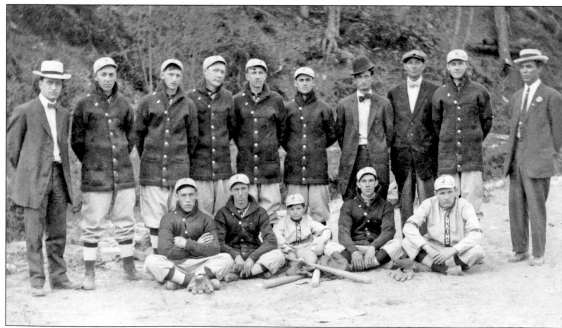

Jenkins baseball team, circa 1915. *Courtesy of David Ravencraft*

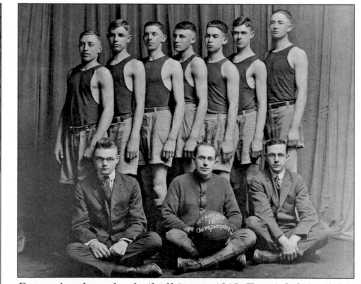

Berea Academy basketball team, 1918. Front, left to right: manager Horace J. Godbey, assistant coach Miller and coach Shutt. Standing: Bane, Baleo, Davis, Lewis, captain Kennedy, Williams and Bilberg. *Courtesy of Frank Godbey*

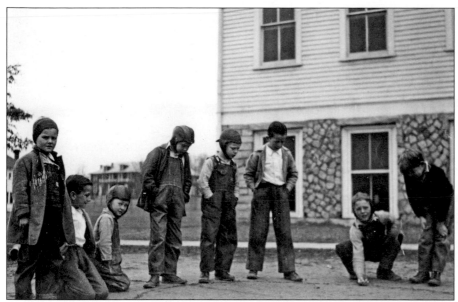

Boys shooting marbles at the Annville Institute, a Dutch Reformed school, in Jackson County. *Courtesy of Annville Institute Collection, Southern Appalachian Archives, Berea College*

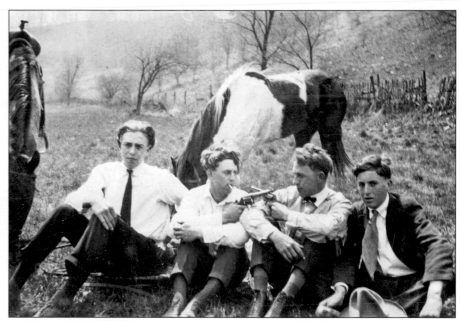

Young men from Denwood, Floyd County, circa 1920. In the middle with the guns are brothers Charles Ed and Sam Stumbo. *Courtesy of Sharon Stumbo*

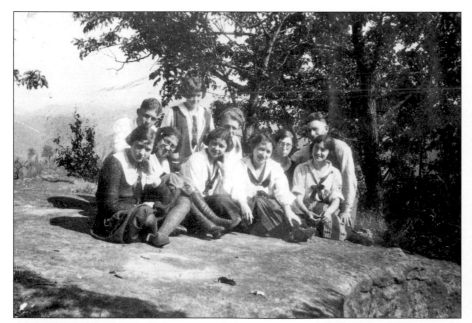

Group from Caney Creek Community Center on an outing, circa 1928. *Courtesy of Sarah C. Pulliam*

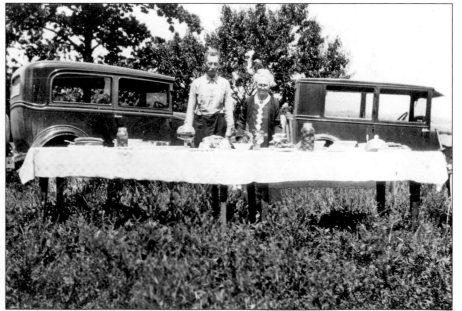

Alvin and Louvisa Risner Mann preparing for a family picnic at Prather Ridge at Dan, 1924. *Courtesy of Harold L. Mann*

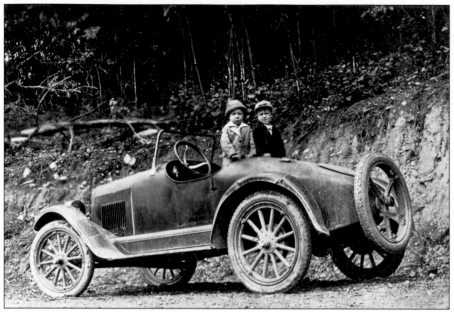

Jack W. Blair with John Edwin "Jack" Passmore in one of his father, Charles G. Passmore's, race cars in Whitesburg, 1926. *Courtesy of Norma Thompson*

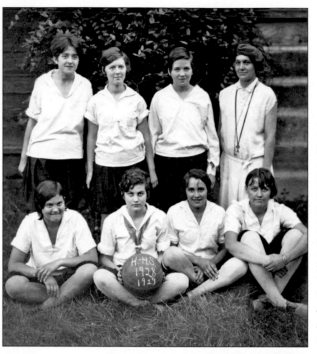

Hindman High School girls' basketball team, 1928–29. Front row, left to right: Gertrude Smith, Emma Dukes, unidentified and Ora Lee Mosley. Back row: Monnie Hicks, Bessie Sturdivant and Hessie Hicks. *Courtesy of Photographic Archives, Appalachian Learning Laboratory, Alice Lloyd College*

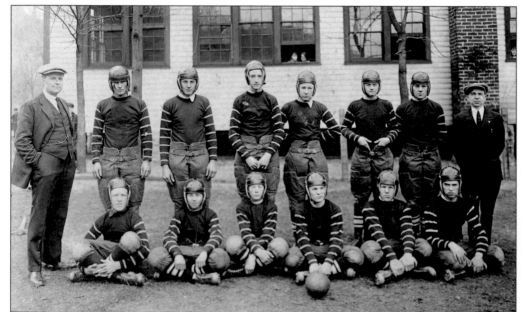

Belfry High School football team, 1928. The player behind the football is Ermal Lewis Runyon. *Courtesy of Stone Heritage, Inc.*

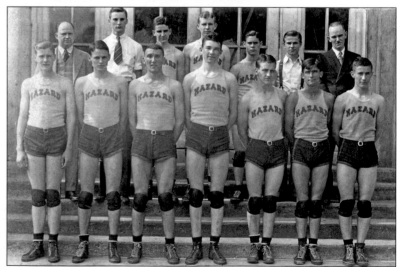

Hazard High School basketball team, circa 1930. Front row, third from the left is Ed "Pappy" Edwards, fourth is Sanders Petrey and fifth is "Hoot" Combs. Back row, left to right: coach J. Foley Snyder, Joe Craft, Lewis Warren, unidentified, Earl Steele, Eugene Brashear and Pat Payne. *Courtesy of Bobby Davis Museum and Park*

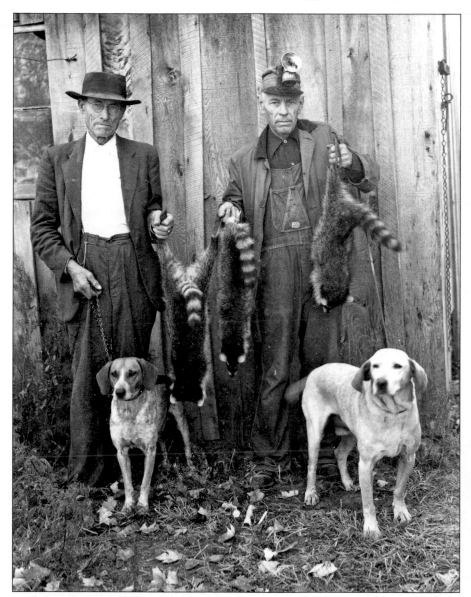

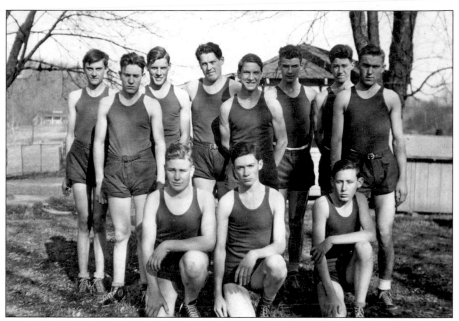

Basketball team at Hazel Green Academy, circa 1930. *Courtesy of Hazel Green Academy Collection, Southern Appalachian Archives, Berea College*

Andrew Jackson "A. J." Dobson and William "Banjo Bill" Cornett with their hunting dogs, Wheeler and Bob, Knott County, circa 1930. *Courtesy of Photographic Archives, Appalachian Learning Laboratory, Alice Lloyd College*

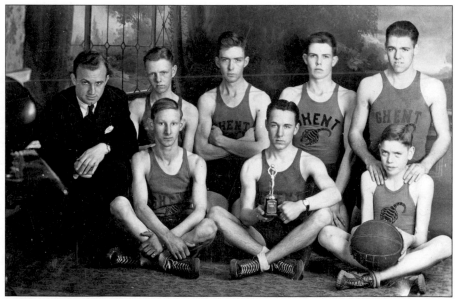

Ghent High School basketball team, Class B champions, 1932–33. J. O. Cannon Jr. is holding the trophy. His brother, William Cornett Cannon, is on the right in the back row. *Courtesy of Bill Martin*

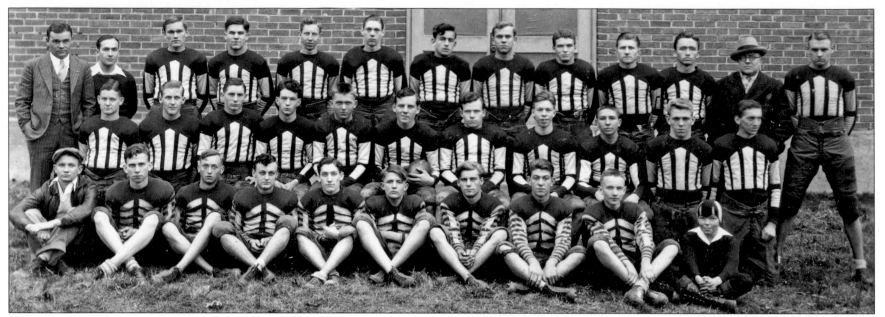

Corbin High School football team, circa 1930. On the far left is coach Nick Denes, and the tallest player, near the middle, is Malcolm Shotwell. Coach Denes led the 1935–36 Corbin Redhounds football and basketball teams to state championships. *Courtesy of John Shotwell*

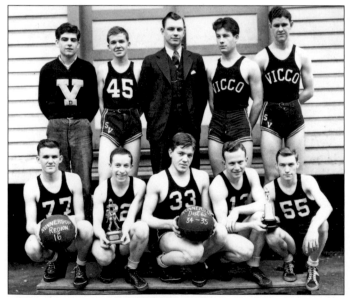

Vicco basketball team, runners-up in Region 16, District 62, 1934–35. *Courtesy of Photographic Archives, Appalachian Learning Laboratory, Alice Lloyd College*

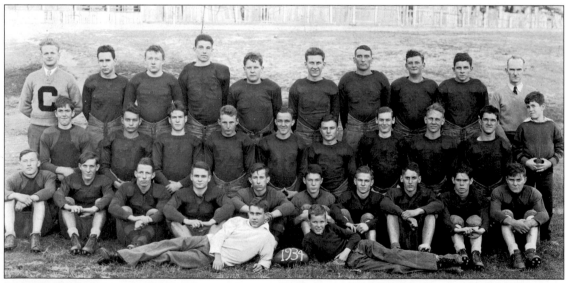

Hazard High School football team on the grounds of the Hazard Baptist Institute, 1934. The coach, Pat Payne, is on the right end of the third row. In the first row, second from the left is Robert Cornett and ninth is Earl Steele. Ed Edwards is seventh from the left in the third row. *Courtesy of Bobby Davis Museum and Park*

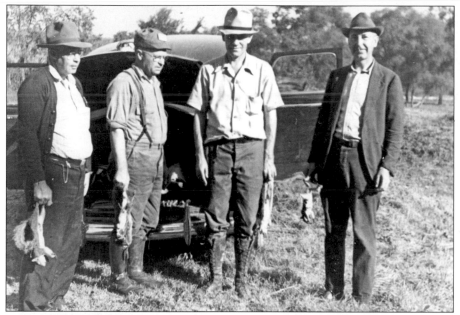

Squirrel hunting in Floyd County, circa 1934. Fourth from the left is Dr. John F. Hall. *Courtesy of Johnny and Patti Hall*

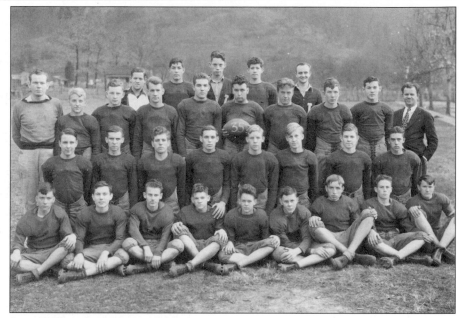

Loyall High School football team in Harlan County, 1935. *Courtesy of Reba Lacey Whalen*

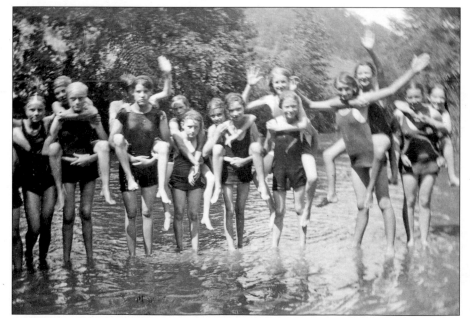

Campers at Camp Nathanael in Troublesome Creek, 1934. *Courtesy of Camp Nathanael*

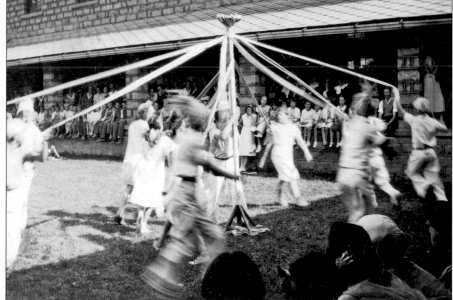

Maypole at Hindman, circa 1935. *Courtesy of Special Collections & Archives, Camden-Carroll Library, Morehead State University*

RELIGION

Eastern Kentucky has known good times and hard times, but underlying both have been the deep religious beliefs of its people.

Church was a center of the community and church activities the center of daily life. And even the poorest mountaineer managed to keep a set of clean, Sunday-go-to-meeting clothes and wore them regularly.

Shown in this section is a traveling preacher on horseback, a Sunday school class in Mount Vernon and the ladies of a church at a luncheon in Harlan.

Especially interesting are the images of good, old-fashioned river baptisms. If you've never seen one in person, know this: The morning sun probably was glinting off the surface of the water as the sinner was immersed. And afterward, there often was a wide smile on the face of the sputtering newly-saved Christian.

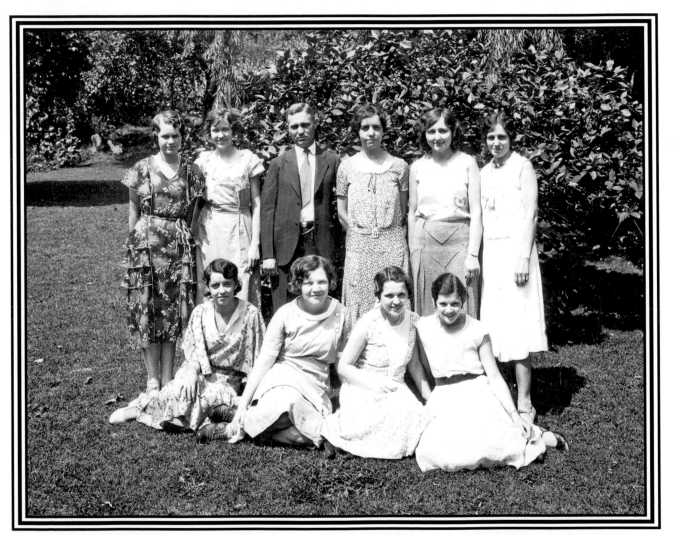

Group from First Christian Church, Corbin, circa 1931. Front row, left to right: Hazel Olinger, Virginia Goodwin, Gerry Givens and Margie Smith. Back row: Naomi Roaden, Juanita Masters, Bro. and Mrs. Wolfe, Ada Gray Gilliam and unidentified. *Courtesy of Peggy Jo Williams*

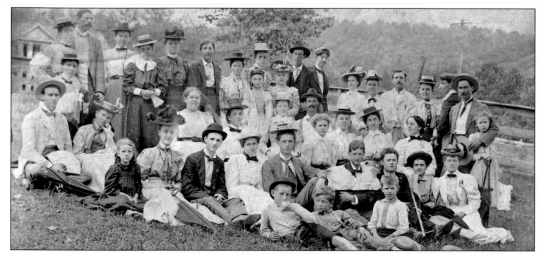

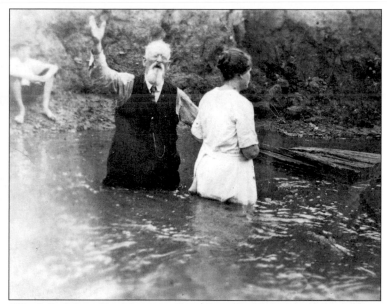

Sunday school class of First Christian Church, Mt. Vernon, Aug. 4, 1898. Rev. Boswell was the minister at that time. The group is gathered on the front lawn of the "Mammy" Fish home. Included are Alza Logan Davis and Edgar Albright (who are in the center of the front and have traded hats), Lena Newcomb (with the white collar and fan), William J. Newcomb, Cleo Williams Brown, Lizza Adams, Lura Heathon (on the front right with the fancy hat), Margaret Fish and Rissie Williams. *Courtesy of Ann L. Henderson*

"Uncle" John Hopkins, a Regular Baptist, baptizing Mina Frazier Hall in Beaver Creek, Floyd County, circa 1910. *Courtesy of Barry Dean Martin*

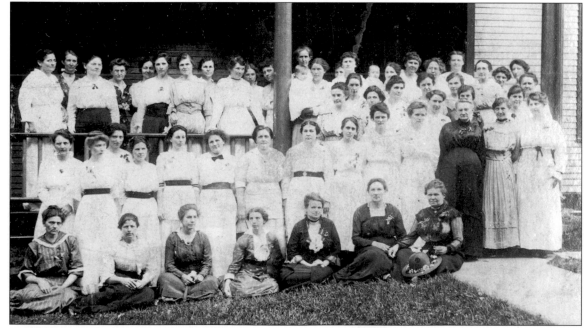

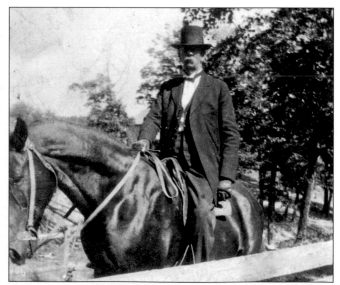

Ladies luncheon, Harlan, circa 1910. *Courtesy of Mary Blanton Cotton*

John Westley Masters in Corbin, 1900. He was a pioneer preacher who established 19 churches in southeastern Kentucky, including the two churches in Corbin. *Courtesy of Peggy Jo Williams*

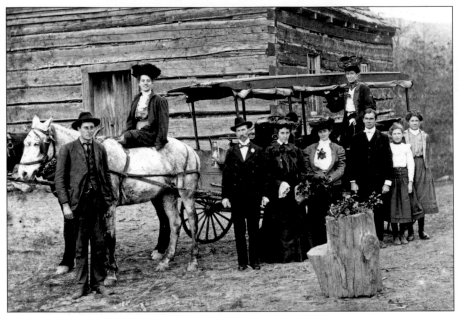

Group leaving church in Johnson County, circa 1910. *Courtesy of Photographic Archives, Appalachian Learning Laboratory, Alice Lloyd College*

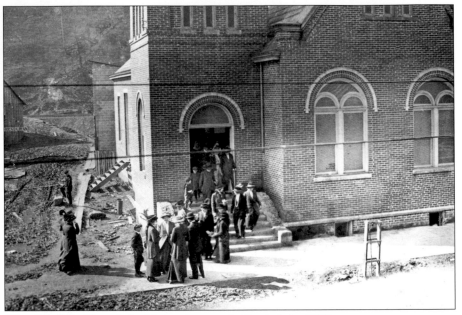

The Baptist Church in Hazard was dedicated in 1912. *Courtesy of Bobby Davis Museum and Park*

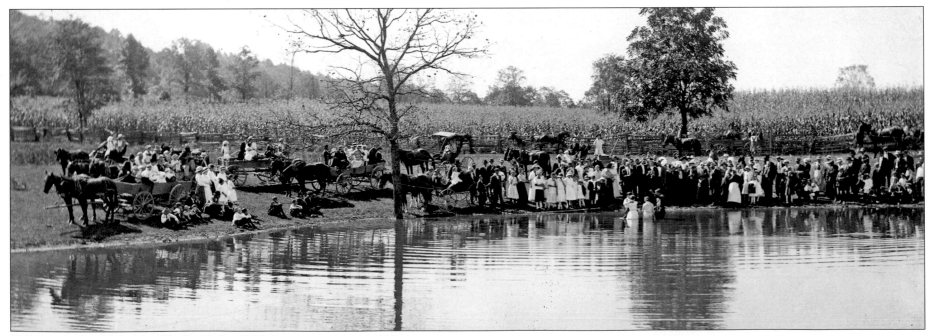

Baptism in the W. L. Linville Pond, Scaffold Cane, summer of 1916. *Courtesy of Appalachian Photoarchives, Southern Appalachian Archives, Berea College*

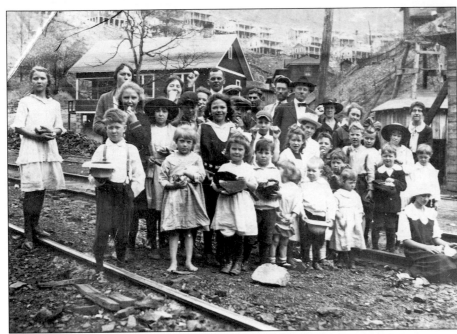

Sunday school at Heiner, Perry County, circa 1920. *Courtesy of Karen Fritts Bates*

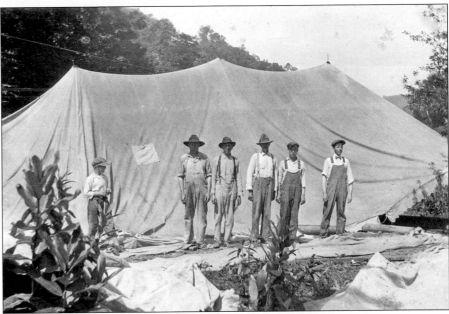

Residents erecting a tent for a revival led by Mother Burke from Asbury College in Fleming, Letcher County, 1922. *Courtesy of Karen Fritts Bates*

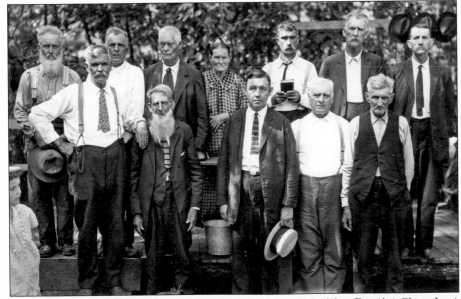

Preachers and lay members of the Old Regular Primitive Baptist Church at a Sandlick Association meeting near Holly Cemetery in Perry County, circa 1925. *Courtesy of Photographic Archives, Appalachian Learning Laboratory, Alice Lloyd College*

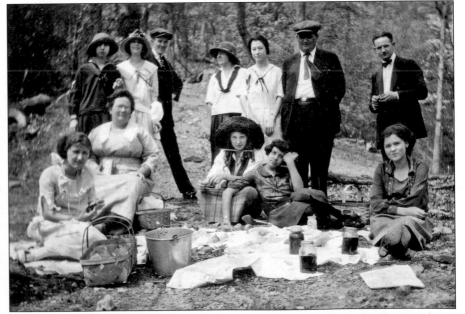

Mrs. Walters, seated second from the left, with her Sunday school group from Combs Methodist Church on a picnic, 1923. *Courtesy of Karen Fritts Bates*

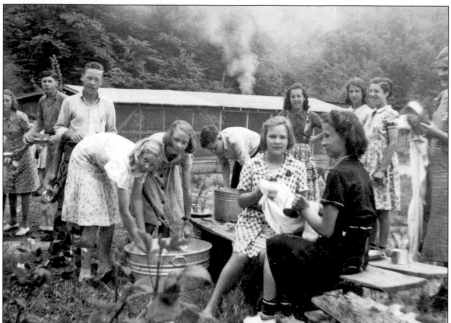

Dishwashing crew at Camp Nathanael, 1934. *Courtesy of Camp Nathanael*

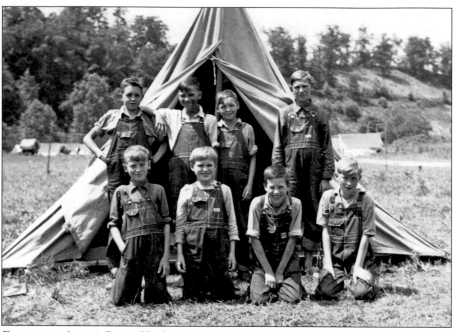

Boys camping at Camp Nathanael, 1934. *Courtesy of Camp Nathanael*

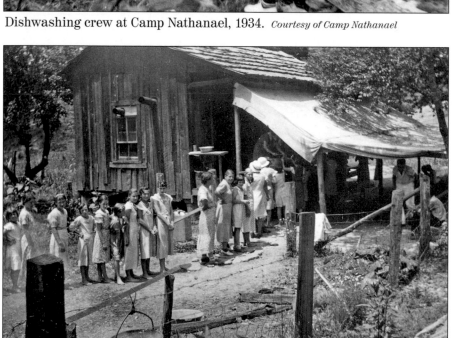

Camp Nathanael campers line up for a meal at Mary Mosley's summer kitchen, 1934. *Courtesy of Camp Nathanael*

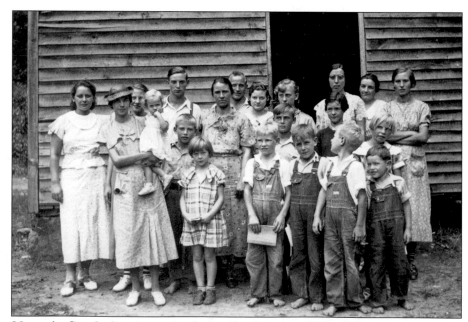

Muncy's Creek Sunday school, Leslie County, circa 1935. *Courtesy of Camp Nathanael*

COMMUNITY & FAMILY

The hills of Eastern Kentucky once were much more populated than they are today. People not only knew their neighbors, they also often were related to them. A hollow could be filled with siblings, grandparents, aunts, uncles and cousins.

Families were large, but family reunions swelled them, sometimes to the size of small villages.

Related or not, people in Eastern Kentucky looked after one another. If children did something they should not do, there were plenty of surrogate parents around to set them straight.

In this section, you will also find images of everyday life in those close-knit communities: women at the spinning wheel, children hauling precious water, young girls with their dolls, boys on a first trip to town.

Also shown here are special days, the floods, the Fourth of July celebration. And look at the photo of the Hazard Coal Carnival, with its banner carriers and bands marching past the drug store, the department store and the lunch counter.

It is quintessential Eastern Kentucky, quintessential America.

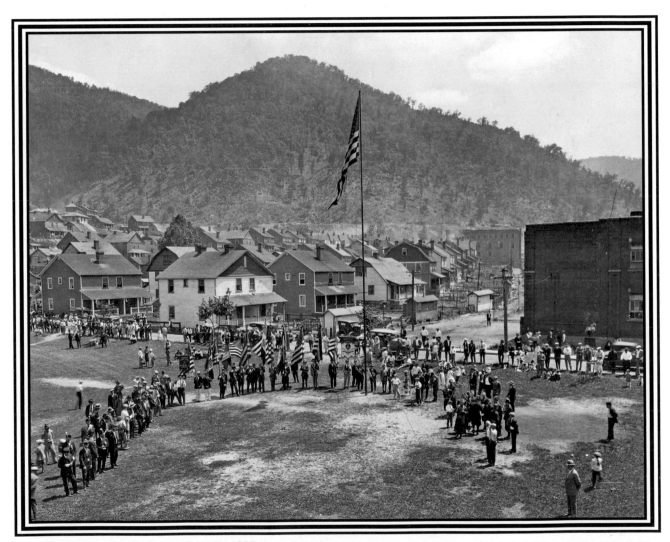

Fourth of July celebration in Lynch, 1927. *Courtesy of Southeast Kentucky Community and Technical College, Godbey Appalachian Archives*

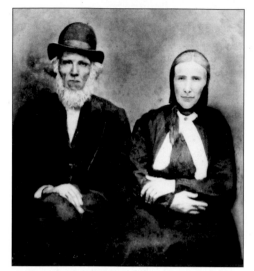

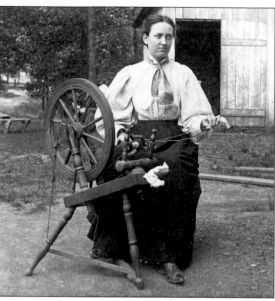

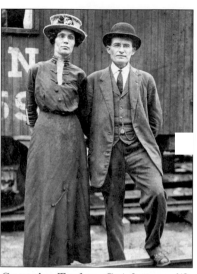

George Washington King and his wife, Tabitha Burchett King, circa 1875. They lived in Jackson County and were the parents of thirteen children. *Courtesy of Linda Ramsey Ashley*

Green Stacey on the farm at Whites Branch, 1875. *Courtesy of Harold L. Mann*

Mattie Ambrose with her spinning wheel, June 1898. *Courtesy of Appalachian Photoarchives, Southern Appalachian Archives, Berea College*

Georgia Turley Cutshaw with Charles Edward Cutshaw in Fleming, circa 1900. Charles was a construction engineer with the railroad. *Courtesy of Ann Ross*

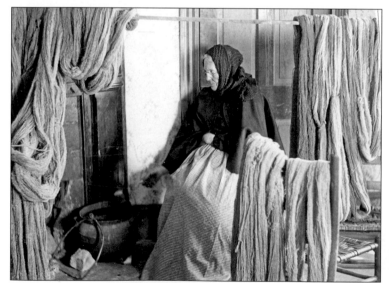

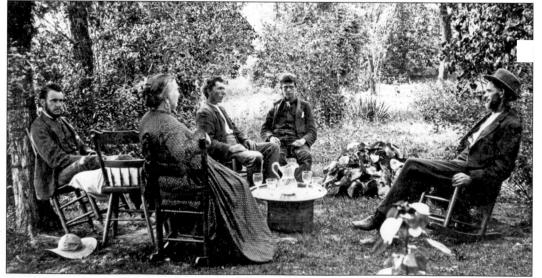

Polly "Aunt Pop" Coyle with her yarn and dye pot, Walnut Meadow Pike at Berea. The dyes she used were made from walnut hulls, hickory bark, alder tips and so on. *Courtesy of Appalachian Photoarchives, Southern Appalachian Archives, Berea College*

Group gathered under the shade of trees for refreshments at Oliver Ely's home near Flat Lick, Knox County, 1884. Seated are R.C. Ballard Thurston, Mrs. Ely, Jas. Renfro, T. H. Morgan and Oliver P. Ely. *Courtesy of Photographic Archives, Appalachian Learning Laboratory, Alice Lloyd College*

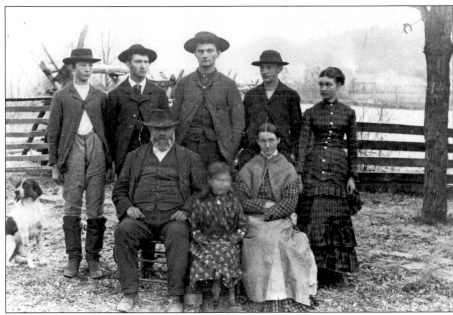

Jonathon K. Bailey and his family, Mt. Pleasant, Harlan County, 1884. *Courtesy of Photographic Archives, Appalachian Learning Laboratory, Alice Lloyd College*

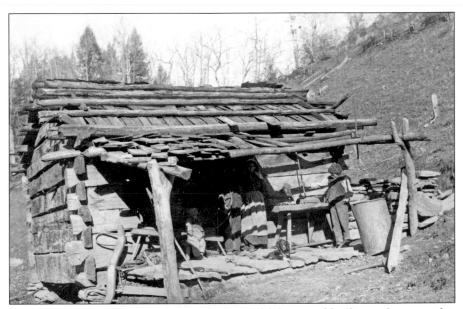

Log cabin at Poor Fork in Harlan County, which served both as a home and a hand mill to the family standing on its porch, circa 1890. *Courtesy of Photographic Archives, Appalachian Learning Laboratory, Alice Lloyd College*

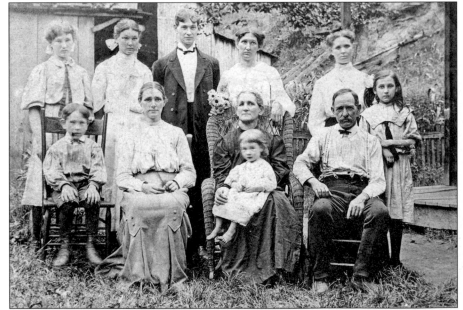

Pearl Risner and family, Frozen Creek, Breathitt County, 1890. *Courtesy of Harold L. Mann*

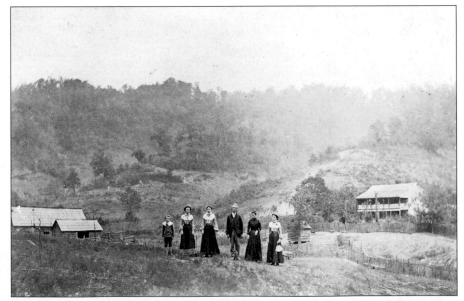

The Ratliff family in Langley near Maytown, 1895. Jefferson and Emmaline May with their daughters, Dorcus, Louise and Mag, and an unidentified child. *Courtesy of Sarah C. Pulliam*

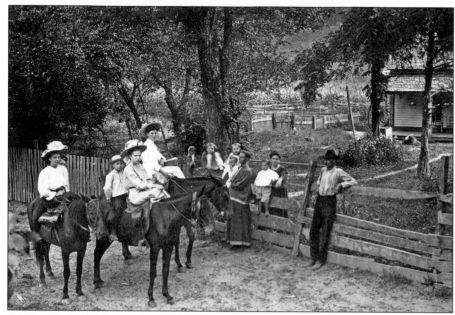

Students starting off for Berea School from a Rockcastle County home, circa 1900. *Courtesy of Appalachian Photoarchives, Southern Appalachian Archives, Berea College*

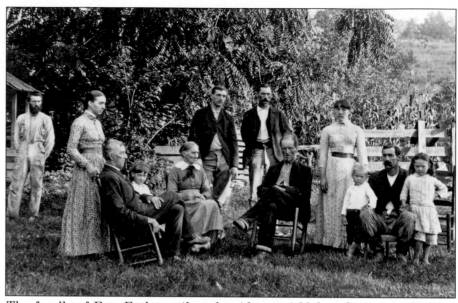

The family of Esq. Farley gathered outdoors at Mahan Station in Whitley County, circa 1900. *Courtesy of Photographic Archives, Appalachian Learning Laboratory, Alice Lloyd College*

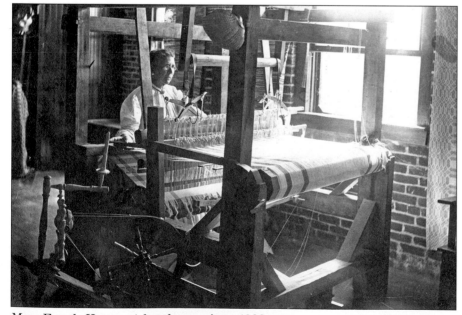

Mrs. Frank Hayes at her loom, circa 1900. *Courtesy of Appalachian Photoarchives, Southern Appalachian Archives, Berea College*

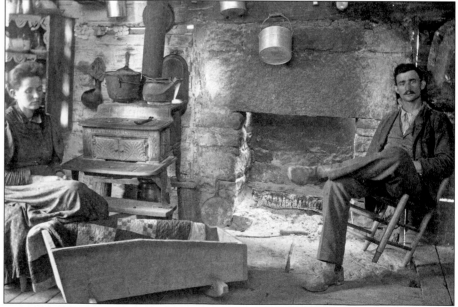

Interior of a "$20 home" on Cow Creek in Estill County, circa 1900. *Courtesy of Appalachian Photoarchives, Southern Appalachian Archives, Berea College*

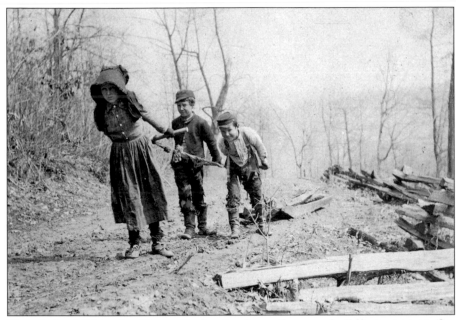

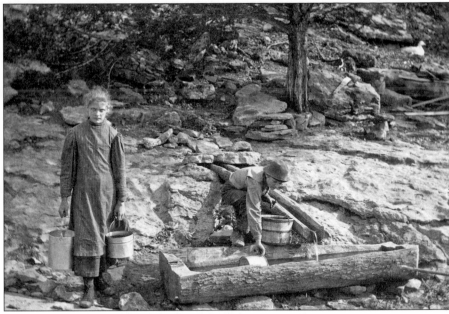

Mountain children hauling rails for the fence they are building, seen on the right. *Courtesy of Appalachian Photoarchives, Southern Appalachian Archives, Berea College*

Children hauling water to their home in Estill County. *Courtesy of Appalachian Photoarchives, Southern Appalachian Archives, Berea College*

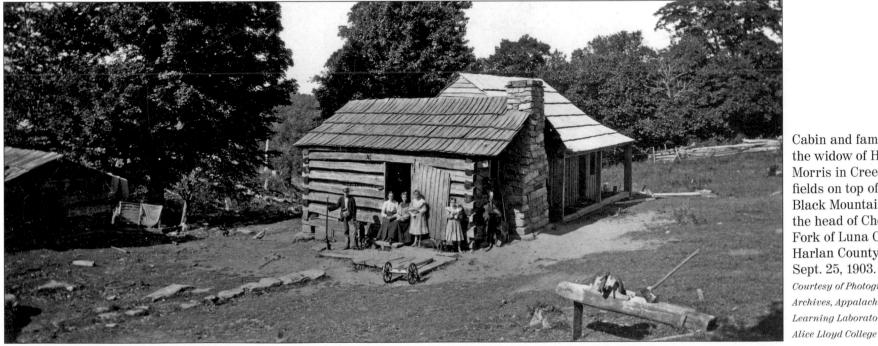

Cabin and family of the widow of Henry Morris in Creech fields on top of Big Black Mountain at the head of Cherry Fork of Luna Creek, Harlan County, Sept. 25, 1903. *Courtesy of Photographic Archives, Appalachian Learning Laboratory, Alice Lloyd College*

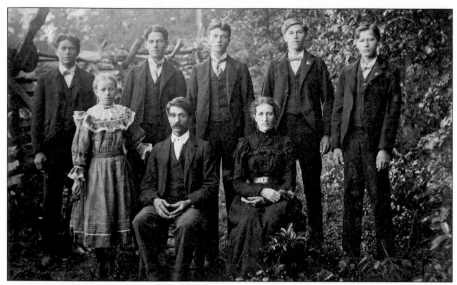

Moore family at Sturgeon Creek, Jackson County, circa 1900. Front row, left to right: Lucy, Andrew Jackson and Sarah Goodman. Back row: Alfred, Bob, Will, John and George. Andrew Jackson Moore was a descendant of James Moore, the first settler in Owsley County in 1796. *Courtesy of Mac C. Moore*

Cannon family at their home in Nicholas County near Carlisle, circa 1910. From left to right: Anna Cannon, J. O. Cannon Sr., William Harvey Cannon, Rita Ellen Stamper Cannon and Amy Cannon. *Courtesy of Bill Martin*

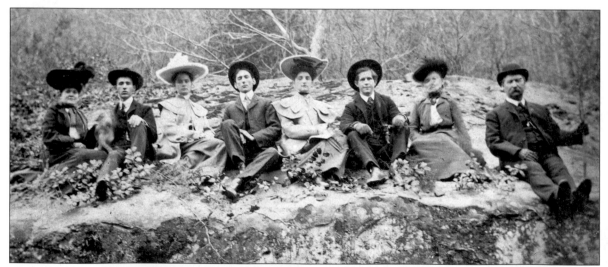

The Ashley family at Torrent, Powell County, circa 1904, where they had come to work in timber. Left to right: Ethel Sparks Ashley and husband Carl T. Ashley, Treva Jones Ashley and husband Casper Earl Ashley, Pearl Ashley Moore and husband Alvin Moore and parents Ella Belford Ashley and Charles Thomas Ashley. *Courtesy of Carl Thomas Ashley*

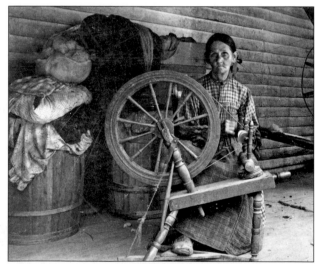

Mrs. Jason Jackson spinning flax on her porch one and one-half miles above Poor Fork, Harlan County, Sept. 15, 1903. *Courtesy of Photographic Archives, Appalachian Learning Laboratory, Alice Lloyd College*

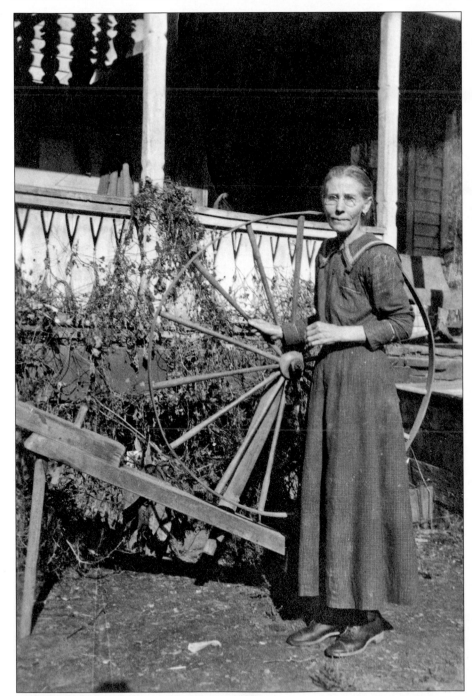

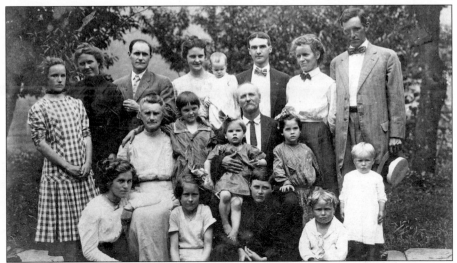

The F. G. Lewis family on their farm in Harlan, 1910. Front row, left to right: Grace Lewis, Helen Lewis, Fred Lewis, unidentified and Goldwin Lewis. Second row: Mary Blanton Lewis, Ella Lewis, F. G. Lewis holding Nell Farmer and Edith Farmer. Back row: unidentified, Olive and Will Lewis, Nora Lewis Farmer holding D. Ernest Farmer, John White Farmer, Cora Rice Lewis and John Blanton Lewis. *Courtesy of Mary Blanton Cotton*

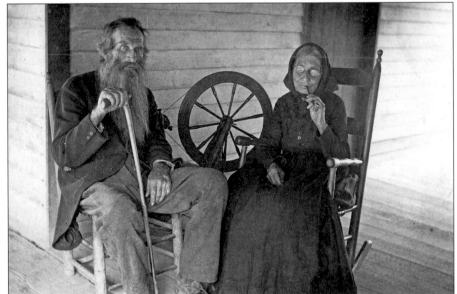

Jackson County couple on their porch, circa 1910. *Courtesy of Southern Appalachian Archives, Special Collections & Archives, Berea College*

Mag Ratliff Hopkins from the Prestonburg area. *Courtesy of Sarah C. Pulliam*

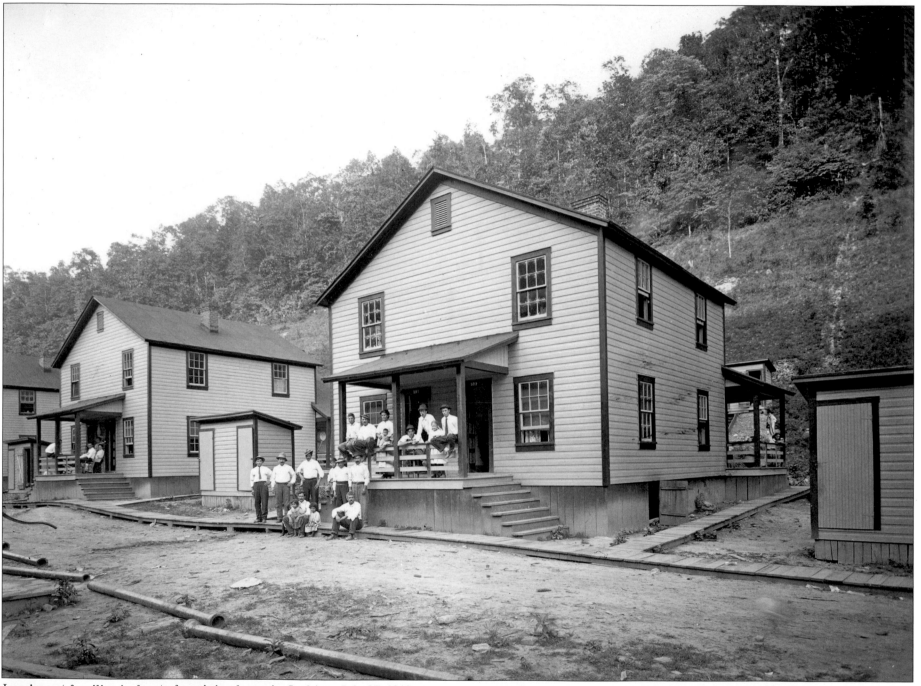

Immigrant families in front of a mining home in Jenkins, July 27, 1912. *Courtesy of Photographic Archives, Appalachian Learning Laboratory, Alice Lloyd College*

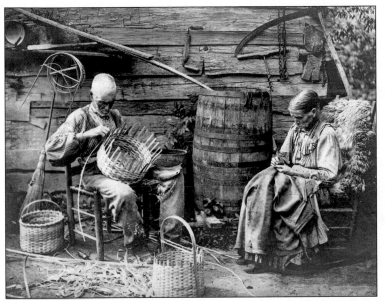

Jim and Kristine Buller Edmonds Henry making baskets at their home in Rockcastle County. *Courtesy of Appalachian Photoarchives, Southern Appalachian Archives, Berea College*

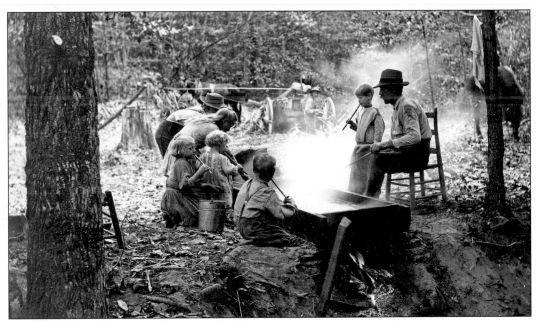

Tasting the sorghum during molasses making, circa 1910. *Courtesy of Appalachian Photoarchives, Southern Appalachian Archives, Berea College*

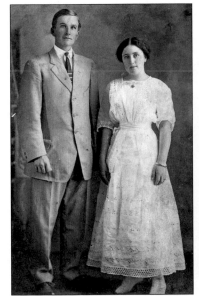

Kash and Lena Brandenburg on their wedding day, Booneville, circa 1911. *Courtesy of Bill Martin*

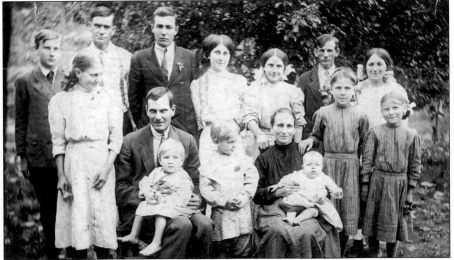

The Ball family of Ell's Branch, Clay County, 1912. In front: Bettie Ball, George Washington Ball holding Willie Murray Ball, Allen Ball, Rose Ann Allen Ball holding Tabitha Ball, Ollie Dora Ball and Esther Ball. Back row: Jennings Bryan Ball, Willie Murray, Chester Clark, Fannie Ball Clark, Louise Ball, Tommy Miller and Cora Ball. *Courtesy of Marjorie Allen Ball Barnett*

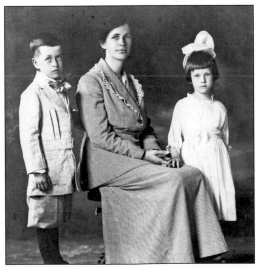

The family of Dr. Reed Spencer Johnson, 1918, Betty Mitchell Johnson with Kermit and Helen. They lived in Praise, which later became Elkhorn, before moving to Pikeville. *Courtesy of Ann E. Carty*

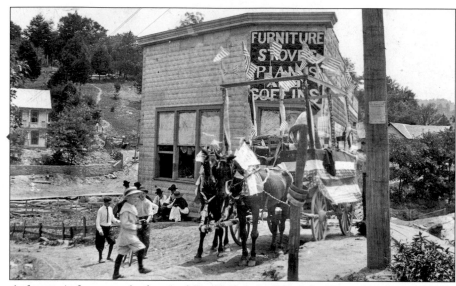

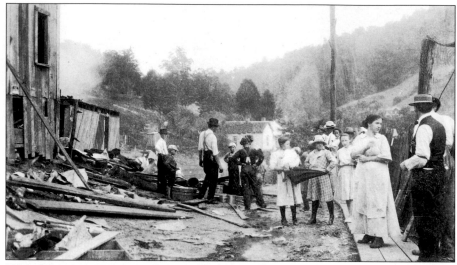

A decorated wagon in front of Dr. Kelly's building in Hazard welcomed the Louisville Boosters who arrived by train on May 22, 1913. The boosters stayed in town for an hour to make speeches, then boarded the train to go to the next stop. *Courtesy of Bobby Davis Museum and Park*

High Street in Hazard after the fire of April 2, 1915. The fire started on the second floor of Malen Standifer's home. The fire hose was brought out, but the pump to the water tower was in disrepair. A bucket brigade tried to fight the fire to keep it from spreading. Six houses were burned before the fire was extinguished forty minutes after it began. *Courtesy of Bobby Davis Museum and Park*

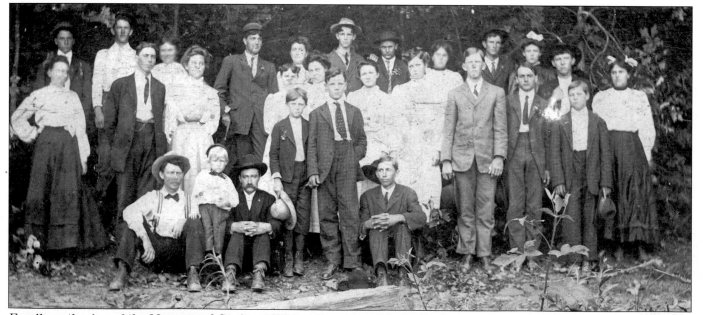

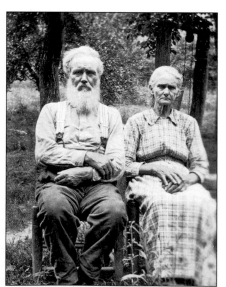

Family gathering of the Manns and Crafts at Whites Branch at Dan, 1915. In the second row, Charles Mann is second from the left; Lela Mann is third. *Courtesy of Harold L. Mann*

Shade Smith and Polly Ann Cornett Smith, great-granddaughter of Kentucky pioneer William Cornett. *Courtesy of David Ravencraft*

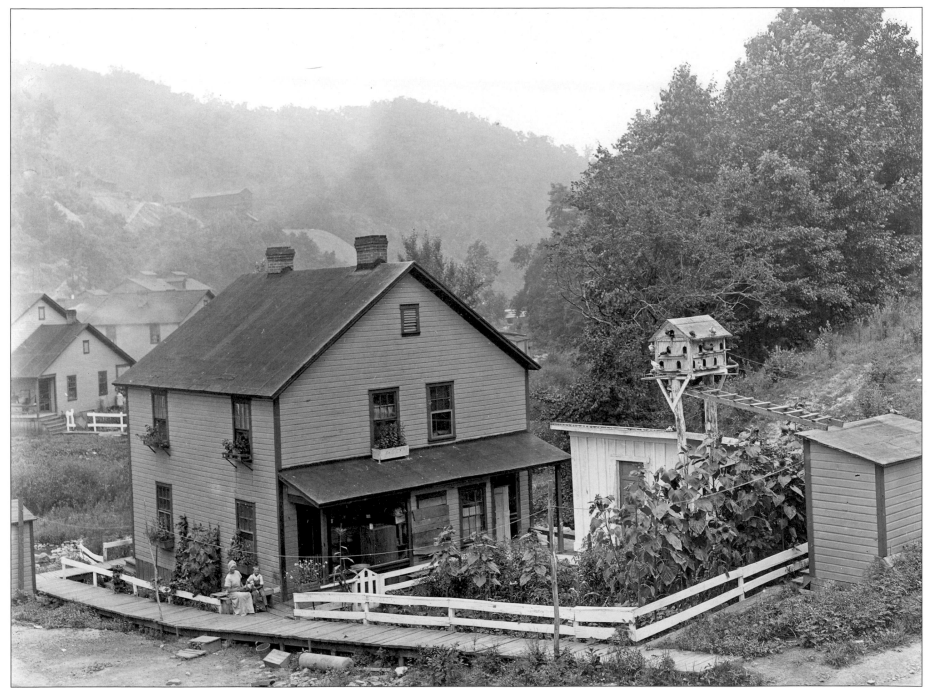

Residence in Burdine, 1916. *Courtesy of Photographic Archives, Appalachian Learning Laboratory, Alice Lloyd College*

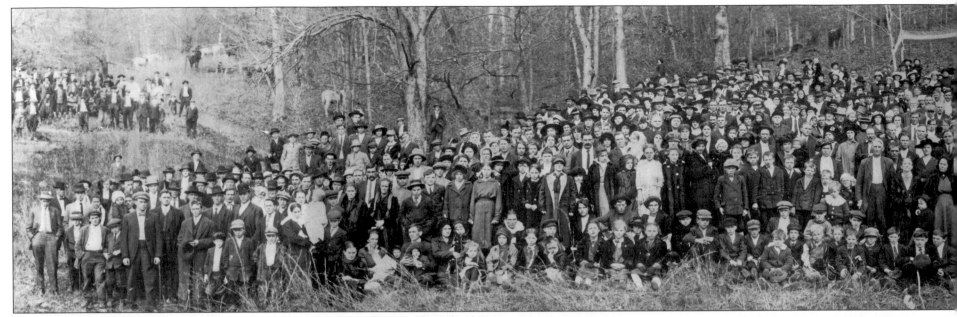

Wells family reunion on Route 3 near Paintsville in Johnson County, Nov. 13, 1915. *Courtesy of Michael Wells*

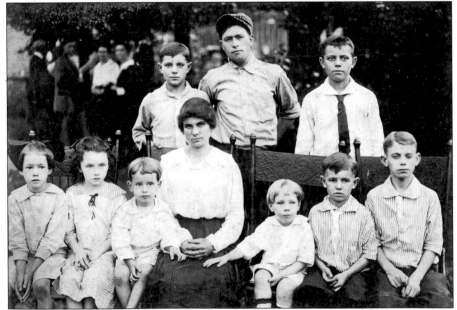

Shotwell family at Corbin, circa 1915. Seated, left to right: Viola Shotwell, unidentified, Bruce Cannon, Meady Walker Shotwell, Malcolm Shotwell, unidentified and Elmer Taylor. Back row is unidentified. *Courtesy of John Shotwell*

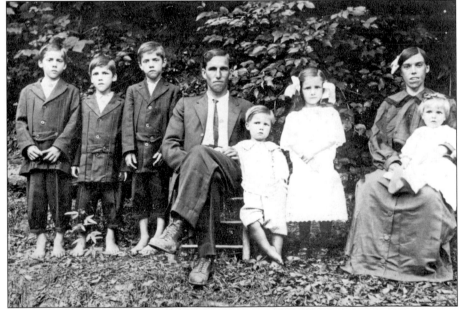

Meade family in Mine Fork, circa 1917. From left to right: Rollie Martin, Albert Jackson, Tollie Clay, Wannie Clayton, Lloyd, Chole Mae and Mary Alice Wheeler Meade holding Nola Angeline. *Courtesy of Sallie Meade Kellems*

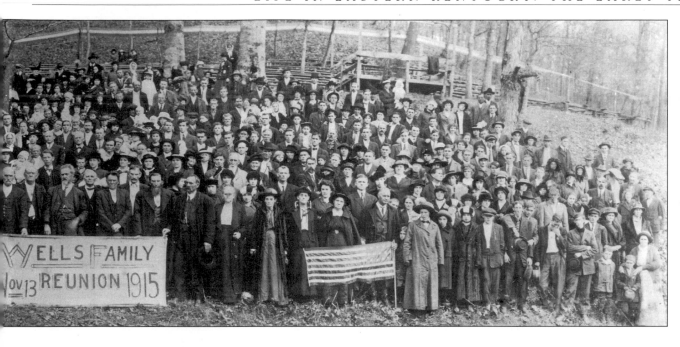

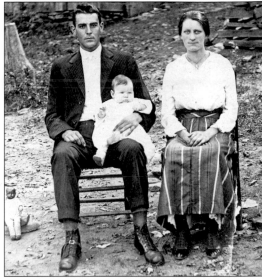

Milford J. and Birdie Hall with their daughter, Alta, at Denwood in Floyd County, 1917. *Courtesy of Opal Hall Waddell*

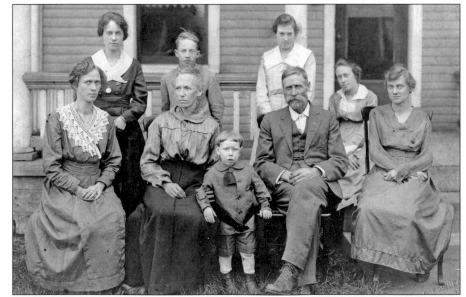

McClave family at their home in Edgington in Greenup County, circa 1918. Front row, left to right: Sarah, Mary Louella, William M. Covert, Claudius and Ruby May. Back row: Clotine, Arthur Bayless, Hattie and Alice. *Courtesy of Michael Wells*

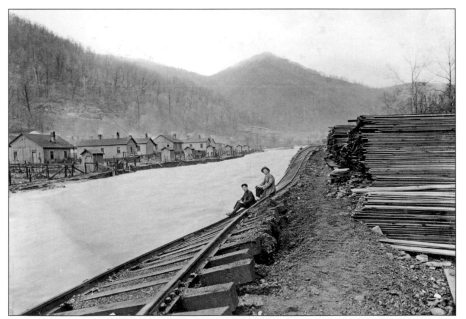

View up Looney Creek at Benham with the coke ovens and the Louisville & Nashville Railroad tracks during a flood, Jan. 28, 1918. *Courtesy of Southeast Kentucky Community and Technical College, Godbey Appalachian Archives*

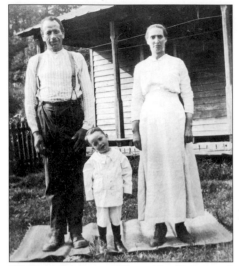

Walter Skaggs with wife Judy and youngest son Volney at Elk Fork in Morgan County, 1919. They had four other children: Sarah, William, Ira and Sena. *Courtesy of Mabel Forman*

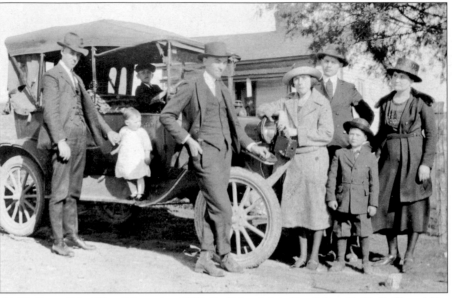

At McDowell in Floyd County, 1923. Left to right: Dr. John. F. Hall, Franklin Hall, John Lovell Hall in the car, unidentified, unidentified, unidentified, Glennon Hall and Mrs. John F. Hall. *Courtesy of Johnny and Patti Hall*

Dessie and Mae Planck with a quilt pieced by Dessie and grandmother Angeline Planck in Harris, 1920. *Courtesy of Mary Hamilton Adams*

Camp house in Haymond, Letcher County, 1922. *Courtesy of Karen Fritts Bates*

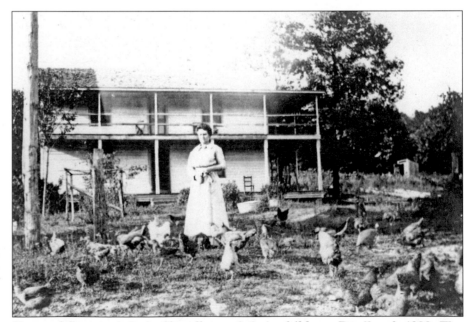

Home of Sam and Josie Chandler and their children, Brodhead, 1923. The home was built in 1912. *Courtesy of Rex Layne*

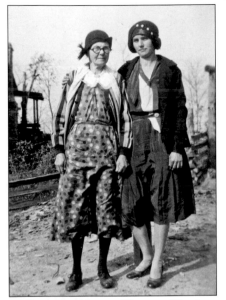

Neller Davidson King with her daughter, Nannie King Davis, circa 1920. *Courtesy of Roni Martin Scott*

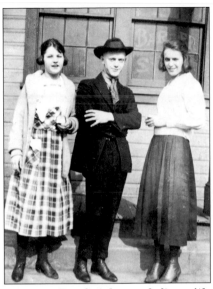

Blanch E. Cutshaw, left, with Dewey Elliott and Bertie Cutshaw at the company store in Fleming, 1921. *Courtesy of Ann Ross*

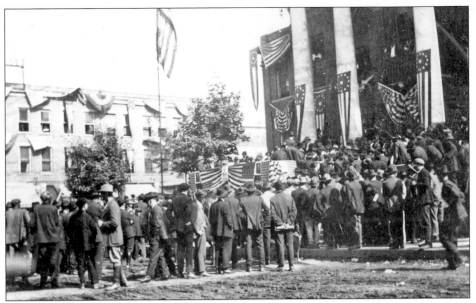

Teddy Roosevelt Jr. speaks in front of the Perry County Courthouse on behalf of presidential candidate Warren G. Harding on Oct. 5, 1920. *Courtesy of David Ravencraft*

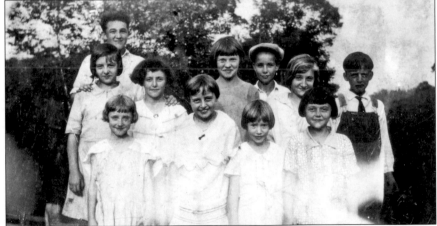

Grandchildren of Joab Hignite Begley and Mariah Jane Bailey Begley on the Begley farm in Jackson County near McKee, 1926. Front row, left to right: Marie Begley, Gladys Lainhart, Freda Begley and Dorothy Begley. Second row: Elsie Lainhart, Eva Begley, Ruth Begley, Earl Farmer, Ella Lainhart and Tad Lainhart. Elmer Begley is in the back row. Their parents are Govan and Stella Farmer Begley, John B. and Stella Jones Begley and Martha Begley Lainhart. *Courtesy of Freda Platt Walters*

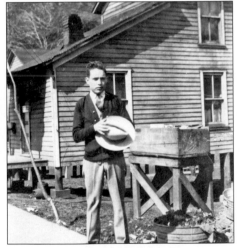

In front of a "shotgun house" common to the coal camps in the area, circa 1925. It was said you could shoot a gun from the front door to the back door and not hit anything in the house. *Courtesy of Barry Dean Martin*

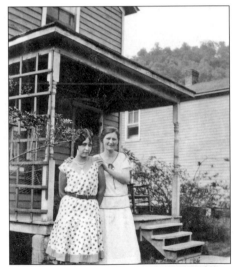

Magnolia Sizemore, left, and Birdie Hall in front of a home in Weeksbury Coal Camp, Left Beaver Creek, Floyd County, circa 1925. *Courtesy of Barry Dean Martin*

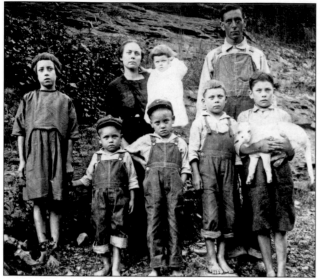

The Fields family, Pinetop, 1924. Front row, left to right: Nora, Milvin, Benny, Loren and Ova. Back row: Bertha, Daisey and John. *Courtesy of Photographic Archives, Appalachian Learning Laboratory, Alice Lloyd College*

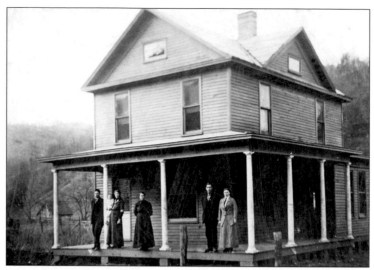

Home of Lon and Saviller "Betty" Hovermale on Back Street in Frenchberg, circa 1925. On the porch, left to right: Robert Menefee Buchanan; his wife, Julia Daroset Buchanan, holding their son, Woodrow; unidentified; Lon Hovermale; and Saviller Hovermale. *Courtesy of Julie Buchanan*

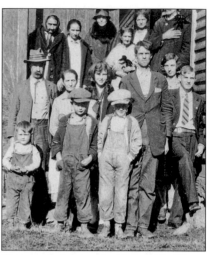

Descendants of Carr Britton, who was the grandson of Gen. George Britton, at Martins Fork, October 1928. Gen. Britton was the first clerk and founder of Harlan County. *Courtesy of John Britton*

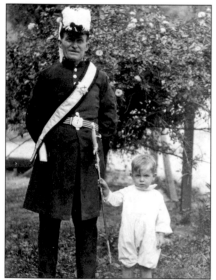

Charles Edward Cutshaw, in his Masonic uniform, with son Thomas Scott Cutshaw in Fleming, circa 1925. *Courtesy of Ann Ross*

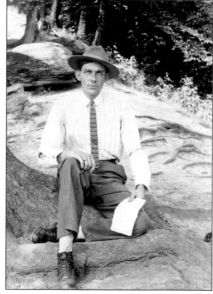

Ernest Stanley Fritts on a church picnic in Combs, Perry County, 1924. *Courtesy of Karen Fritts Bates*

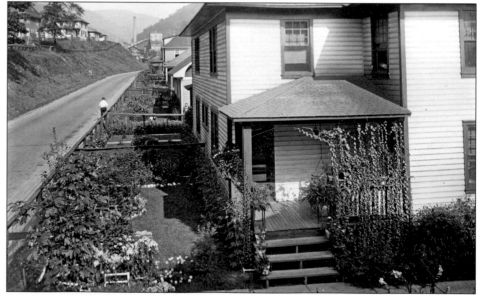

Second-prize flower garden at house No. 60, the home of Alex Lopalsky, on the west end of Lynch, July 30, 1928. Lopalsky worked as a motorman. *Courtesy of Southeast Kentucky Community and Technical College, Godbey Appalachian Archives*

Effie Francis Hahn Fritts and Ernest Stanley "Rusty" Fritts Jr., Christopher, Perry County, 1929. *Courtesy of Karen Fritts Bates*

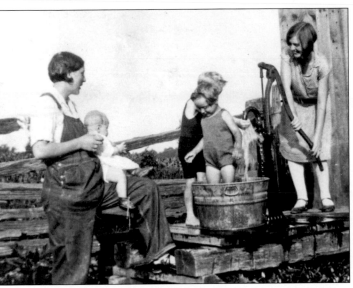

Cooling off in the hot summertime in Wellington, 1929: Rhoa Little holding Donald Mann, Charles Davis Mann, Marilyn Mann in the tub and Gladys Handy pumping water. *Courtesy of Harold L. Mann*

Elkhorn Coal Company workers in Fleming, circa 1928. In the second row, with an arm around a friend, is Dewey Elliott. Behind him is his wife, Fay Cutshaw Elliot. On the far right is Michael Elliott. *Courtesy of Ann Ross*

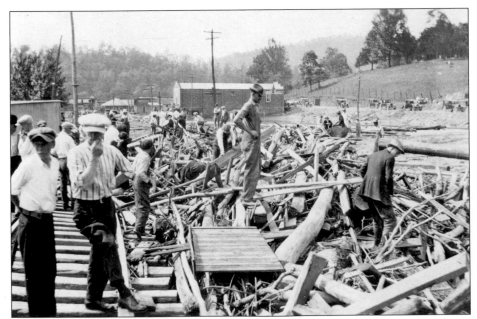

Debris collected behind the railroad bridge in Lothair following the 1927 flash flood. *Courtesy of Bobby Davis Museum and Park*

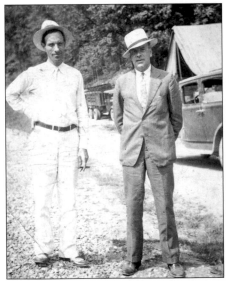

Webster Berckman, left, and a friend at Civilian Conservation Corps camp in Johnson County, 1933. *Courtesy of Winifred "Wini" Berckman Humphrey*

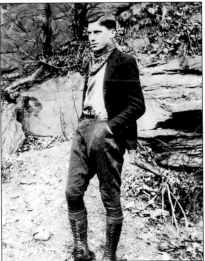

Russell Hall as a student at Caney Creek Community Center, 1930. He later became a physician serving Wheelwright. *Courtesy of Sarah C. Pulliam*

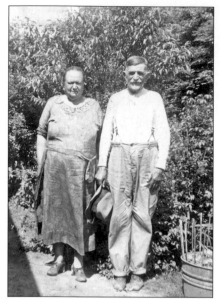

Brack and Martha Young after a Sunday dinner in Breathitt County, circa 1930. *Courtesy of Lois Brewer*

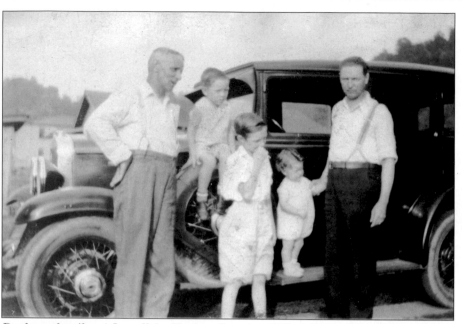

Durham family at Loyall in Harlan County, 1930, left to right: John, Glenn, Gene, Al and Ted. *Courtesy of Alfred E. Durham*

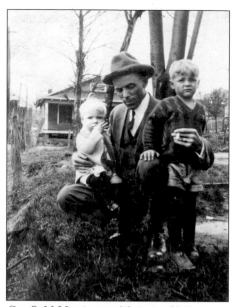

Garfield Masters with two of his sons, David and J. W., Corbin, 1927. *Courtesy of Peggy Jo Williams*

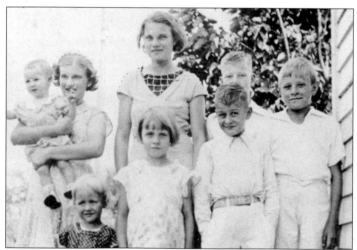

Family gathering at the Jim Smith home on Argillite Road, Flatwoods, 1932. Front row, left to right: June Lee Smith, Ruth Ann Smith, Jimmy Manning and George C. Smith. Back row: Shirley Tune holding Linda Jane Smith, Lucille Smith and Harve Manning. The Smith children are all siblings; the others are cousins. *Courtesy of Randy Smith*

Dorothy Bevins with brother Ralph in Pikeville, 1932. *Courtesy of Barbara Mason*

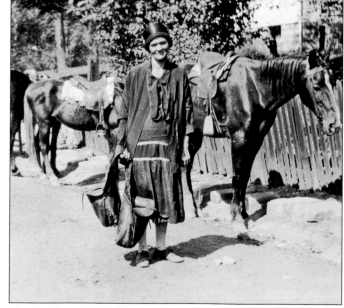

Trade Day in Hyden, Leslie County, circa 1935. *Courtesy of Camp Nathanael*

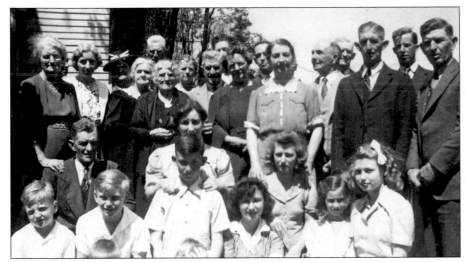

Hillock family reunion, Nicholas County, 1933. They are the descendants of Cinnie Rice and Samuel W. Hillock. *Courtesy of Jean F. Wallen*

Betty Stanfill with cousin James Broaddus, 1935. *Courtesy of James R. Broaddus*

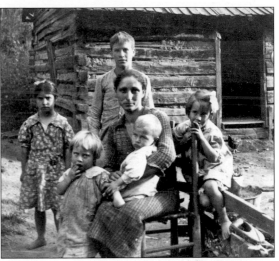

The Wooten family at home in Leslie County, circa 1935. *Courtesy of Camp Nathanael*

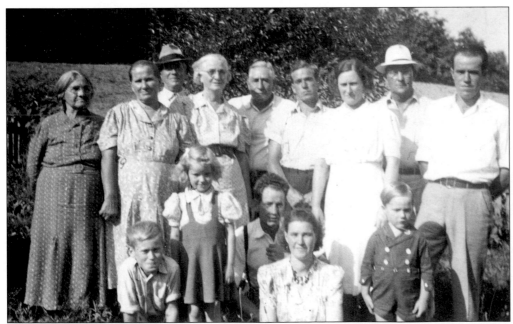

Family reunion at Tarfork Creek in Harris, 1935. Those included: Alice Smith Hamilton, Ella Mawk Howard, Wilce Howard, Mary Mawk Stafford Keefe, Leon Keefe, Connar Howard, Stella Howard Ervin, Grover Ervin, Leslie Howard, Henry Gorman, Donna Lou Davis (Kannard), Ted Davis, Omadee Howard Davis and Burgess Howard. *Courtesy of Mary Hamilton Adams*

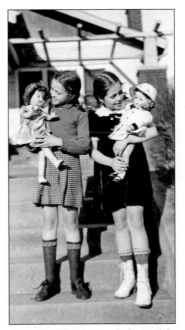

Peggy Masters, left, with Janice Rose holding a "Princess Elizabeth" doll in Corbin, 1938. *Courtesy of Peggy Jo Williams*

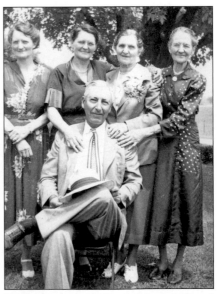

Five of ten Hall children, Floyd County, 1938. Dr. John Hall served as a dentist in Fleming County. From left to right are sisters Birdie Hall, Bertha Turner, Rose Hall and Evelyn Martin. *Courtesy of Opal Hall Waddell*

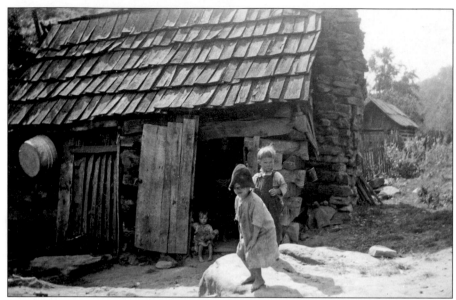

Home in Leslie County, circa 1935. The little girl in the hat suffered from trachoma, which was prevalent in the area at that time. *Courtesy of Camp Nathanael*

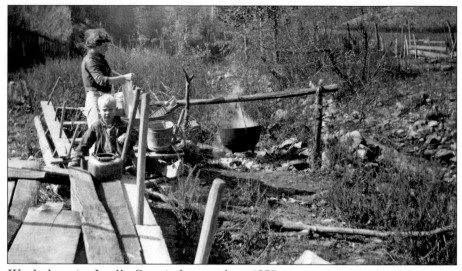

Wash day at a Leslie County home, circa 1935. *Courtesy of Camp Nathanael*

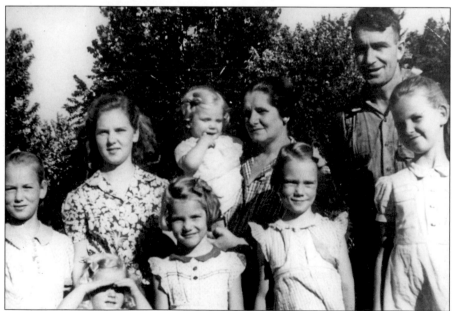

The A. C. Guenther family, Catlettsburg, circa 1939. Myrtle and August are with their daughters Kay Sondra, Delores Del, Barbara Ann, Carolyn Joyce, Gloria Jean, Nelda Lake and Linda Gayle. *Courtesy of Gloria Jean Richardson*

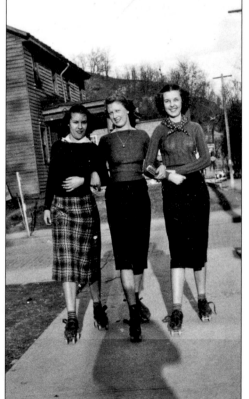

Paintsville in Johnson County, 1937, left to right: Josephine, Evelyn and Mary Hope Vanhoose. Jo and Hope were sisters; Evelyn a cousin. They went home after school, put on their skates and skated back to school to see Eleanor Roosevelt. She was in Eastern Kentucky to dedicate the new $100,000 WPA high school in West Liberty. Roosevelt drove to West Liberty behind the wheel of her own roadster at the head of a motorcade led by Gov. "Happy" Chandler, Sen. Allen Barkley and the wife of Treasury Secretary Henry Morgenthau Jr. *Courtesy of Dianna Teater Walke*

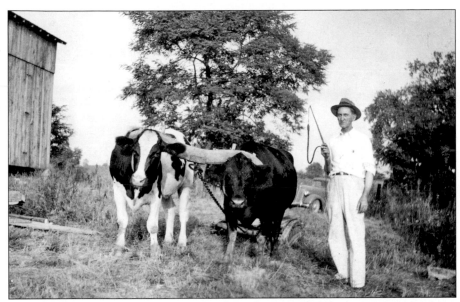

E. V. Hall on his farm in Fleming County, circa 1935. He was born and raised in Floyd County, one of ten children. He became president of Farmers Bank in Flemingsburg. *Courtesy of Opal Hall Waddell*

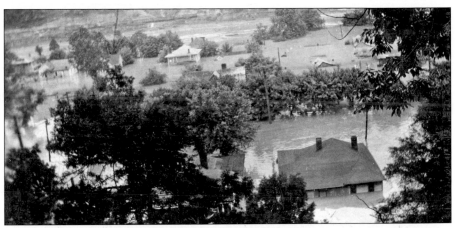

North fork of the Kentucky River during the flood of 1937 at Hazard. *Courtesy of David Ravencraft*

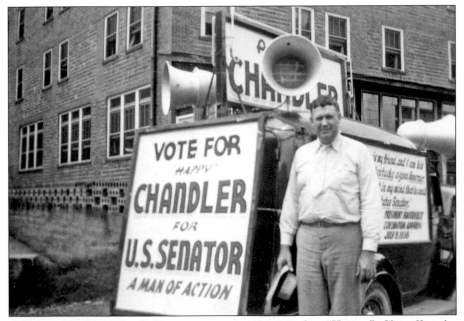

Charles Rucker "Epp" Epperson campaigning for "Happy" Chandler in Pikeville, 1938. *Courtesy of Ann E. Carty*

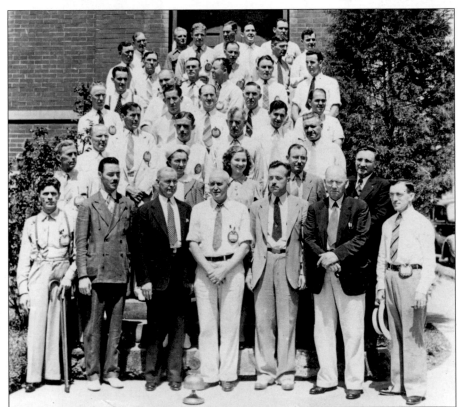

Pikeville Kiwanis Club and visitors, August 1939. *Courtesy of Paul B. Mays Collection, Pikeville Public Library*

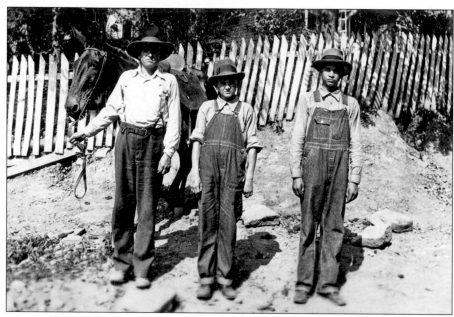

Leslie County boys on their first trip to town, circa 1935. *Courtesy of Camp Nathanael*

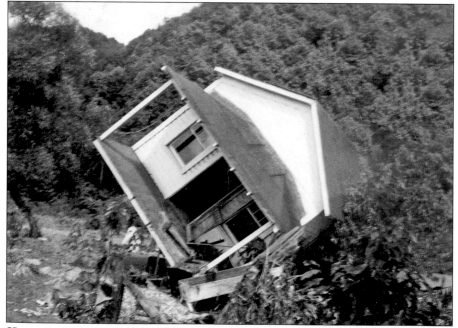

House toppled by the 1937 flood in Morehead. *Courtesy of Harold L. Mann*

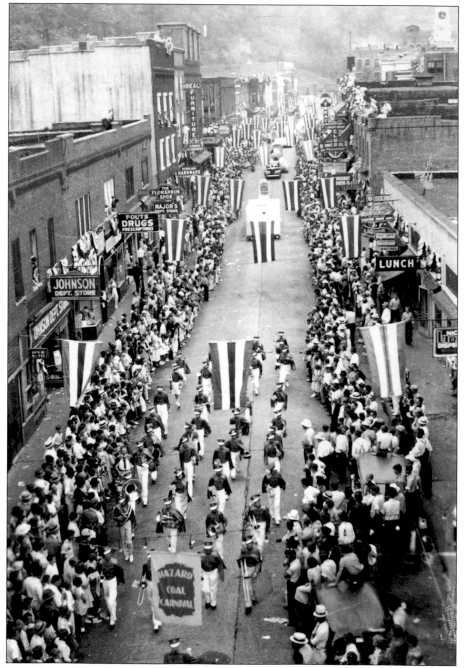

Parade for the Hazard Coal Carnival, 1937. *Courtesy of Bobby Davis Museum and Park*